Textualterity

Editorial Theory and Literary Criticism

George Bornstein, Series Editor

Series Editorial Board

Jo Ann Boydston, Southern Illinois University
Hans Walter Gabler, University of Munich
A. Walton Litz, Princeton University
Jerome J. McGann, University of Virginia
Peter Shillingsburg, Mississippi State University

Palimpsest: Editorial Theory in the Humanities, edited by George Bornstein and Ralph G. Williams

Contemporary German Editorial Theory, edited by Hans Walter Gabler, George Bornstein, and Gillian Borland Pierce

The Hall of Mirrors: Drafts & Fragments *and the End of Ezra Pound's* Cantos, by Peter Stoicheff

Textualterity: Art, Theory, and Textual Criticism, by Joseph Grigely

Textualterity
Art, Theory, and Textual Criticism

Joseph Grigely

Ann Arbor

THE UNIVERSITY OF MICHIGAN PRESS

1998 1997 1996 1995 4 3 2 1

A CIP catalogue record for this book is available from the British Library.

Library of Congress Cataloging-in-Publication Data

Grigely, Joseph, 1956–
 Textualterity : art, theory, and textual criticism / Joseph
Grigely.
 p. cm. —(Editorial theory and literary criticism)
 Includes bibliographical references and index.
 ISBN 0-472-10579-5 (alk. paper)
 1. Criticism, Textual. 2. Art and literature. 3. Transmission of
texts. 4. Arts—History—Philosophy. I. Title. II. Series.
P47.G75 1995
801'.959—dc20 95-16051
 CIP

The great shortcoming of Europeans is always to philosophize on the origins of things exclusively in terms of what happens within their own milieu. . . . When one wants to study men, one must consider those around one. But to study man, one must extend the range of one's vision. One must first observe the differences in order to discover the properties.
—Jean-Jacques Rousseau

Contents

Illustrations ix

Acknowledgments xi

Introduction Art History and Textual Criticism 1

Chapter One Textual Eugenics 11

Chapter Two Textualterity 51

Chapter Three The Textual Event 89

Chapter Four Textual Space 121

Chapter Five Intratextuality 155

Notes 183

Index 203

Illustrations

Figure 1. Endpaper advertisement for the Eugenics
Education Society 15

Figure 2. Endpaper advertisement for *The Works of
Charles Darwin* 17

Figure 3. Title page and frontispiece from *Nature's Secrets
Revealed: Scientific Knowledge of the Laws of Sex Life
and Heredity or Eugenics* 25

Figure 4. John Keats, MS fair copy of the "Ode to Psyche,"
verso of leaf 1 36

Figure 5. Title page and frontispiece from Thomas Bowdler,
The Family Shakspeare 63

Figure 6. Rodin, *The Thinker* 77

Figure 7. David Hammons, *How Ya Like Me Now?* 79

Figure 8. (Upper) "Uffizi Artworks Damaged or Destroyed" 81

(Lower) "Firefighters Dead or Missing" 81

Figure 9. Lear House, Easthampton, New York 83

Figure 10. "A Skin of Beauty Is a Joy Forever" 129

Figure 11. Richard Serra, *Square Bar Choker* 146

Figure 12. Richard Serra, *Square Bar Choker,* 1989 149

Figure 13. Jackson Pollock, *Number 1, 1950
(Lavender Mist),* detail 159

Acknowledgments

The ideas expressed in this book have a long history that for me began with David Foxon's lectures on textual criticism and bibliography at Oxford in the early 1980s. The lectures were a required component of the program that led to the M.Litt. qualifying examination in English Language and Literature, and I was among the postgraduate students who griped about the uselessness of an archaic practice in the age of postmodernism. I later discovered I was wrong about that—wrong about textual criticism as being both archaic and useless—but in the midst of what Foxon described as the "flux" of textual scholarship, it was hard to see where everything was going. Part of the problem was that textual criticism had not yet marketed itself as a theoretical practice, and this had the effect of closeting the discipline as "mere" scholarship. With the publication of Jerome McGann's *A Critique of Modern Textual Criticism* in 1983, textual criticism began to acquire both ideological direction (at least in terms of literary scholarship) and a degree of disciplinary acceptance as a theoretical practice (particularly in relation to master theoretical narratives). Finding a way to relate textual criticism to art took longer. The turning point for me occurred during the mid-1980s when the art world and the federal government debated whether relocating Richard Serra's site-specific sculpture, *Tilted Arc,* would simply constitute an act of relocation (as the government contended) or destruction (as Serra claimed). This event suggested that textual criticism need not be limited to transformations affecting literary texts but could also be used as an ideological tool to help understand the transformations affecting all kinds of cultural texts, including sculpture and painting. Around the same time the Serra controversy was being played out, questions about the restoration and cleaning of the Sistine Chapel were beginning to emerge in both the public and in scholarship, and this too suggested that textual criticism offered art theory a way of conceptualiz-

ing the aesthetic and political significance of transience. My initial explora-
tion of these issues began in earnest in a seminar on art and literature that I
taught at Stanford University while a Mellon Postdoctoral Fellow between
1985 and 1987. I am grateful to the Department of English at Stanford for
the opportunity to offer the course, and to my students for bearing the
novelty of the questions we faced.

All of the chapters in this book were written as separate, yet intertwined,
essays, and all were presented in other formats that have been revised and
expanded for this book. Part of chapter 1, "Textual Eugenics," was initially
read at the Pierpont Morgan Library in 1993 at the biannual conference of
the Society for Textual Scholarship; another part of the chapter was pre-
sented as a series of artworks (primarily installations and conceptual sculp-
tures) in my exhibition entitled *Body Signs: Deviance, Difference, and Eugenics*
at Washington Project for the Arts in Washington, D.C., between Decem-
ber 1993 and February 1994. Chapter 2, "Textualterity," was read at the
1988 MLA convention in New Orleans. The third chapter, "The Textual
Event," was read at the 1989 conference of the Society for Textual Scholar-
ship in New York and was published in *Devils and Angels: Textual Editing
and Literary Theory*, ed. Philip Cohen (Charlottesville: University Press of
Virginia, 1991). Chapter 4, "Textual Space," was read in New York at the
1991 conference of the Society for Textual Scholarship and appeared in *Text
7*, ed. D. C. Greetham and W. Speed Hill (Ann Arbor: University of Michi-
gan Press, 1995). The final chapter, "Intratextuality," was initially read
under a different title at Wesleyan University in March 1993, and in another
format at the Third International Conference on Word and Image Studies in
Ottawa in August 1993. I am grateful to the organizers of these gatherings
for the opportunity to present my work, and I would also like to express my
appreciation to the many people who offered feedback and criticism. Fi-
nally, I would like to acknowledge with immense gratitude the sign lan-
guage interpreters who unflinchingly tangled with the discourse of these
lectures and made otherwise impossible exchanges beween myself and my
audiences possible.

Many people have assisted me in ways that have proven invaluable:
locating documentary texts, asking questions I couldn't readily answer,
commenting on drafts of the work as it stumbled through its early stages,
and by correcting some of the more glaring errors. I would like to thank, in
this regard, Janis Bell, George Bornstein, Lois Bragg, Philip Cohen, Colin
De Land, Paul Eggert, Claire Farago, Sarah Greenough, David Greetham,
Connie Harsh, Susan Hirshberg, Robert Lobe, Beth Loizeaux, Jerome

McGann, W. J. T. Mitchell, and G. Thomas Tanselle. I would also like to thank Nancy Yeide and Marla Prather of the National Gallery of Art, Washington, for facilitating my research on Jackson Pollock's *Number 1, 1950*. For financial support that assisted the completion of this study I am grateful to the National Endowment for the Humanities and the Gallaudet University Department of Graduate Studies and Research. I would also like to acknowledge a number of important friends and colleagues who contributed to shaping both the ideas that went into this book and the life of the person who wrote it: Diane Brentari, William Van Wyke, Ira Livingston, Doug Montalbano, Rob Evans, and Penny Smith. I am extremely grateful to all of them. My most important acknowledgment, however, is to a bricklayer named Joe and a homemaker named Anne, and this book is dedicated to them.

Introduction
Art History and Textual Criticism

This book is about the transmission of cultural texts, and about how individual works of art undergo change as part of the process of being disseminated in culture. Variation, drift, and rupture characterize or describe certain kinds of change whose primary function in critical discourse is indexical: they alert us to the fact that the dynamic aspects of culture are not merely temporal but consist of different kinds of temporality. "It is not enough to indicate changes. . . . We must define precisely what these changes consist of" is Foucault's observation on the subject, which he follows with a suggestion that we abandon the general reference to change and substitute for it "the analysis of *transformations*."[1] This study is about textual transformations and textual difference: what I call textualterity. The underlying premise is that the uniqueness of the unique art object or literary text is constantly undergoing continuous and discontinuous transience as it ages, is altered by editors and conservators, and is resituated or reterritorialized in different publications and exhibition spaces. Reconfiguration and reterritorialization are germane to art and perhaps are reasons it is able to substantiate itself as art: it does not depend on maintaining a certain intention or condition. The fact that polychromed Greek sculptures are no longer polychromed and lack noses and an occasional arm or leg does not so much detract from their status as art but add to it and perhaps even define it. This reconfigured state is surely not a state intended by the artists and artisans who made these works, but one of my goals in this book is to show that the temporal and spatial peregrinations that works of art and literature undergo rarely pay homage to their creators' intentions. I do not see this as a bad thing, but as something that tells us about art's resiliency as a medium (on the one hand) and about art as a cultural

phenomenon (on the other). When *Tom Sawyer* is condensed by *Reader's Digest* into what the editors describe as a "less formidable" text,[2] the act does not reflect Mark Twain as much as it reflects *Reader's Digest* and the audience for which the text was prepared. Twain certainly would not have approved this reworking of his novel, but I believe that questions about the propriety of editorial acts must be temporarily suspended in order to address a more serious concern about why they actually occur. What's the point in condensing *Tom Sawyer*? What social, economic, or even scholarly concerns are made evident by the process of condensing a widely available children's classic? Few people would consider a *Reader's Digest* condensed text an important text worth scholarly attention, but here I demur. The very fact that such texts exist—exist and are bought and read—should remind us that the vicissitudes of culture are not in the end dictated by the intentions of artists alone.

To the extent that condensed texts and sculptural ruins are both texts and sculptures, this book is concerned with them. Indeed, there is a certain ordinariness about their presence in culture today, and this ordinariness is suggestive of their pervasive presence throughout cultural history. Charles Lamb was retelling Shakespeare at the same time Thomas Bowdler was bowdlerizing him, and Lord Elgin was packing up some rather big chunks of the Parthenon around the same time Sir John Soane was assembling the ruins and fragments that would eventually fill his house-cum-museum. The verbs here are important: retelling, bowdlerizing, packing, assembling. These are human acts—they proceed from a combination of desire and will—and, as transformations, it is acts like these that contribute to the construction of culture. Many of the examples of transience in art and literature discussed in this book were thus chosen for the sake of the things they tell us about culture in general terms, and for the ways in which they exemplify how works of art and literature are made, unmade, remade, and made over. The fact that we are inured to change—we expect paintings to need cleaning and texts to need editing—does not make my subject less, but rather more, important, in part because of how little we have come to appreciate the value of change, and how it has both aesthetic and social importance. As Mohsen Mostafavi and David Leatherbarrow point out in their recent study on transformation in architecture, *On Weathering*, buildings are "re-formed" over time: accumulations of dirt construct a finish or patina, just as erosion of a surface constructs another kind of finish.[3] To clean or otherwise remove this finish is problematic because it invokes one

form of transience (suddenness, or rupture) against another (accretion) and thereby draws out one of the problems about transience: that it is (as Foucault suggested) quantitative. Yet, transience like this is inevitable, whether the subject of the transience is a building or a sculpture or even a poem: for as a work of literature is resituated in different publications and reedited in different contexts, it too undergoes a crucial form of remaking. One of my goals in this book is to show how artworks, like literary works, have multiple texts, how the space of these texts is a discursive space, and how the meanings we create for a work of art or literature are (to a large extent) a product of the textual spaces we enter and engage in. My purpose here is thus almost ironic: I want to use history to interrogate history. I want to take us closer to the history of text production in order to reveal, on the one hand, the importance of this history, and, on the other, its limitations.

The importance of this history in relation to the practice of reading is a crucial consideration. Increasingly, art theory has shifted attention from the context of authorship to the context of readership. As Keith Moxey recently wrote in *The Practice of Theory,* "Mine is rather a call for a politically committed form of art historical interpretation, which acknowledges that the narratives we construct are the products of our own values as these have been shaped by, and in reaction to, the social forces responsible for the construction of our subjectivity."[4] This emphasis on social forces having shaped the reader's reading of a work is also shared by Norman Bryson, who suggests that *"Our* context has latterly enabled us to realize different contexts, and that it is we who set them up."[5] What is particularly compelling about this position is its equanimity: it does not so much dispense with history as it looks closely at the idea of multiple histories and the ultimate importance of the reader's own. As Moxey acknowledges, this is one of the fundamental approaches to what is known as New Historical criticism. Moxey's more general thesis is that the very idea of "history" needs a closer examination because history cannot be studied apart from the language and the narratives that are used to construct it. This is important because the objects and narratives that we study are themselves discursive systems, and we can only understand how complex all of this really is by coming to terms with the loose ends of language, of interpreters, and of cultural objects themselves. As Moxey correctly observes, "The history of art must develop a more considered account of what it considers history to be."[6] This is true, in a very general sense, for all forms of cultural activity

that depend on the transmission and dissemination of aesthetic objects, including literature, film, drama, and both plastic and conceptual arts. For me the neglected historical narrative in cultural studies is that of the work of art, or what is usually categorized as "the text itself." I do not mean to speak of an abstract text, but a concrete text: a very particular text that reveals what a very particular reader is actually reading, and the conditions under which this text has transpired to acquire the form in which it is being read. What is important, I think, is not the historical context of the work alone, or the social context of the critic alone, but the way these contexts overlap with the contexts of textual reproduction—the continuously *discontinuous* remaking of texts by editors and curators in the process of their dissemination. It is thus the space *between* the author and the reader that is engaging, crucial, and neglected. Unlike the synchronic histories of authorship and readership, the histories of textual transformation are diachronic. Diachronic histories both support and undermine the very idea of the construction of a context, in part because they expose the way spatial contexts are imbricated with temporal contexts and force us to consider: where do contexts or frames begin, and where do they end? These are not easy questions, but they effectively communicate just how complex the idea of a context really is, and how contexts are not so much found as they are made.[7] For me a context is not so much a space surrounding or accompanying a text (the Latin *con-* as a prefix meaning "together, together with, or in combination with") as it is a process or *activity* of spatial enactment (which is closer to Partridge's excavation of the Latin *contexere,* "to weave together," and hence "to join"). By closely examining the ways in which artworks can be said to move, I hope to show that our own interpretative movement (best characterized by indeterminacy) is not the result of the failure of our theoretical paradigms (though the search for new paradigms may reflect this), but because, in part, we treat texts as if they had no movement, or as if this movement is redundant.

When I suggest that artworks move, I do not mean to imply that this movement is active; but rather, that it is (as Paul Eggert suggested to me) passive, and that it is the manifestation of differences between texts of a single work that bears traces of this movement. Sometimes this movement is characterized by an evolving original (like Keats's two "La Belle Dame's" and Wordsworth's two *Preludes*), and sometimes it is characterized by what Benjamin would call reproduction or replication (a postcard of *Mona Lisa* or a copy of *David*). Benjamin's essay "The Work of Art in the Age of Mechanical Reproduction" is quite relevant here, although there are some

limitations to its usefulness. Benjamin is clearly at his best in discussing how, in an age of mechanized reproduction technology, the uniqueness of the "original" work of art is realigned vis-à-vis the public. Benjamin explains the situation thus: "[T]he technique of reproduction detaches the reproduced object from the domain of tradition. By making many reproductions it substitutes a plurality of copies for a unique existence."[8] In this respect, Benjamin's crucial gesture is to direct our attention to how the dissemination of works of art has a bearing on culture as a whole. It is not the work as an aesthetic entity that commands our attention as much as the filiation of the work.

Benjamin's essay, prescient and insightful for the most part, is not without problems. He did not seem to grasp one of the essential facts about textual and bibliographical study: that reproduction involves the *illusion* of re-production. Changes, often minute, but rarely insignificant, are frequently introduced to a text in the process of reproducing it: in the case of literary works, punctuation is often altered, sentences are edited, and bibliographical elements (title page, font, binding, and so on) undergo change. By this process, "multiples" are not necessarily identical. There is also a converse operation that affects the individual work of art. When a single painting is reexhibited in different institutions and galleries, or reproduced through different media (magazines, postcards, and catalogs), it experiences various kinds of shifts (scale, color, perspective) that ultimately affect how it is read. Its uniqueness is no longer unique in relation to the individual painting, but in relation to its many texts. Donald Preziosi, in particular, has pointed out how a combination of photographs and slides have shaped and modernized art history as a profession, having provided the essential taxonomic tools for study and analysis.[9] Photographs have also provided the primary means by which works of art are disseminated in culture. Even as reproductions, photographs and related print media do not so much reproduce these works of art as reconfigure them through their unique modality, and thereby contribute to reontologizing the entire sphere of aesthetic activity. Ultimately, this phenomenon forces us to look more closely at what exactly happens in the process of textual production and reproduction. Benjamin claimed that reproductions lack "presence in time and space," and he pointed to photography and film as two exemplary genres. Yet individual photographic and film works have multiple texts that vary considerably between them, and this explains why terms like "director's cut" (to indicate a director's preferred film version in relation to other versions) and "vintage print" (to indicate a photograph printed by

the photographer and not by other personnel) help define authority where authority was for many years glossed over and presumed absent.

Benjamin's error, specifically, was in assuming that copies and reproductions were by definition alike. Copies clearly have a potentially unique existence, first by virtue of the fact that they are copies *of* something (in which case their existence as copies is indebted to a certain social or economic need), and second in terms of their uniquely configured media, which also meet certain social needs: slides of artworks are not the same as postcards of artworks, just as a *Reader's Digest* edition of *Tom Sawyer* is not the same as a critical edition of *Tom Sawyer*. Each has a particular function and therefore can be said to possess uniqueness in relation to that function. If anything, these issues all complement and reinforce the larger thesis of Benjamin's essay: that mechanical reproduction politicizes art by realigning the ways in which art is disseminated in the public sphere. It is precisely the variations among the "reproductions" that reflect their politicalization.

In an age of post-Marxist realignments of both the world itself and the various critical theories that comprise transdisciplinary studies in art and literature, it seems almost tautological to engage the word *politics*. Yet I do so here, in part because Benjamin himself did, and in part because any surrogate term would evade the disconcerting truth that many changes that occur in the transmission of cultural texts do in fact occur for political reasons—reasons that relate, more specifically, to the displacement and distribution of power among those involved in making and remaking cultural texts. There is, simply, no other way to describe the sense of purpose or intention underlying recent public controversies in the arts such as the removal of Richard Serra's commissioned sculpture *Tilted Arc* from its site-specific location in lower Manhattan, and the debate about whether the cleaning of the Sistine Chapel was essentially good or bad.[10] But what is surprising about these controversies is the fact that they are considered surprising at all. The social, aesthetic, and political complexity of the works, and the forces that reconfigured them, seem almost ordinary in the context of cultural history. But given the fact that this history is so complex—it encompasses almost every defining aspect about being human—it is little wonder that we remain indifferent to, and uncritical of, many of the myths of cultural history. It is somewhat disconcerting, given the record of unending change physically altering artworks, that many people continue to believe that art is immutable, that the artist's intentions are paramount, and that original works should be "preserved" from various agents of change. Perhaps this is simply a reflection of our desire for stability and order: to

think of art (as Seneca said) as something that will endure—unlike life itself. Art does endure, of course, and one reason it endures is because it is able to absorb and incorporate change of various kinds. Political tensions, and the changes that are a product of these tensions, are hardly damaging to culture—even in cases involving censorship—as much as they are perhaps necessary, in part because of the ineffable ways in which they make manifest the construction of culture. Like a series of snapshots over centuries, a work of art is a linear and discursive accretion whose transience is an indication (in an indexical sense) of its cultural life. It is not just the reality of difference that is important, but the fact that there are different kinds of differences, not all of which can be easily cataloged, classified, and summarized for critical or scholarly purposes.

Traditionally, the study of the transmission of cultural texts, or more specifically literary texts, has been the domain of a field of literary study known as textual criticism. As a discipline with roots in biblical and classical philology, textual criticism was developed out of a need to organize and map different texts of a single work so that their relationship between each other could be better understood. The discipline's general theoretical premise (to the extent that there is one) is that in the process of composing and disseminating a single work of literature numerous texts are produced and that these texts differ in both linguistic and nonlinguistic (or bibliographic) ways: there are drafts, transcripts, proofs, and differing publications and contexts. Since all of these texts are historically conditioned and have specific reasons for having existed, their presence takes us closer not just to the process of composition, or the work's meanings, but closer to the vicissitudes of cultural activity by emphasizing the exchanges of this activity rather than the objects that are a product of it.[11]

This emphasis on the processes of textual transmission is important. While textual criticism evolved by focusing its attention on inscribed and printed texts whose embodiment in different formats leaves traces of transience and change, it is not the material objects themselves that are so important, but the activities that relate to their production and dissemination. Thus, while the origin of the discipline is based upon prevalent technologies and genres, this origin is ultimately the foundation for understanding all forms of bibliographical, postbibliographical, and cultural change. As we increasingly engage complex technologies for textual production and reproduction (including hypertext and virtual reality), we are likely to see textual theory incorporate these technologies into its range of

practices in a way that does not really alter the fundamental premise of the discipline: that a specific text is the manifestation of the tensions between desire and reality. The one enduring goal of textual criticism (and this goal is shared by those with as differing editorial methodologies as Jerome McGann and Fredson Bowers) is to make textual consciousness, if not textual criticism itself, a part of all critical activity. Such engagement sees textual criticism as more than a preliminary activity (that is, to edit "reliable" texts), but as something that is fundamental to the experience of literature, for it brings us closer to the human contexts by which literature is written, printed, disseminated, and read.

One problem with textual criticism is that, despite being a scholarly discipline for over a thousand years, and despite having developed a remarkable set of methodological tools during this time, it has not exerted a profound influence on how we more generally understand the transmission of cultural texts. Its focus has been almost exclusively on literary texts, and usually with the pragmatic goal of editing these texts. As David Greetham, one of the founders of the Society for Textual Scholarship, recently said of textual criticism, "[I]ts theory has been that there is no theory, only method."[12] There are reasons for this, however, and one of the goals of this book is not to create or supply this missing theory but to show why it is so hard to do so. In order to survive as a critical practice, textual criticism and bibliography have been very careful about how genres and modalities affect editorial choices and how those choices are also affected by the limitations of convention and technology. In expanding this range of genres and modalities to include art and performances my purpose is not to dispose of extant textual-critical practices, but to attempt to find in them a theoretical orientation that is relevant not just to literary texts, but to cultural texts. I am occasionally critical of certain editorial practices and the rhetorical claims that editors frequently append to their work, but this criticism is accompanied by an immense respect for editorial practitioners including W. W. Greg, Fredson Bowers, James Thorpe, Hans Walter Gabler, G. Thomas Tanselle, Jack Stillinger, and Jerome McGann. None of the criticism in this book could have been possible without their contributions, and to a large extent the ideas expressed here constitute a homage to the implications of their work.

As I remarked a moment ago, the purpose of this book is not to offer a theory of cultural editing but to show some of the problems and complications of such a theory. A general theory of the transmission of cultural texts

can at best be only one theory among others and, rather than subsuming, is ultimately subsumed by the actual poems, paintings, and sculptures that it seeks to order and describe. For this reason I have made an effort to substantiate my theoretical assumptions with examples of textual change from a wide variety of sources. Most are anachronistic, and as much as they elide time they also elide genres and media: Caravaggio and Jackson Pollock, John Keats and Johnny Rotten, Thomas Bowdler and Fredson Bowers, Frank Lloyd Wright's Guggenheim Museum and the house at 128 Main Street in East Hampton, New York, and assorted other examples gleaned from the galleries and museums in New York, the deserts of the American Southwest, and advertisements from forgotten nineteenth-century magazines like *Kunkel's Musical Review*. Some of my examples (particularly my discussion about Richard Serra's site-specific sculpture, *Tilted Arc*), are sufficiently problematic as aporias that they help reveal some of the contradictions of theory and how, in a sense, contradiction is a necessary condition of cultural theory. Donald McKenzie remarked in his prescient Panizzi lectures on bibliography that an understanding of the "bibliographical principle" in nonbook forms is, at this incipient stage of inquiry, usually studied through homologies and concurrences between literary and nonliterary texts,[13] and in this respect many of my examples constitute a form of homological play. Notwithstanding formal semiotic distinctions between works of different media—the difference between poetry and painting, for example—I try not to let these distinctions overwhelm pragmatic considerations implicit in the exhibition or distribution of works of different genres or modalities. While I do discuss some of these code-based, or semiotic, distinctions (particularly in chapters 3 and 4), one of my intentions is to demonstrate some of the problems that arise from putting too much faith in these codes, and show how a nominalistic view of textual production cannot in the end substantiate itself among the unpredictable realities of cultural activity. Art and meaning will always subvert our best theoretical paradigms—that is one reason we are always inventing new ones—and so lead us to a point of concluding that our most useful critical paradigms are those that are able to subvert subversions.

Inasmuch as this book is about textual criticism, and inasmuch as most of its examples involve permutations of various contemporary definitions of art, it is written with two distinct audiences in mind: textual critics and art historians and theorists. My hope is that textual critics will find their traditional practices challenged by exposing them to some of the problems of nontraditional genres and media, and that art historians (as well as

curators and conservators) might reconceptualize notions of "original" texts and textual transmission by being exposed to the practices of textual criticism. While the first chapter, "Textual Eugenics," is essentially a critique of twentieth-century textual criticism and discusses art only indirectly, it lays the groundwork for later chapters in its argument for considering the value of the relative authority of cultural texts, particularly texts we would otherwise consider irrelevant to scholarly study. The remaining four chapters discuss the redistribution of this authority among texts that are historically situated in space, time, and the reader's ultimate construction of a "context." These discussions are not without contemporary relevance: ours is an age of competing cultural authorities, whereby issues related to intentions, ownership, copyright, fair use, and moral rights are entangled with something that presumes to, but does not, resist its involvement: the art object. If art objects could exist in a vacuum of unalloyed objecthood there would be no need for a book like this. But when the object becomes a subject of two or more competing authorities—restored paintings, relocated site-specific sculptures, colorized films, appropriated images, condensed books, "definitive" editions, and so on—then the tensions themselves, not merely their resolutions, become a subject of critical discourse. This book is about those tensions, the ways they are manifest, and the value they hold.

Chapter One

Textual Eugenics

What does the history of Anglo-American eugenic thought have to teach us about the history of Anglo-American editorial theory? To the extent that eugenicists treat the body as a text (to be "edited" eclectically), and editors treat the text as a body (describing it in pathological terms), there is in the two disciplines an interface of critical discourse that concerns how we look at, categorize, and describe human and textual differences. Since both eugenics and textual editing are Romantic enterprises that retain a large measure of their Romantic idealism in an age of postmodernism, this chapter is concerned with the implications of this irony and how they reflect on some of the changing paradigms in current editorial theory. My approach involves three operations: first, to briefly describe some of the more compelling and troubling aspects of eugenic history; second, to examine some of the parallels between eugenic ideology and editorial practices; and, finally, to discuss how these eugenic/editorial paradigms might be reoriented in terms of a postmodern conception of alterity. My examples in this discussion include Richard Monckton Milnes's mid-nineteenth-century effort to edit Keats's letters and poetry and *Reader's Digest*'s late-twentieth-century effort to edit and "condense" *Tom Sawyer*. While both examples involve canonical conditions, the texts themselves are not what one would call canonical texts. Milnes's version of Keats and *Reader's Digest*'s version of *Tom Sawyer* are instead what textual critics might call "corrupt" texts: they presumably lack authority and as a consequence are rarely discussed or studied in a scholarly context. Yet, while these texts lack institutional authority, they are historically situated in very important ways, and my reason for discussing them is to reflect on the origins and problems of textual idealism (whether represented by an ideal text or an ideal body), and show how our approaches to cultural manifestations of variation and difference are perhaps most usefully understood in terms of reciprocal human difference.

11

Eugenics: A Brief History

In 1926 a rather thick book, twenty-seven chapters long and bound in blue boards, was published in London by John Murray. The book is entitled *The Need for Eugenic Reform*. Among the twenty-seven chapters can be found the following subject headings:

Evolution

The Laws of Natural Inheritance

The Inheritance of Acquired Differences

Racial Poisons

Feeblemindedness

The Lessons of the Stockyards

Tests of Desirable Qualities

Is the Race Deteriorating?

The Burden of the Less Fit

The Elimination of the Less Fit

The Multiplication of the More Fit

Eugenics and the Riddle of the Universe

The volume itself—all 523 pages of it—is argued with passion and mild persuasion, and, given the gravity of its sociopolitical implications, it is as rhetorical and imposing as one might expect such a text to be. With few historical antecedents, the work could only be described as coyly inviting, even seductive in how it presented a pragmatic and logical scientificism that made any contrary arguments seem untenable, even fanatically irrational: "Eugenics," wrote the author in the first chapter, "consists in the utilization of knowledge acquired in the study of the evolution of living things in order to promote the progress of our race."[1] The word *eugenics* was coined in the late nineteenth century by Francis Galton to denote a science of genetic improvement whereby the human race might be manipulated through selective gene management—what Galton called "the cultivation of race":

We want a brief word to express the science of improving stock, which is by no means confined to questions of judicious mating, but which,

especially in the case of man, takes cognisance of all influences that tend in however remote a degree to give the more suitable races or strains of blood a better chance of prevailing speedily over the less suitable than they otherwise would have had. The word *eugenics* would sufficiently express the idea; it is at least a neater word and a more generalised one than *viriculture*, which I once ventured to use.[2]

Galton's theory was, in principle, simple and involved a curious twist to natural order, whereby Darwinian natural selection was replaced by artificial selection—the very premise underlying contemporary experiments in recombinant DNA technology.[3] But Galton's theory was not just a technological theory of good genes replacing those considered dysgenic or "kakogenic." There was also a distinctly social consideration that complicated the matter, the intratextual body being inextricable from the social body. For Galton and his followers, certain human conditions, particularly chronic illnesses and "feeblemindedness," and certain races stymied human progress and also burdened others by creating a permanently expanding underclass. In order to purify society and purge itself of impending racial disorder, Galton argued, it would be necessary to implement a program of social or applied eugenics.[4]

Because genetic analysis searches for common denominators of innate identity, the eugenics movement sought not only to qualify and categorize states of, or conditions of difference but also to quantify it in disturbingly arbitrary ways. The Mental Deficiency Act of 1913, for example, established four classes of persons coming under purview of the act: idiots (people unable to protect themselves against common physical dangers); imbeciles (people incapable of managing themselves or their affairs); feebleminded persons (those incapable of receiving proper benefit from instruction in ordinary schools); and moral imbeciles (what was regarded as a permanent mental defect coupled with strong vicious or criminal propensities).[5] Taken together, these classes were further described as "aments"—a coinage (via amentia and dementia) that describes a pejorative state of insanity for which "deviant" simply wasn't strong enough. Nor was it enough for eugenicists to say that feeblemindedness was bad or that races should not mix: taking the premise that "like produces like" to extreme ends, it was also claimed that illegitimate children would grow up and produce illegitimate children of their own; and it was even suggested that drunkards, habitual criminals, and all who refuse to work should undergo compulsory segregation: "We should not treat the crime but the criminal"

was the motive for this action.[6] During the first three decades of the twentieth century, dozens of books appeared espousing in a quasi-religious, quasi-scientific discourse the tenets of eugenic ideology and the need for eugenic reform.[7]

The big blue book on *The Need for Eugenic Reform* was written by Major Leonard Darwin, Charles Darwin's son. The relationship is more than a little ironic: Darwin's discoveries in natural selection were, in a sense, being used as an argument to favor a eugenic model of artificial selection. The entire book is actually framed by Darwin's credibility, not in the least because he is invoked at two critical points: in the dedication, which is more sober than effusive (thereby connoting a tone of logical rationalism), and in a series of advertisements at the end of the book. The dedication serves to imply a continuation of Darwinian thought when, in fact, it represented a radical reconfiguration and manipulation of natural biological order.[8] The advertisements are even more compelling. The first, on an unnumbered recto page following the index, is an advertisement for the Eugenics Education Society, which was founded in 1908. It clearly states a definition of eugenics and the means by which "practical results" could be obtained: segregation, sterilization, and legislation affecting social conventions such as marriage. Metonymizing Major Darwin's arguments, the advertisement functions as the gesture between ideology and initiation, between articulation and enactment. If we recall the book's title with emphasis—*The* Need *for Eugenic Reform*—we realize that it fits neatly into the genre of writings that, emerging out of romanticism's utopian desires, could somehow justify themselves on scientific grounds. For the eugenicists, the industrial revolution would now have a new subject: not the social environment of the population, but the population itself. In a tricky and almost self-consciously evasive way, Major Darwin's book can also be read as a prelude to the advertisement for the Eugenics Education Society, whose ultimate goal of social reform was bolstered by the performative function of Major Darwin's 523-page appeal.

The second advertisement, on the recto page following the notice for the Eugenics Education Society, is a publisher's advertisement for the works of Charles Darwin. Because John Murray published both the major and his father—Darwin's work under Murray's imprint ran to over fifteen volumes and included "popular" editions of *The Origin of Species* and *The Descent of Man*—the advertisement does not seem particularly unusual. But in another respect, the advertisement's diction is compelling in its very ordinariness: "The first edition of this book, which has passed out of

The Eugenics Education Society

(FOUNDED 1908)

52 Upper Bedford Place, W.C.1

PRESIDENT - MAJOR LEONARD DARWIN, Sc.D.

ELECTED OFFICERS, 1925-26

Vice-Chairman:
PROFESSOR E. W. MacBRIDE, F.R.S.

| *Hon. Secretaries:* | *Hon. Treasurer:* | *Hon. Librarian:* |
| LADY CHAMBERS, R. A. FISHER. | W. HOWARD HAZELL. | MISS E. CORRY. |

Definition.

Eugenics is the study of heredity as it may be applied to the betterment, mental and physical, of the human race.

How can practical results be obtained?

1. By educating the general public to think eugenically, and to recognize the responsibility of parenthood.
2. By furthering such measures or tendencies as would prevent the diminution of superior types or the multiplication of the inferior.
3. By insisting that the palpably unfit and degenerate shall not reproduce and multiply their kind.
 This may be accomplished by *segregation*, and ultimately, perhaps, by *sterilization*, voluntary or compulsory.
4. By watching and recording the results of eugenical research and legislation in other countries.
5. By collecting statistics and facts that may be of use for legislative and scientific purposes in this country.
6. By keeping in close touch with current legislation and executive action in order to intervene, either with objection or support, where the racial qualities of the empire may be affected.

What the Society is doing now.

1. A Review is published quarterly, as well as reprints of articles and papers in pamphlet form.
2. A loan library has been formed and is being kept up-to-date.
3. Monthly meetings are held, when papers are read and lectures are given.
4. The Society arranges for lectures and courses of lectures and film demonstrations to be given in any town or district. Lecturers' travelling expenses are asked for, and a small fee for the lecture will be appreciated if such is within the means of the society asking for the lecture.

The Library is in the offices of the Society,
 52 Upper Bedford Place, W.C.1. Tel. Museum 9640.
 Hours: 10—12 a.m., 3—5 p.m., except Saturdays.

Lectures and Fellows' Meetings monthly, open to all members (invitation by notice); other meetings may be arranged by application to the Secretary.

Fellows (elected by Council): Life, £10; Annual, £1 1s.; Members, 10s.

Fig. 1. Endpaper advertisement for the Eugenics Education Society. Reproduced from Leonard Darwin, *The Need for Eugenic Reform* (London, 1926).

copyright, is the imperfect edition which the author subsequently revised and which was accordingly superceded. This is the only corrected copyright edition, published with the approval of the author's executors."[9] The telltale phrase is this: the first edition is an "imperfect edition"—that is, dysgenic—and "accordingly superceded." While contemporary textual-critical discourse is inured to describing texts in terms of their deficiencies, the sense of imperfection is grossly amplified in the context of an entire book devoted to the horrors of imperfect bodies and the need to reform them. What therefore happens in this advertisement is that the language of eugenics becomes entangled with the language of textual criticism. For both eugenics and textual criticism this language is a rhetorical language whose distinguishing trait is persuasion. Progress is measured not solely by the elimination of a text's imperfections, but by the rhetorical explication of the act of progress itself. Like other historical manifestations of progress, whether in science, industry, or social science, improvement initially consists of the *image* of a certain kind of goodness replacing a certain kind of badness. It does not matter whether the supposed image of goodness is actually good or not—that cannot be decided by those contemplating the rhetoric of change, but only by those inheriting the consequences of those decisions. What takes on importance is the possibility of transcending one state for another, since the conditions of goodness and badness are forever in flux. That is why, with respect to texts, the idea of "corruption" was not a new observation, even in the early twentieth century: eighteenth-century editors of Renaissance texts had already made it a commonplace descriptive term. But the entanglement of human dysgenics and textual dysgenics was in fact something quite new and revealed how authority itself could be rendered inabsolute and converted into a rhetoric involving the tangled exchange of power.

The "imperfections" of Darwin's first edition (and subsequent superseded editions) are thus not about corruption and errors in the sense that Shakespeare's texts were; instead we are dealing with authorial drift, with changes that are the product of changing intentions and changing social ground. *The Origin of Species* went through five major revisions between the first edition of 1859 and the sixth edition of 1882, the year Darwin died.[10] Many of the revisions are stylistic, but many more are dialogic in the sense that they respond to the book's critical reception and thereby create a narrative consisting of absent exchanges. For the third edition of 1861 Darwin undertook major revisions, as he remarked, "in hopes of making many rather stupid reviewers at least understand what is meant."[11]

THE WORKS OF
CHARLES DARWIN

'For myself I found that I was fitted for nothing so well as for the study of Truth; . . . as being gifted by nature with desire to seek, patience to doubt, fondness to mediate, slowness to assert, readiness to reconsider, carefulness to dispose and set in order; and as being a man that neither affects what is new nor admires what is old, and that hates every kind of imposture. So I thought my nature had a kind of familiarity and relationship with Truth.'—BACON. (Proem to the *Interpretatio Naturæ*).

THE ORIGIN OF SPECIES
By Means of Natural Selection, or the Preservation of Favoured Races in the Struggle for Life. Popular Edition. 7s. 6d. net—also F'cap 8vo. 2s. 6d. net.

The first edition of this book, which has passed out of copyright, is the imperfect edition which the author subsequently revised and which was accordingly superseded. This is the only corrected copyright edition, published with the approval of the author's executors.

THE DESCENT OF MAN
And Selection in Relation to Sex. With Woodcuts. Popular Edition. 9s. net.

VARIOUS CONTRIVANCES BY WHICH ORCHIDS ARE FERTILISED BY INSECTS
With Woodcuts. Popular Edition. 7s. 6d. net.

MOVEMENTS AND HABITS OF CLIMBING PLANTS
With Woodcuts. Popular Edition. 7s. 6d. net.

VARIATION OF ANIMALS AND PLANTS UNDER DOMESTICATION
With Woodcuts. In 2 Volumes. 21s. net.

JOHN MURRAY, ALBEMARLE STREET, LONDON, W.1

Fig. 2. Endpaper advertisement for *The Works of Charles Darwin*. Reproduced from Leonard Darwin, *The Need for Eugenic Reform* (London, 1926).

In this sense, then, *The Origin of Species* is a metonym of its own ideology, evolving through revision in order to survive as a social text, each act of revision being determined by the relationship between internal configurations of the text and its external environment.

But Darwin's death, even if it meant the extinction of his revisions, simply initiated the taxidermy involved in mounting, exhibiting, and distributing his work. No longer was there a question about *The Origin of Species* selling itself as a book; the new question, fictionalizing the question of authority, was which text of *The Origin of Species* was *certified* as authoritative. By claiming the first edition (whose copyright had expired) was "imperfect," Murray was attempting to scare readers from purchasing competing editions that nevertheless bore the same title and the same texts. Appleton issued a two-volumes-in-one "Authorized Edition" in 1925. Murray's "Popular Edition" appeared the following year. In 1927 Macmillan issued for the American market a "Modern Readers' Series" text using American spellings but also, like the Appleton and Murray texts, based on the sixth edition. J. M. Dent published, as part of its Everyman series of texts, a new edition in 1928, and it too was based on the sixth edition. Four different editions by four different publishers in four successive years could only have meant one thing: a highly competitive market existed for Darwin's *Origin of Species*. This is not to suggest Murray was being innovative, however. When Galignani's piracy entitled *The Poetical Works of Coleridge, Shelley, and Keats* was published in Paris in 1829, the fact that all three authors hardly had a market did not deter the publishers. Rather, they tried to *create* a market by claiming, as Murray would later do, the superiority of their edition. A prefatory "Notice of the Publishers" ran, in part: "Mssrs. Galignani beg leave to intimate, that the present edition of the Works of Coleridge, Shelley, and Keats, is infinitely more perfect than any of those published in London."[12] Like Murray's advertising claims and other claims connected with marketing practices, Galignani's preface helps reveal how powerfully generic words (*"imperfect," "corrected," "superseded"*) affect the selling of textual difference. These words also recall the kind of arbitrary labeling of various states of human difference practiced by eugenicists. The connection is not coincidental, but fundamental, to understanding the ways that cultural difference, as a product of human activity, is categorized. Murray's advertisement reminds us that arguments about eugenic reform were not just about humans, but about activities, cultural and otherwise, concomitant with being human. Eugenics, that is, is not just about the physiological differences of human morphology, but about cul-

tural differences that are, by necessary extension, a product of those human differences. Adjudicating texts and textual differences means adjudicating the makers and remakers of those texts and their consumers as well. It is of course a very broad cultural paradigm that I am describing, one that ultimately seeks to orient cultural activity within and around both individual and social difference. Major Darwin's dogmatically hermeneutic treatment of Western humanism could not create a utopia without also creating a dystopia, and both would ultimately undergo continuous re-creation in twentieth-century history: the Final Solution posed by National Socialism, "ethnic cleansing" in the Balkans, and the "scientific racism" underlying the controversial implications of the human genome project.[13] I do not intend to politicize my argument by make such references. While they are indeed about politics, they are explicitly about the qualitative politicization of competing categories of difference, which is the very premise upon which eugenic ideology is founded. In his presidential address at the First International Eugenics Congress, which was held in London in 1912, Major Darwin summarized this ideology in the following terms: "As an agency for making progress, conscious selection must replace the blind forces of natural selection; and men must utilize all the knowledge acquired by studying the process of evolution in the past in order to promote moral and physical progress in the future."[14]

I shall stop now—stop, that is, this brief recitation of social history and turn to the history, or rather a history, of twentieth-century textual criticism.

Textual Criticism and Textual Eugenics

For roughly seventy-five years, various critics have described textual criticism and bibliography as being scientific activities. In his 1912 address to the Bibliographical Society of America, Sir Walter Greg defined bibliography as "the science of the material transmission of literary texts."[15] A meticulous scholar predisposed to understatement rather than overstatement, Greg qualified this new science by adding that it was not a "great" science like mathematics, but rather a science defined by rigorous methodology, a science "by which we coordinate facts and trace the operation of constant causes." Later, in his *Calculus of Variants*, Greg would attempt to engage a disinterested approach to science via mathematics as a means by which the formal logic of Bertrand Russell and A. N. Whitehead might contribute to greater certainty in coordinating the material evidence of texts. For textual bibliographers like Greg, science represented an abstract,

immaterial conception of reality that promised to organize what mere empiricism had hitherto failed to do. Through a typology of that which was present (a method exemplified in Darwin's work), science promised a way of discovering facts about antecedent presences. This, of course, was only the beginning. The great dream of science was to calculate or predict future presences through the manipulation of the typology—or, to be more precise, the genotype. Concerns about both antecedents and future states were paramount to textual bibliographers, who saw a need to understand how history had altered and remade texts during the course of their transmission and how this process of change needed to be stabilized in order to protect texts from further deviance.

Greg's invocation to science as the sanctifying paradigm of textual bibliography has problems, however. As James Thorpe forewarned in 1969 in an essay entitled "The Ideal of Textual Criticism," to call textual criticism a science or scientific is "to begin the process of attaching the attributes—or even the metaphors—which go with the name."[16] Thorpe, whose work has been overshadowed somewhat by the prolific and centered presence of Fredson Bowers, is to me the most pivotal textual critic that America has known. He has not been the most influential—that honor belongs to Bowers—but Thorpe's work is, in a discipline characterized by extraordinary flux during the past twenty years, enviably enduring, and his cautionary warnings (about authorial collaboration on the one hand and the illusions of scientific methodology on the other) are emerging as some of the most salient issues in contemporary textual theory.[17] If we do take Thorpe's advice and look closely at the attributes and metaphors that comprise much of the discourse generated by textual and bibliographical critics during the past seventy-five years, we can find evidence that we are dealing not just with an abstract, or honorific, conception of science, but, because of textual criticism's interest in genetics and pathogenesis, with particular conceptions of science: biology and pathology. Historically, textual criticism has treated texts as bodies—bodies whose physical condition, or state, is described with terminology that evokes pathological overtones. Like the first edition of Darwin's *Origin of Species*, texts are sometimes said to be in a state of "imperfection," "decay," or "deformity" and thus deviate from a normative or presumably ideal condition. As I mentioned earlier, the application of qualitative judgments about textual authority was not new even in the late nineteenth century; both Pope and Johnson wrote about the degeneration affecting Shakespeare's texts, and classical scholarship antedates their opinions by another thousand-odd years. The patho-

logical metaphors become more explicit in the case of eclectic editing because the editor has the responsibility of locating a text's illness and eradicating it, where possible, through emendation. The qualification "where possible" is necessary because some textual states have been described as being of hopelessly terminal authority. The famous German textual critic Paul Maas, for example, has described the conditions under which a text is said to be "incurable."[18] This kind of textual ideology has been prominent in the preparation of Anglo-American literary editions since the 1920s, particularly in editions sponsored by the Center for the Editing of American Authors (CEAA), wherein the goal of the editorial operation is distinctly ameliorative rather than palliative. This ideology, heavily influenced by the pioneering work of Sir Walter Greg and Fredson Bowers, aspires to not just the status of science, but, as I have implied, to the status of medicine.

Like medicine, textual criticism is specifically a form of body criticism: it examines a text as a body for symptoms, or signs, of difference and seeks to interpret the cause of those symptoms and correct them. When textual critics speak about how certain changes have entered into the system of textual transmission, their approach to the relationship between cause and effect is thus, as in medicine, etiological in nature. But body criticism is not just about illnesses affecting the individual body; it is also about traits that are inheritable from generation to generation, whether the passage is from body to body or text to text. Like human bodies, linguistic texts are carriers of distinctive and unique codes, and the fact that there is (because of the conventions of writing and punctuation) an internal, system-regulated limit to the code means that it is possible to trace representations of the code rather easily. This is one reason textual criticism has found more extensive application with literary and musical texts as opposed to dense sign systems like painting and sculpture: a formal code allows one to categorize difference with respect to the code itself and its internal oppositions.[19] Karl Lachmann's pre-Mendelian conception of textual genealogy is important here. As Greg pointed out in his *Calculus of Variants,* a textual genealogy is not strictly biological since texts are asexual; and their reproductive activity, requiring only one parent, is therefore parthenogenic.[20] But this distinction vanishes when we realize that whether one is searching for a lost archetype (as textual critics do) or attempting to create a new archetype (as eugenicists try to do), both processes work in the direction of the convergence and that it is precisely at the point of convergence that the archetype is created: Y marks the spot.

Like the discovery of the stethoscope, X-rays, and techniques for chromo-some mapping, Lachmann's genealogical approach made possible certain diagnostic activities without presupposing or morally validating how those diagnoses are acted upon.

The distinction between identifying and mapping differences, which is a descriptive activity (Lachmann called it "recensio"), and adjudicating or otherwise manipulating them, which is a prescriptive activity ("emenda-tio"), is important. Lachmann's analytical discoveries, like Greg's *Calculus,* are what I shall call code-mapping techniques. Like parallel techniques in the biological sciences, mapping puts moral authority on the edge of exercising its power. That is, code mapping of genotypes makes it possible to move beyond mere mapping and engage in certain forms of gene splic-ing and hybridization. This is not to imply that names like Galton, Bur-bank, and Bowers are linked by complicity, although some might indeed argue this point. I am suggesting, instead, that the editorial basis of eclecti-cism is not independent of other forms of sociobiological eclecticism that similarly involve the identification and removal of dysgenic features and the restoration of, or even creation of, eugenic features. An eclectic body is like an eclectic text in that it is composed of "ideal" features of discrete bodies or texts that are combined to create a new body or text. While Darwinian natural selection tends to work in the direction of eclecticism, eugenics, as a form of artificial selection, tries to enhance and cultivate the process. As Galton wrote, "[W]hat Nature does blindly, slowly, and ruth-lessly, man may do providently, quickly, and kindly."[21] On the other hand, the dissemination of texts tends to have the opposite effect. As texts are printed and disseminated and become further removed from the author's control, there is a corresponding increase in the likelihood that they will become detached from whatever intentions the author had. For this rea-son, it is believed by textual critics that critical intervention—artificial selection of another kind—is necessary to reverse this trend and stabilize a text. Thus, eugenics and eclectic editing are alike in their predisposition toward idealism on the one hand and intervention on the other.

While it is very well known that authors have different intentions at different times, and while arguments about best intentions or last inten-tions are essentially arguments about ontological slippage, editors of eclec-tic texts tend to agree that whatever the intentions are, it is the intentions that are paramount. As G. Thomas Tanselle reminded us not too long ago, and as he likes to keep reminding us, to present the author's intended text has been the primary goal of textual criticism since the discipline was

initiated by Alexandrian librarians in the third century B.C.[22] Under this premise the editor's job is to identify *and* eliminate what are called "corruptions"[23]—that is, to unremake a text. Fredson Bowers, the editor who did the most to make authorial intentions and eclectic principles dominant considerations in twentieth-century American editing, put forth his case in the following terms:

> Only a practising textual critic and bibliographer knows the remorseless corrupting influence that eats away at a text during the course of its transmission. The most important concern of the textual bibliographer is to guard the purity of the important basic documents of our literature and culture. This is a matter of principle on which there can be no compromise.[24]

Without wishing to excessively diminish the positive influence Bowers has had on our editorial traditions, I would like to suggest here that his diction is particularly instructive in how it helps us to understand the categories of thought upon which eclectic editing is based. I am referring, of course, to Bowers's use of the term "purity"—a eugenic term—and how it is contrasted with "corrupting influence," which is clearly dysgenic. Bowers had an unmisgiving predilection for textual hygiene: in his famous essay entitled "Textual Criticism and the Critic," an emphasis on "the purity of an author's words" appears on four occasions in the space of six pages,[25] and Bowers again repeated this emphasis in his essay on textual criticism that was published in the Modern Language Association's *Aims and Methods of Scholarship* in 1963: "The recovery of the initial purity of an author's text . . . and the preservation of this purity . . . is the aim of textual criticism."[26]

More important, perhaps, is the way in which Bowers positions himself and, more generally, the discipline of textual bibliography as guardians of the purity of cultural texts. What is disconcerting here is the creation of what is, in effect, a textual caste system. In an intelligent and insightful essay published in 1985, K. Ruthven commented how this "residual moralism" was a sign of "patriarchial anxiety about legitimacy of descent, related in turn to nineteenth-century notions of property and inheritance."[27] Filiation, in this respect, involves invoking the past in our present actions in order to protect the value of this past and preserve it for the future. Dissemination thereby becomes regarded as a form of potential dilution as it threatens to undo the authority (and hence the power) of social, domestic, economic, and aesthetic structures. Moral didacticism is a sensitive

subject precisely because it wields an effective rhetorical force, and objections to any representation of the moral good of society are condemned as being either egotistic or perverse. The eugenics movement thereby understandably proclaimed its rationale in preservation, guardianship, and a moral obligation to future generations. Widely published voluntary appeals on behalf of self-help organizations advocated judicious actions toward marriage and reproductive activity and represented this responsibility as an individual responsibility under which eugenic principles would be a guiding force. A volume published in Indiana in 1917, entitled (in part) *Nature's Secrets Revealed* and authored "by noted specialists," offers a good example of this combination of rhetorical and moral didacticism. The frontispiece consists of a portrait of a guardian angel standing behind two children poised on the edge of a cliff, one child about to step off the cliff and pull the other along with him. Because bibliographical convention requires the title page to be on the recto with the frontispiece on the facing verso, the child about to step off the cliff both steps and gesticulates toward the space beyond the cliff, an empty space that lies beyond the margins of the book itself—that is, the vacuum of ignorance. Positioned this way, only the guardian angel(s) of eugenics could save the children, just as for Hitler only the guardian protection of the state could save society. This analogy is neither flip nor inappropriate. In the United States the eugenics movement succeeded in making state-legislated sterilization programs an integral form of guardianship. By the mid-1930s over 20,000 sterilizations of "deviants" had been performed (the number would rise to 36,000 by 1941), and Hitler's National Socialist Party, formulating its own eugenics policies, acknowledged a great debt it owed to the precedence of American eugenics programs.[28] In the end there were enormous differences, but the desire for control, and for controlling the "purity" of the genome, was a unifying precept. In *Mein Kampf* Hitler wrote that the state

> has to put the race into the center of life in general. It has to care for its preservation in purity. It has to make the child the most precious possession of a people. . . . Thereby the State has to appear as the guardian of a thousand years' future, in the face of which the wish and the egoism of the individual appears as nothing and has to submit.[29]

The rhetoric of protecting posterity provided a convenient facade behind which racial hygiene could operate. The German word for eugenics,

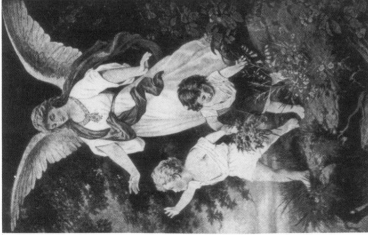

Fig. 3. Title page and frontispiece from *Nature's Secrets Revealed. Scientific Knowledge of the Laws of Sex Life and Heredity or Eugenics* (Marietta, Ohio, 1917).

Rassenhygiene, offered another conception of purity that was posed in a way that made any other choice seem self-serving. In this case, however, there were no choices: there was only the double bind of enforced "sacrifices," whereby language was forced to provide the euphemisms that reality itself could never create.

Hitler has always been an easy target for criticism, but my rationale for engaging him here has a very distinct purpose: to show how the eugenics movement, in taking on various apparitions, invariably couched its arguments in the guise of benevolence and progress. Hitler the humanitarian: could anything be more grossly ironic? The rhetoric of eugenics was persuasive because it promised universal social betterment. As evidence of the success of this rhetoric is the fact that the eugenics movement attracted an audience of supporters who considered themselves essentially democratic: Winston Churchill was (for a time) a vice president of the Eugenics Educations Society, as was Charles W. Eliot (president of Harvard) and David Starr Jordan (president of Stanford). Eventually they learned what many learned only as a consequence of World War II: that eugenics is primarily about the control of populations. This could only be antithetical to the idea of a democratic society. Even today we face new, yet equally troubling, applications of eugenic thought, particularly in the complex human genome project, which consists of an international scientific effort to map the approximately 100,000 genes comprising the entire human genome. The project enjoys wide government and popular support, yet it is also facing opposition among those who recognize the eugenic implications of the project and how—instead of classifying certain people as being deviant—the moral dilemma will be in classifying individual genes in the same way.[30] What all this shows, I think, is the seductive power of images of perfection and how easily we embrace the unalloyed promises of this power.

By juxtaposing Bowers's pleas for pure texts and Hitler's demand for a racially pure society my intention is not to discredit Bowers as a person but simply to show how the textual-critical strategies of eclectic editing were strongly influenced by the residue of eugenic ideology surviving in the discourse of midcentury idealism.[31] As the French textual theorist Louis Hay observed, "[E]diting has always embodied the main ideological and cultural concerns of its day."[32] The similarities between the diction of Bowers and others is thus not surprising, for it was to a large extent a product of the concurrence of thought that was part of the American political and social, even domestic, scenery. This was the age of Ivory Soap and Mr. Clean, an age in which the marketing of products, like the market-

ing of ideologies, was accomplished through appeals to cleanliness, order, and tranquility. Clorox bleach was advertised in *Life* magazine as a product that removes stains, deodorizes fabrics, and *"conserves* your linens too."[33] Purity, in other words, implied permanence. This unusual chain

⟨ Bowers ⟩⟨ Hitler ⟩⟨ Clorox ⟩ is held together not by the actual conditions of their respective intentions as ideologies or cleansing agents, but by language itself; the diction of perlocutionary discourse was startlingly similar for each of them. The appeal of purity was located in its safely generic condition of difference: it was not so much what purity was that was so important, but what it was *not,* that is, something unclean, corrupt, or bad.

Perhaps because of this, textual critics and bibliographers have had little to say as a follow-up to Bowers's remarks about the need for pure texts. Instead their concern is primarily with the condition of impurity, with the dysgenic, and the apprehension of alterity as something fundamentally perjorative. Editorial theory has always seen textual differences as symptoms of historically accountable conditions or events: the elisions of editors, the bloopers of typesetters, the piracies, the hack editions for the millions. Such texts and textual states are, in a sense, cultural poses: like snapshots, they reveal both beauty and ugliness, the intended and the unintended. But these historical poses have too rarely received the genial treatment that Jerome McGann and Donald McKenzie, among a few recent textual theorists, have extended.[34] Instead, traditional eclectic textual criticism holds that different states that cannot be verified according to an author's explicit or inferred intentions could only be one thing: bad. Bad, and therefore to be emended. A lengthy quotation by James Thorpe provides a characteristic exigesis of parthenogenic deterioration:

> [T]he texts of the works which constitute our literary heritage become progressively corrupt. The process of the transmission of a text is full of chance for error at every step of the way. The typist or the copyist cannot for long follow the text without making a mistake. The compositor, the proofreader, the pressman, and the binder all err from time to time. Some people write additions, some make corrections, and some delete passages—all in the sweet name of improvement. These and many other people have a hand in the transmission of the text, with thousands of possibilities for change; every one of the changes that actually takes place without the knowledge or consent of the author can

only be an error, only a corruption. A text is never self-correcting or self-rejuvenating, and the ordinary history of the transmission of a text, without the intervention of author or editor, is one of progressive degeneration.[35]

This is G. Thomas Tanselle, writing more recently (1989) on the same subject:

The world of documents is a world of imperfection. A writer may write about human striving but will probably consider the text flawed if it betrays the uncertainties and accidents of its own composition and transmission. Yet they cannot be kept out.[36]

Under this paradigm—I shall call it the lemma of inherent deterioration—the normative state of a text is a priori bad, and only with retrospective consideration can it free itself from this status and claim authority. What is judged bad is therefore stigmatized by virtue of its mere difference, and the latent force of the stigma continues its range of influence beyond the text precisely because it functions to repel us from the text: it is adjudicated corrupt or unimportant and therefore is ostracized as not being worth the attention of literary critics (on the one hand) or the masses of readers (on the other).

The most important question facing us at this point is this: if, as Tanselle says, the world of documents is a world of imperfection, and if, as Thorpe says, textual transmission involves continuous change, then why have textual critics historically stigmatized this inevitable transience with pejorative terms? Corruption. Deformity. Errors. What exactly do these words really mean? Too many things, it seems. James Thorpe has suggested that there are two fundamental types of variation: intentional changes (revisions by author, editor, or even bowdlerizer) and unintentional changes that arise out of the process of textual transmission (printer's errors, proofing mistakes, and so on).[37] While this is a useful nominalistic distinction, it is important to acknowledge that both types of changes overlap, and even unintentional changes like spelling "errors" have latent semantic power: we cannot, either as editors or as readers, predict what kind of significance they hold for a text. In this sense we are dealing with a condition of "inabsolute difference," whereby the qualitative state of a particular variant cannot be determined solely on the basis of author-

ity. Inabsolute difference is unlike the condition known as "invariance" (which holds that two competing texts or states are of equal authority) because it does not require the presence of a variant state against which it declares its authority. What it does instead is ask us to position difference against itself, and examine what this difference has to tell us about literature in the broadest cultural terms—not just about the social process of writing and publishing, but also about cognition and language processing, and (in the case of some "errors") about the difference between writing and speaking. We are sometimes apt to presume an error is just an error (and emend it accordingly) without considering that by doing this we project a hermeneutic reading onto the text and limit its semantic space. This problem ironically helps to show that literature is not just about reading, but about readings, and this paradigm applies to art as well. If artists could proofread their exhibitions—and not all artists participate in the process of installing their work—one wonders what an errata sheet for an exhibition would look like.

The plurality of readings, like the plurality of texts themselves, is a normative condition. By this I mean we should be more surprised by interpretative uniformity than interpretative divergence. And it is difference, playing off its etymology of existing *between* two states or things, that reminds us that identities exist primarily in relation to other identities. Difference, that is, is an evolving set of relations, not a predeterminate paradigm or set of qualities. As Georges Canguilhem wrote in *The Normal and the Pathological*—a work that was drafted in the 1940s but only recently was translated and published in English—sickness, illness, and disease are conditions germane to being human:

> The normal is not static or peaceful, but a dynamic and polemical concept. . . . A norm, or rule, is what can be used to right, to square, to straighten. To set a norm *(normer),* to normalize, is to impose a requirement on an existence, a given whose variety, disparity, with regard to the requirement, present themselves as a hostile, even more than an unknown, indeterminant. It is, in effect, a polemical concept which negatively qualifies the sector of the given which does not enter into its extension while it depends on its comprehension. The concept of right, depending on whether or not it is a matter of geometry, morality or technology, qualifies what offers resistance to its application of twisted, crooked, or awkward.[38]

Normativity is not itself a state of being but a condition by which divergent states are possible, and whose possibility is affirmed by their being actuated. This is the point where textual criticism, in appropriating the metaphors of science and its implied subcategories (pathology, medicine, and mathematical logic) is subject to the late-twentieth-century reconceptualization of these categories. It can no longer appeal to oversimplified, late-nineteenth-century honorific conceptions of science as pure truth, nor can the various hybridized scientific procedures such as genetic recension be engaged independently from their moral import. The elisions concomitant with eclectic editing, while making hypothetical texts real, also make real texts hypothetical by effacing their presence and, by default, their historical drift. What we are apt to overlook here is that eclecticism constitutes a form of institutionally sanctioned forgetting. As Jack Stillinger remarked quite recently (citing earlier sentiments of Donald Pizer), "[T]he Greg-Bowers eclecticism in effect obliterates (rather than preserves) the once-extant documents of the past."[39] A recent reflection of this concern has been an increasing resistance to editing or "overediting" the work of some authors, particularly Shakespeare, because each act of editing simultaneously creates and destroys, thereby destabilizing what is already tenuously unstable.[40] This is not, however, a new observation. As Johnson noted in his staid and relatively circumspect *Preface to Shakespeare,* Lipsius, observing attempts of Alexandrian librarians to edit the work of Homer, complained that they were simultaneously making faults while trying to remove them.[41] In this sense textual criticism, rather than being decreasingly important as a critical theory, is increasingly important because of the huge burden it must bear in describing the range of textual makings and remakings that constitute the enactments and appearances of works of art and literature. Pure texts, like pure truth, can achieve this status only as an immaterial condition, and the texts with which we have contact—printed poems, sculptures, and performances—are anything but immaterial. It is instead their material appearances and the real and hypothetical exigencies accounting for these appearances that comprise the normative state of cultural production and dissemination. What is ideal in textual studies is, simply, what is real.

The Textual Canon and Keats's Uncorrupt Corruptions

Some may object that I am perhaps overstating my case—that to claim the Anglo-American tradition of eclectic editing has been a eugenic tradition

overlooks the simple fact that texts are not humans and that, as a consequence, it is unfair to judge the history of editing in the same way that we judge the history of social thought. But my objection to the objection that texts are not people is the following: that texts are made by people, that they are continuously (even by editors) remade by people, and that this remaking reflects the overlapping structures of individuals and societies and the tensions concomittant with the imbrication of gender, race, and social and economic practices and the thing that we call a "text." The relation between human actions and the agents of those actions is not something a cultural historian can ignore. The filiated relationship between cause and effect is of course a complex relationship, but it is precisely this complexity that ontologically anchors the entire history of human cultural activity. It is, I think, not so much the "pure" texts of authorial intention that reveal to us the heart of this cultural activity, but the ways in which texts are ultimately reconfigured and remade in the process of diachronic cultural creation. A world without Bowdler cropping texts for genteel female readers, a world without Galignani undermining economic protectionism by pirating Byron, and a world without *Reader's Digest* condensing *Tom Sawyer* into reader-friendly proportions, is, I dare say, a world too perfect to believe. These are not, as some might call them, unusual instances of textual reconfigurations. I think, instead, that there is a certain ordinariness about them, and that their unordinary apparition is the result of their being ostracized as textual curiosities not worth serious attention in relation to the textual canon of a work. The phrase "textual canon" may sound somewhat odd, but I believe it is important to recognize that our literary canons are to some extent a product of our textual canons—the various texts, textual states, and textual versions of works that are ascribed to having the status of authority. The textual canon of a work tends to emphasize authorial involvement, either in the process of composing a work (whereby drafts, fair copies, transcripts, and proofs are considered as having relative authority), or in the process of revising published texts. Scholarly editing marks the conference of power and authority: it could be described concretely as institutionally supported canonization. The concern for authority is not so much about synoptic history as it is about selecting certain texts for certain academic purposes. While these texts do have authority that is manifestedly important in relation to their historical conditioning, these texts do not encompass the entire textual history of the work and the vicissitudes of their relation to the reading public across a time span of decades or centuries. One could argue, for example, that

Keats's most compelling moment of critical recognition in the early nineteenth century was not Richard Monckton Milnes's *Life, Letters, and Literary Remains of John Keats* (1848), but Galignani's piracy of 1829, *The Poetical Works of Coleridge, Shelley, and Keats*. In this case, *Blackwood's* caustic criticism of Keats, which originally linked him with Leigh Hunt, was reconfigured to an association with Coleridge and Shelley. The fact that Galignani's text was a piracy also had a measure of appeal because Keats was being pirated at a time when his original three volumes of 1817–20 were still in print. What is discredible about Galignani's text in relation to authority is perfectly credible in relation to cultural history precisely because it is, like other discredited texts, an instance of that history, an enactment of it. Textual criticism is not, as some would have it, about utopias; it is about real texts in a real world, a condition that authors and artists themselves often forget as they struggle to protect their intentions from the effects of transience and social power.

Literary texts have taught us a lot about this transience, but they have not, I think, taught us enough, particularly in relation to nonliterary media and genres. Think of the recent removal of Richard Serra's sculpture entitled *Tilted Arc* from its site-specific location in lower Manhattan or the "restoration" of Michelangelo's Sistine Chapel and Leonardo's *Last Supper;* think of the man who recently pummeled the toes of *David* with a hammer or the unknown party that quite literally dynamited the seat out from under the Cleveland Museum's cast of Rodin's *Thinker* in 1970; think of the cancellation of the Robert Mapplethorpe retrospective at the Corcoran Museum of Art in 1989 and its subsequent exhibition in an alternative artspace, the Washington Project for the Arts; think of the federal hearings regarding film colorization; think of the recent exhibition of the Barnes Foundation Collection of impressionist art in the National Gallery of Art—a collection that was deeded to never leave the Barnes estate or to be shown in any other manner than that specified by Barnes himself, each painting hung in a specific place in a specific room. What all of this reveals, even in the brevity of my too-brief descriptions, is that cultural texts, irrespective of their medium or mode of appearance, are continually being remade. If there is a difference between making and remaking a work of art, it is not a difference demarcated by self-consciousness or the artist's intentions. Making art inherently assumes a process of continuous unmaking and remaking by the artist, by others, and by nature. Art is not something that gets finished when it gets signed or exhibited, just as a work of literature is not finished when it gets published. I think it is safe to say that a work of art has

the potential to outlive not just the artist, but also its own objecthood—
that in the process of being unmade (as an object) and remade (as a text and
as memory) it will ultimately survive itself. It is precisely because remaking
is *about* making, and about how making involves a continuous discontinu-
ity, that makes nontraditional and noncanonical media and genres of cen-
tral importance to any theory of textual criticism. At the editorial level of
literary production most changes occur quietly, and the public is usually
unaware that changes have been made. It didn't take three years of public
debates and massive hydraulic cranes for Keats's editor John Taylor to
remove a couple of lines from "The Eve of St. Agnes" the way it took the
General Services Administration to remove seventy-three tons of Richard
Serra's *Tilted Arc* from Foley Square.[42] It seems that only when authorial or
artistic intentions become part of a larger public debate, as in the case of
film colorization, that we become more sensitive about the degree to which
a certain amount of conjunctive activity is involved in the making and the
exhibiting of art. It shouldn't be like this, though: we need to remind
ourselves that the creation and dissemination of art has always been an
activity involving more people and more intentions than those of the artist
alone and will always be this way.

The remaking of Keats's texts by Victorian editors exemplifies not just the
redistribution of authority (or "reterritorialization" of the texts), but the
inevitable drift and nullification of that authority. Unlike Byron, Keats was
not a poet who felt any significant public demand for his work; his first
volume of poems, published in 1817, was actually remaindered, and the
next two volumes (published in 1818 and 1820) were financial losses for
his publishers. Even Keats's untimely death in 1821 failed to create a
demand for his work. As I just mentioned, however, Keats did have the
honor of having Galignani pirate all three volumes in an 1829 edition
published in Paris. Not ironically, perhaps, this was the same year Richard
Monckton Milnes, Alfred Tennyson, and Arthur Hallam were reading
Keats at Cambridge. A few years later, in the winter of 1833–34 when
visiting Walter Savage Landor in Florence, Milnes was introduced to
Keats's friend Charles Brown. Whatever rapture the experience provoked
didn't reveal itself until the 1840s, when Milnes contacted Keats's surviv-
ing friends, gathered manuscripts and transcripts of unpublished poems
and letters, and in 1848 published a heavily edited collection as *The Life,
Letters, and Literary Remains of John Keats*. Milnes's edition is a fascinating
example of the remaking of an artistic personality and an artistic oeuvre to

fit into a social and critical moment—what I would call a historical ground—no longer Keats's own. Having read Keats closely with Hallam and Tennyson, and having been cognizant with contemporary objections to Keats's poetry, Milnes knew exactly where Keats would be vulnerable. There were, particularly, two problems: Keats's predilection for mythological romance (reading *Endymion,* Wordsworth's sister-in-law Sarah Hutchinson wondered how someone could still write about such a subject),[43] and his affinity for engaging in verbal and syntactic twisting: commenting on *Endymion,* Thomas De Quincey said, "With its syntax, with its prosody, with its idiom, he has played such fantastic tricks as could only enter into the heart of a barbarian, and for which only the anarchy of Chaos could furnish a forgiving audience."[44] Accordingly, then, Milnes sought to construct an editorialized Keats who could avoid the criticism of being judged weak and effeminate (on the one hand) or coarse and of low breeding (on the other).

As most Keats scholars know, Milnes accomplished his task by means of a careful exclusion of materials (most of Keats's carpe diem poems were omitted, as were references to Fanny Brawne in his letters, not to mention the letters to Fanny herself), and by judiciously correcting the glaring intransigiencies of Keats's syntax and diction.[45] In one sonnet, the line "The anxious month, relieving of its pains" is changed to "relievèd of its pains";[46] in another sonnet Milnes changed "browless idiotism" to "brainless idiotism"; in yet another sonnet he added a word to correct a missing foot; in another poem he reversed word order. The previously unpublished poems and letters were extensively repunctuated and edited. A letter to James Rice dated March 25, 1818, for example, lost its sense of spontaneity as Keats's dashes between phrases were replaced with commas, semicolons, and stops, and entire passages of sexual punning—as well as three stanzas from the famous "Dawlish Fair" poem—were omitted. None of these examples are mistakes; they reveal, instead, attempts to instill a sense of poetic, grammatical, and social propriety to Keats's work. Just as De Quincey complained about *Endymion,* most of Keats's contemporaries took a strong exception to his predilection for convoluting reality. Francis Jeffrey, for example, found his work "an interminable arabesque of connected and incongruous figures."[47] Byron particularly disliked this tendency; and more than just disliking it, it *bothered* Byron—a worse sin, which led to his charge that Keats was a poet continually fagging his imagination.[48] But Byron's dissatisfaction, while not altogether fair, does however locate or position what is simultaneously disconcerting and ap-

pealing about Keats and suggests how these oddly headstrong verbal tensions would initially forestall, and later accelerate, Keats's reputation. Milnes wasn't, apparently, the only early-nineteenth-century editor to recognize this problem and try undoing, or at least minimizing, this tension. Keats's publisher John Taylor, perhaps better known for his unforgiving emendations of John Clare's poems, and Richard Woodhouse, an advisor to Taylor and friend of Keats's, both were involved, although the degree of their involvement varies not just with specific texts, but with specific lines or words. There is for example one remarkably enigmatic change to Keats's "Ode to Psyche" that has not yet had an entirely satisfactory explanation, and circumstantial evidence suggests Taylor and Woodhouse were behind the change. Where the text printed in Keats's 1820 volume reads,

O brightest! Though too late for antique vows,

Keats's draft, a copy in a letter, and transcripts by his friends Charles Brown and Woodhouse all read,

O Bloomiest! Though too late for antique vows[.]

Of all of Keats's odd evocations, Robert Gittings has described this as "one of his least happy,"[49] and most of Keats's critics have been content to avoid it as some kind of blemish not worth an argument. And no published edition has had the courage to restore "Bloomiest" to Keats's text. This is not surprising. What is surprising, however, is the deliberate way in which Keats wrote the phrase "O Bloomiest!" in the extant holograph draft. There are few revisions to the ode; apparently Keats wrote it unhastily, telling his brother that of his poems it was "the first and the only one with which I have taken even moderate pains."[50] "Bloomiest," is actually written "Bloom iest," the superlative affix coming after what seems to be a pause in thought, the "iest" locating itself on a slightly subscript plane, thus: "Bloom $_{iest}$." Were it not that Keats repeated "Bloomiest" in a copy of the poem that he sent in a letter to his brother, it might be suspect;[51] instead it is oddly deliberate, as the phrase "wam slumpers creep" from the ode "To Autumn" is not (he meant "warm slumbers creep"). What then happened to this delightfully disconcerting apostrophe, and how did it get changed to "O brightest"?

A few facts. It is known that Keats corrected *some* of the proofs of the volume in which the "Ode to Psyche" was published (the proofsheets for

Fig. 4. John Keats, MS fair copy of the "Ode to Psyche," verso of leaf 1. Reduced. Courtesy The Pierpont Morgan Library, New York.

"Lamia" are at Harvard's Houghton Library), but it is not clear just how far he got with them because on June 22, 1820, while the volume was still in press, he had a relapse of blood spitting that was related to a hemorrhage he had had in the spring. Production of the volume continued without Keats's assistance, because when it finally appeared on the thirtieth, it included an advertisement dated June 26 in which Taylor and his copublisher Hessey offered an apology for *Hyperion's* unfinished state ("it was printed at their particular request, and contrary to the wish of the author.")[52] In a copy of the volume Keats gave to a neighbor named Davenport, he crossed out the advertisement and wrote at the top of the page, "This is none of my doing—I was ill at the time."[53]

But Keats did see some early proofs to the volume. He found in "The Eve of St. Agnes" what he described as "an alteration in the 7th stanza very much for the worse:"[54] "Her maiden eyes divine / Fix'd on the floor saw many a sweeping train / Pass by" was changed to "Her maiden eyes incline / Still on the floor, while many a sweeping train / Pass by." Was the change from "Bloomiest" to "brightest" another such alteration? There is evidence (based on the printer's copytext and corrected proofs to "Lamia") that Taylor and Woodhouse reworked Keats's texts, and approximately five times as many substantive changes were made by Woodhouse as by Keats.[55] What appears to have happened, then, is that Keats, Taylor, and Woodhouse were all involved in making changes and corrections to the 1820 volume, and after Keats became ill and withdrew from the task, Taylor and Woodhouse finished the job. Both "Lamia" and "The Eve of St. Agnes" appear early in the volume; *Hyperion* came last, and the odes all came in between—the gray area of uncertainty.

What we learn, however, is that Taylor and Woodhouse, like Milnes, sought to present a slightly defensive, almost apologist text of Keats. This is a crucial aspect of Keats's reception history: that it is a history marked by apologies and excuses. Jeffrey found his work "at least as full of genius as of absurdity"; even Byron, lamenting so much else about Keats, found good things to say about *Hyperion;* Amy Lowell's biography finds all kinds of praise for Keats's influence on modernism, and all kinds of excuses for the poetry that made her uncomfortable (she'd remark he was young, or rash, or experimenting, or some combination of these). The end of apologies occurs in John Bayley's unfettered reading of Keats, wherein he turns apology against itself by not apologizing for Keats's badness, finding within it the very elements of his greatness.[56] The change from "Bloomiest" to "brightest" obfuscates this tension between the good and the bad in Keats while si-

multaneously drawing it out and showing how it came to bear upon Keats's readers who, as his editors, were in effect his rewriters. It is a simple matter to say that "O brightest!" is a better choice, but we are not, from our own critical perspective today, being asked to make better choices; we are asking instead why the choices we have do exist, and what the tension between the choices may have meant to Taylor and Woodhouse, and why they made the choice they ultimately did. My own preference for "Bloomiest" is not simply an appeal to its quirkiness, but because it also seems quintessentially Keatsian in its deliberate edginess, in its willingness to risk so much on a single word. Often he would attempt to work into a composition a word much in the same way a person might try to work into a jigsaw puzzle a piece before finally abandoning it, realizing that the fit was not right. He gave the word *tinge* three tries in one line of "The Eve of St. Agnes" before giving up; *pluck* also got three unsuccessful tries in the "Ode to Psyche." Sometimes, however, Keats left his forced and awkwardly misfitting pieces right where he jammed them into place: "O Bloomiest!" It doesn't work, of course, it could never work, but Keats let it stand in his texts as long as he did in order to find a way of making it eventually work. *Bloom,* being both noun and verb, was a favorite word, in part because of how it suggested a sense of movement that is so important to Keats's poetry. He is "descriptive," to use a hackneyed word, but rarely is he *merely* descriptive. There is, for example, a passage in the "Ode to Psyche" where a blooming movement is suggested in his portrayal of the transitions between different stages of blooming, in the movement from bud to fully opened flower: "buds and bells and stars without a name." Having already used "bloomiest" in the poem, Keats couldn't use it again here, or even a variation of it; but there remained the question of just how he could make it work for him. The answer, in part, was another kind of movement, a movement that is both linguistic and typically Keatsian: to move beyond a horticultural context into a new category of thought. To make this work there has to be both a sense of familiarity and a sense of surprise, and this is precisely what Keats achieved in the ode "To Autumn," where, for once, the word *bloom* finally fits: "While barred clouds bloom the soft-dying day."

What is compelling about Keats's misfitted phrases is the fact that they have so much bearing on his work as a whole. The canonized Keats is more meaningful when placed beside the embarrassing Keats. That he could be both, and be both in a single line, is to a large extent what is so appealing about him. This could not be said for Byron, or even Wordsworth; at least not in the same way. The subject of single words and misfitted phrases

might initially seem archaic or out of place in an age of postmodernism, but I do not think this is the case. The subject is not a decontextualized linguistics or aesthetics or stylistics (as the New Critics practiced), but one that explores attititudes toward language in diachronic terms: how Keats read Keats, how Milnes read Keats, how Joseph Grigely reads Keats. It is about both how we inherit the past and how we read this inheritance. Social expectations of linguistic propriety were part of the critical ideology of Keats's contemporaries, and these in turn were a late-eighteenth-century inheritance. The Pre-Raphaelite predilection for Keats was a predilection not for Keats as a poet or storyteller, but for Keats as a phrasemaker. Like Keats's contemporaries (particularly Leigh Hunt), they liked "beauties"— fragments within fragments—but they wanted them in grammatical (one hesitates to say straightforward) English. (One is reminded of Johnson's significant complaint in his *Preface to Shakespeare*: "The stile of Shakespeare was in itself ungrammatical, perplexed and obscure.")[57] The changes that crept into the publication of Keats's 1820 volume, like the changes in Milnes's edition of the poems and letters, reveal an editorial self-consciousness attuned to those social expectations—the social ground around which a text is temporally centered. While a modern critical edition like Jack Stillinger's edition of *The Poems of John Keats* provides some of this ground, it does not provide us with Milnes's texts unless they have the status of competing authority. Perhaps we should not expect this, because Stillinger's edition does not desire to be, nor attempt to be, historically synoptic. Milnes's remaking of Keats is a remaking that occurs within the enclosure of his own mid-nineteenth-century historical space. Many of his changes simply reflect this remaking (as one could argue Stillinger's emendations reflect *his* remaking of Keats within the institutional space of late-twentieth-century textual scholarship). As a consequence, Milnes's texts are neither erroneous texts nor bad texts, but rather texts that are traces of the shifting intersections of production, consumption, and social space.

The Textual Canon Again: Condensing *Tom Sawyer*

By reappraising the conditions by which a particular textual state is judged as being either eugenic or dysgenic, I am, of course, implying the legitimacy of changes, subversions, and editions that our institutionalized critical industry would not otherwise pay attention to—abridgments and condensed books, for example. A eugenic text, edited according to the author's last intentions, has neither more nor fewer conditions for its existence than

a condensed text; it simply markets itself as a professionalized text, particularly if it is identified, like Stillinger's edition of Keats, as a "definitive" edition. The condensed text is not inherently stigmatized by its status as an abridgment, or *Reader's Digest* would not advertise it as "condensed" on the title page. This word is not used as a disclaimer (though some of us may perhaps read it this way); it instead clearly has a very definite appeal to an audience that buys and reads such a book. A recent full-page advertisement in the *New York Times Book Review* for Alex Haley's *Queen* touted that the book was both a "Super Release of the Literary Guild" and a "*Reader's Digest* Condensed Book Selection."[58] These are labels denoting marketing status and marketing spaces: the implied certificate of institutional authority (the Literary Guild and *Reader's Digest*) simultaneously authenticates the book's social contract and locates that contract within a certain milieu (the *New York Times* on the one hand, and the Literary Guild and *Reader's Digest* on the other). This is not an advertisement that one would find among the pages of *Critical Inquiry* or even the *New York Review of Books*. Thus it is clear that both the eugenic text and the condensed text reveal that a text is not just a trace of other texts (in the Derridean sense) but is also a trace of conditions of confluence: the editor, the audience, and the social and economic spaces with which they interact. This generalization seems almost too easy, but it is in fact not easy at all: there is an enormous difficulty demarcating the boundaries at which a text ends and a context begins. That is one of the reasons why scholarly editions, particularly those that feature an apparatus of variants, appear to crop texts: purporting to reify contexts, they actually shift or recontextualize them or, at the very least, relocate the text among the paradigms of institutionalized scholarship. For this reason the condensed, reader-friendly edition of *Tom Sawyer* that I cited earlier is hardly unimportant as a text reflecting our cultural condition. In 1989 I bought my copy for 99¢ in a suburban Safeway grocery store in Silver Spring, Maryland, and it came with a free *Parent's Guide* that explains how "Potentially difficult wording has been removed without changing meaning."[59] It doesn't take a cognitive semanticist to realize that something is more than slightly amiss here. For 99¢ it was a very good deal for a very important book that revealed, among other things, that there are no "niggers"—I use this word advisedly—in the world of *Reader's Digest*.[60] Jim's just Jim. The hard question that arises is this: does the act of removing words merely efface meaning or does it *change* meaning? This is, of course, a trick question, because the act of effacing one context must necessarily create another that recalls the act of

effacement itself—a double turn. A text, one might thus say, cannot hide from its past *or* its present. One example of this double turn occurs when Tom and Huck are talking with each other shortly after their second failed attempt to steal the box of gold coins being guarded by Injun Joe. In the *Reader's Digest* text their exchange goes like this:

> "Now, Huck, I'll go home. It'll begin to be daylight in a couple of hours. You go back and watch, will you?"
>
> "I'll ha'nt that tavern every night for a year, Tom! I'll sleep all day and I'll stand watch all night."
>
> "That's all right. Now, where you going to sleep?"
>
> "In Ben Rogers' Hayloft."
>
> "Well, if I don't want you in the daytime, I'll let you sleep. I won't come bothering around. Anytime you see something's up, in the night, just skip right around and meow."[61]

Ben Rogers' hayloft is here a place, but a place without a context beyond that of being a hayloft. But let us now turn to another version of Twain's novel, in particular the Signet Classic edition—a text I have chosen not because it is scholarly, but for the opposite reason: it is a popular edition, widely available for not much more than the price I paid for my *Reader's Digest* text—$1.95:

> "Now, Huck, the storm's over, and I'll go home. It'll begin to be daylight in a couple of hours. You go back and watch that long, will you?"
>
> "I said I would, Tom, and I will. I'll ha'nt that tavern every night for a year! I'll sleep all day and I'll stand watch at night."
>
> "That's all right. Now, where you going to sleep?"
>
> "In Ben Rogers' hayloft. He lets me, and so does his pap's nig-german, Uncle Jake. I tote water for Uncle Jake whenever he wants me to, and any time I ask him he gives me a little something to eat if he can spare it. That's a mighty good nigger, Tom. He likes me, becuz I don't ever act as if I was above him. Sometimes, I've set right down and eat *with* him. But you needn't tell that. A body's got to do things when he's awful hungry he wouldn't want to do as a steady thing."
>
> "Well, if I don't want you in the daytime, I'll let you sleep. I won't come bothering around. Anytime you see something's up, in the night, just skip right around and meow."[62]

The condensation that occurs in the *Reader's Digest* text involves a reduction of volume without a corresponding increase in density. This is of course necessary because language is not tangible matter in the sense that Campbell's soup is and thus cannot (despite Ezra Pound's homage to Basil Bunting's discovery in a German-Italian dictionary that "dicten = condensare") be reduced. Twain probably would not be happy with even the effort. On one occasion, upon learning that a certain printer's proofreader was tinkering with his punctuation, Twain telegraphed orders to have the man shot without giving him time to pray. It is an apocryphal story—nearly every textual critic has heard it[63]—yet it is a story that ultimately has no bearing on the *Reader's Digest* text of *Tom Sawyer,* because this text is not about Mark Twain—it's about *Reader's Digest,* the rhetoric of its editorial strategy, and the readers for which it was edited. It is, in short, more about *Reader's Digest*'s America in the 1980s than it is about Twain's America in the 1870s.

Behind the act of condensation lies a series of ironies that, I think, reflect a tendency to delegate authority, even in the case of something presumably so basic to our everyday life as the reading of children's books. It is one thing for Charles Lamb to condense (or paraphrase) Shakespeare for young readers; it is another thing to condense a text that was already meant to be read by young readers. There is a rationale for this irony, but the rationale is not without ironies of its own. The *Parent's Guide to the Reader's Digest Best Loved Books for Young Readers* "accompanies" the text of *Tom Sawyer,* but quotation marks are necessary here because the *Parent's Guide* is published spearately and is therefore a *detachable* rationale. Like arguments offered by proponents of eugenics, the *Parent's Guide* stresses the goodness and utilitarian value of its program: the book is edited to make it "less formidable" and "more accessible," yet it purportedly retains its identity as a classic—"The rich language, marvelous adventures, and vivid characters are there for your child to enjoy."[64]

But what about Ben Rogers' hayloft? Emptied of the apparently too-formidable subject of race relations, the moment of Tom and Huck's exchange is not merely condensed; it is also remade from being a moment of commentary on social tension to something less troubling. The hayloft we see in the words "Ben Rogers' hayloft" is a hayloft filled merely with hay, subverting the passage Huck must work through in order to arrive at this site of imaginary repose. Where the *Reader's Digest* text emphasizes (by default) the site itself, the Signet text emphasizes the social negotiations

involved in Huck's arrival at the site. Even more than this, the Signet text registers this site as a site of difference, because it is here that the novel's most difficult difficulty is exposed and italicized: "That's a mighty good nigger, Tom. He likes me becuz I don't ever act as if I was above him. Sometimes, I've set right down and eat *with* him." This is a crucial turning point, and precisely because it *is* a turning point (for Huck, for Tom, and for the absent reader), it must grope for an excuse to mollify the apparent indiscretion of the act: "A body's got to do things when he's awful hungry he wouldn't want to do as a steady thing." The absence of this moment from the *Reader's Digest* text would not be ironic were it not that the *Parent's Guide* wants us to think *in terms of* Huck's negotiations, thereby making absent what is claimed to be present: "these books will help your child understand what makes other people think and act in certain ways." The text continues:

> Authors such as Mark Twain and Stephen Crane are renowned for the keen insight into human nature they bring to their prose, helping your young reader to better understand what makes people act the way they do. With this understanding will come a new spirit of cooperation. Because the characters in these books face the same challenges that your young reader faces in growing up, a special bond is formed between reader and character.[65]

Of course, when we backtrack again to what we are told occurs within the text of the novel ("Potentially difficult wording has been removed, without changing meaning"), it becomes clear that the definition of *difficult* is not confined to diction or syntax (slang, portmanteau words, or discursive sentences), but what is difficult because it is socially troubling and presumably requires a historical context that is absent. The absence of a certain history is therefore a rationale for the absence of certain words; and by this process, a new history of absence is constructed, a history that is in part about purifying and cleansing. Neither entirely a historical fact nor a historical fiction, yet both as fact and as fiction, the *Reader's Digest* edition of *Tom Sawyer* participates in the construction of the American literary consciousness—a phenomenon firmly rooted in our late-twentieth-century culture of hypersensitivity. A recently published illustrated edition of *Tom Sawyer* acknowledged the work's difficulty not by effacing it, but by way of a disclaimer on the copyright page:

Publisher's Note: portions of this work contain racial references and language which the modern reader may find offensive. These references and language are part of the time period and environment written about, and do not reflect the attitudes of the editors or the publisher of this current edition.[66]

The story does not, however, end here. When I tried to obtain copies of the *Reader's Digest* text of *Tom Sawyer* for my senior seminar in literary theory at Gallaudet University, I received a polite but curt response from the publisher that they would not sell the book to college bookstores. Presumably this is an insignificant matter, but it introduced a significant and engaging question: does it really matter where a text is sold, or how it is presented in the context in which it is sold? If, in contradistinction to the linguistic code, the bibliographical code of a book includes the physical features of a text (binding, the title page, ornamental features, and so on), and if this bibliographical code is important because it provides what Jerome McGann calls an interpretative context,[67] then the sites and the means by which texts are sold become important factors in considering the premises by which the text itself exists, and how it positions itself vis-à-vis potential readers. This, surely, doesn't matter with every text, nor does it matter with some texts all of the time, but in certain edited texts aimed for mass audiences (Knight's illustrated editions of Shakespeare from the 1840s and Peterson's Cheap editions of Scott's Waverly novels, for example), it matters immensely. At least it mattered enough to Choice Publishing and *Reader's Digest* that their reader-friendly edition of *Tom Sawyer* could be sold at Safeway for 99¢, but could not be sold in college bookstores for 99¢ or $99. Eventually my class obtained its books by negotiating a prepaid order, but not without also learning that the issues here cannot be reduced to a simple formula about the highbrow and the lowbrow. The issues also have a lot to do with advertising, with distribution networks, with credit ratings, and with the idea of using products (like literature) to sell other products (like rutabagas). When a supermarket advertises and sells a product for less than it pays for it as a way of attracting potential customers to the store, this product is described as a "loss leader"—a slightly ironic, but very effective, marketing practice. It somehow makes more sense to use Mark Twain to sell rutabagas than to use rutabagas to sell Mark Twain. And all of this, when it finally comes together, is part of an even larger practice that, in the West at least, we call culture.

At this point I would like to recall a relevant and pragmatic observation by Terry Eagleton:

> Those who work in the field of cultural practices are unlikely to mistake their activity as utterly central. Men and women do not live by culture alone, and the vast majority of them throughout history have been deprived of the chance of living by it at all, and those few who are fortunate enough to live by it now are able to do so because of the labor of those who do not. Any cultural or critical theory which does not begin from this single most important fact, and hold it steadily in mind in its activities, is in my view unlikely to be worth very much. There is no document of culture which is not also a record of barbarism.[68]

Like Benjamin before him, and like Marx before Benjamin, Eagleton makes clear that culture is intertwined with other noncultural practices and activities. This is simple enough. But what is not so simple is acknowledging how the boundariless boundary between cultural and noncultural practices is held in abeyance by tension and difference. Just as tension holds together the fabric of a textile, it also holds together the fabric of literary and social texts. A fabric of parallel threads cannot, either in theory or practice, hold itself together unless there is present an agent of resistance. The textual condition is thus, as Jerome McGann has often reminded us, a synecdoche for the human condition.[69] Without the ability to recreate itself in different societies at different times and in different ways, art would not be privileged enough to call itself art. Even forgeries of artworks expand the textual history of the work they presume to replicate by being part of the cultural production and consumption of that work. In the simplest terms, the forgery tells us both about itself and the work it passes itself as and how, taken together, they reveal cultural history as a history of processes, enactments, and events—not just objects. My interest here can be said to perhaps go beyond the act of editing to the act of reading. But inasmuch as I am interested in how different textual states reveal the complex and sometimes quirky machinations of cultural production and consumption, I am in this sense concerned with how textual consciousness is an integral part of the experience of reading cultural texts—not just literature. The unifying premise (despite my use of terms like *production* and *consumption*) is not explicitly political, historical, sociological, or aesthetic; it is instead pragmatic. It simply acknowledges that aesthetic activities are imbricated with other kinds of human activities, and that the interaction between them

creates a text that cannot be created but *by virtue of* that interaction. Even textual errors, particularly what are conventionally described as "slips of the pen," are sanctuaries of difference: they tell us not just something about language itself, but about language as an abstract medium for an art we call literature and how the human mind works with this medium.[70] Keats's letters and poems are filled with unintentional slips and odd phrases: on one occasion, lamenting the incessant rain of Devon's "urinary" weather, Keats remarked that he wasn't particularly "peedisposed" toward it; on another occasion, having spilled blackcurrant jelly on a copy of Ben Jonson he hastened to lick it but lamented that it remained very "purplue," an unconscious combination of purple and blue; hastily drafting the ode "To Autumn," Keats's hand articulated a rewarding phonetic utterance I mentioned earlier: "wam slumpers creep."[71] There is a long list of such so-called "errors" in Keats's work, and his most sensitive critics, ranging from John Jones and John Bayley to Christopher Ricks and Marjorie Levinson, have continued to find ways of commenting upon them—a reminder that we can never predict how the latent implications of slips and errors will bear upon larger structures of a text.

If pretextual slips and puns reveal (as Picasso once remarked) the personality of the artist,[72] perhaps we could also conclude that the post-textual reconfigurations of a work tell us something about the personality of a culture. As John Velz recently observed, the variorum editor must unfold a sequence of editions that constitute "an index to cultural history," they being records of their cultural passages more than of any parameter of authorial intentions.[73] That is why abridgments like Bowdler's Shakespeare, condensations like the *Reader's Digest* editions, and even paraphrased texts like *Cliff's Notes* are so important. Their very presence (on the one hand) and their popularity (on the other) is a reflection of the broad continuum of cultural differences and the ways in which canonized works that achieve the status of cultural icons will be dispersed, each act of dispersion fulfilling a distinct need or function, either for its readers or its makers. The kinds of questions criticism asks about cultural texts are thus in part guided by the texts themselves: a genetic text like Gabler's edition of James Joyce's *Ulysses* might be useful for a formal study of the novel's composition, but by itself it is somewhat less useful for a study of the novel's reception. That is why one text can never be enough; why "pure" texts or intended texts can never be enough; why there will *never* be enough—because culture will continue to make and remake texts and will continue to find a need for doing so.

The Rhetoric of Editing and Textual Consciousness

It should be clear, by now, that I see textual criticism and its various descriptive practices as not just a tool for editorial theory, but as a tool for reading. I do not intend to here simply repeat the editor's commonplace lament that critics are frequently unaware of the authority of the texts they are writing about. This will always remain true to some degree, and I see no great benefit in chastising those who are happy in their ignorance, since to some extent all of us are. Critical theory and critical practice are adequately delimiting so as to allow for an enormously wide range of ideologies and approaches to culture, and textual criticism can respond most strongly by exerting itself as a mode of reading whose pragmatism is underscored by textual consciousness, by an awareness that our reading of a work of literature involves not just reading a text of the work, but the texts of the work and their inter- *and* intratextual relations. Textual conscious is itself not new, but footnoted as a New Historical practice it has not really asserted itself as an ideology wherein the differing and shifting textual and bibliographical states of a work constitute its semantic or intratextual ground. The primary appeal in textual consciousness is in its micro/macro adaptability, in its ability to be at once a stylistics and a social theory. It has a double turn: composition on the one hand, dissemination on the other. The composition of a work and the process of composing it will always be considered important, and it is by virtue of this composition that our interest in the cultural dispersion of a work is validated. But the composition of a work and its initial publication are simply acts of initiation that inaugurate the cultural assimilation of that work. The European editorial paradigm known as *critique genetique* is admirable for its intense focus on prepublication versions and states and its way of presenting and unveiling the layers of a work in progress.[74] But such an edition, while compositionally synoptic, is essentially a study of a beginning that only temporarily ends with the work's initial publication: the work will continue to be rewritten as it is republished, and it will of course be rewritten not just by the author-as-reviser, but by subsequent editors and publishers, even if no words are changed, even if each comma and period remains in place. It is simply not possible today for an edition (on the one hand) or a catalogue raisonné (on the other) to accumulate all of these texts, or to preserve the extensive breadth and array of cultural spaces into which texts penetrate. At one time it was a simple matter to hierarchize texts according to their eugenic features and crop them from their contexts, but this

activity clearly effaces the conditions by which cultural history creates itself. If we are concerned about this history—not as truth but as the fiction it must necessarily be—we will need to relocate textual criticism into the practice of reading and become aware that one's choice of texts is not immutably predeterminate but is instead based upon the orientation of the cultural inquiries we make as critics. Just as there is no single, correct, or best approach to editing an author's work, there is no universal best text for a critical investigation: the choice of a text, or texts, is necessarily related to the kinds of questions being asked, and these questions themselves frequently change in the course of reading. When I first began doing research on Keats as a graduate student in 1980, the ostensible choice of texts was Jack Stillinger's "definitive" edition, *The Poems of John Keats*—a judiciously compiled eclectic edition. Eventually, however, I found myself attracted to texts and readings that were of tenuous authority: Milnes's edition, Galignani's piracies, American editions, even appropriated quotations of Keats's poetry that appeared in biographies (especially Amy Lowell's) and advertisements. These texts did not just constitute a form of reception history of Keats's work but also showed how Keats, in positioning himself among his contemporaries and his predecessors (Chapman's Homer instead of Pope's Homer, Johnson and Steeven's Whittingham Shakespeare instead of a facsimile of the 1623 folio), was positioning himself with the same sort of temporal specificity that would subsequently be applied to his own work. It is clear then that useful critical studies can be written based on foul papers, cheap reprints, condensed books, periodical reprints, and so on; and it is also clear that, rather than disparaging such texts, we might consider their importance in the bibliographical chain of a work and how a stemma based on authority is not the only kind of stemma that can be written. Textual criticism and bibliography could therefore be redefined as disciplines that study manifestations of difference in cultural texts, wherein "difference" does not presuppose a genre or a system of values. What it does presuppose is the existence of some historical condition to explain a certain state of difference, even if that condition is ultimately irrecoverable. My feeling at this triparate juncture in critical history, editing theory, and social relations is that we should abandon the eugenic/ dysgenic and either/or paradigms upon which critical editing has based itself and explore instead the tension existing between differentiated states. This is not a plea to unedit texts, or a call for the end of editing, but a reappraisal of the ways in which editing practices might be made more useful in light of changing contemporary conceptions of human diversity

and social differences. My argument is positioned not against editing per se but against the dogmatism of editing's rhetorical claims, and in this respect I seek more active engagement in, and use of, historically situated editions and texts that might otherwise be described as "superseded." Toward this end an ideal edition might not be an edition at all, but a guide to historically situated texts, a Baedeker of the diachronic publication history of individual works. Jack Stillinger's *The Texts of Keats's Poems,* which, using genealogical trees, shows the filiation of Keats's drafts, transcripts, and early publications, is such a work; but its too-easy dismissal of nonauthorial texts (such as Galignani's texts) goes one step too far in adjudicating difference. Some may argue that this is perhaps necessary, since authority is a condition of difference—it is one way to distinguish one text from another. But authority does not negate difference or its sociohistorical significance, just as our own authority does not, presumably, negate the sociohistorical perspective we reveal in our readings. For this reason we need not expend unnecessary energy arguing that one text is better than another text but might instead look at what occurs in the transition *between* texts and how our critical locus may not be on one text or another text, but at the point of transition between those texts. This is the point of social transfer. It concerns not just X marks the spot, but the conjunctive moment by which "X" is created. What Ralph Williams has recently called a "tranche de texte"[75] is by necessity also a *tranche de temps* and is implicitly dislocated from real time: it can only be a conceptual construct. Either as a moment or as a space, a text is of little meaning historically without other texts with which we can align it, and in the process align the work both intra- and intertextually. If a draft of a poem is important, it is even more important in relation to that which it is a draft of. *Difference,* hanging on to its etymology as a relationship between two or more states, reminds us that a text like the *Reader's Digest* edition of *Tom Sawyer* is a product of unstable exchanges that are not simply cultural or economic, and that our interest should not be confined to the results of the exchange alone, but to its interface.

Yet we cannot study these interfaces without the diversity of the texts themselves, just as we cannot study social exchanges without a history of participants. For this reason an exclusively eugenic conception of editing is as disturbing as a eugenic conception of society. In discussing a topic so emotionally charged and politically controversial as eugenics, my intention is to show how its many controversies about difference, deviance, categories, and control are all relevant to contemporary textual and editing

practices. The comparison is necessarily a general comparison, but it is not a mere analogy: the relationship between social eugenics and textual eugenics is vital to our understanding of representations of alterity, and its usefulness extends to an awareness that texts, being a cultural product produced by both cultural and noncultural practices, invariably reflect traces of human involvement in those practices. This sort of generalization seems almost too easy, but in fact it is a very complex generalization: it means that textual authority is not within the author alone but is dispersed among the producers of texts and editions, dispersed even among editors like Galignani and *Reader's Digest,* both of whom could claim that their texts are perfectly authoritative in relation to their intentions, and in the process tell us—as all texts do—a little more about the people who put them together, the society they lived in, and the world we share.

Chapter Two

Textualterity

Art and Textual Criticism

Unlike most theories that comprise the literary-critical marketplace, particularly semiotics, deconstruction, and interdisciplinary imports like psychoanalytic criticism, textual criticism and bibliography are what one might call native critical theories: they originated not in disciplines anterior to literary study, but as a product of literature itself, particularly biblical and classical literature, and the need to establish a textual base as an activity preliminary to the act of reading. If, in the history of the discipline of literary institutions, criticism was preceded by philology, we can say by extension that philology was preceded by textual criticism and bibliography.[1] Zenodotus' efforts to edit the *Iliad* and the *Odyssey* while he was employed as head librarian at Alexandria in the third century B.C. initiated our modern conception of textual pragmatism, a conception based on the relationship between the discursive practices of composition and dissemination, whereby the editor is not a neutral or disinterested compiler of texts, but an engaged figure, like authors themselves, in the network of evolving cultural activity. As I remarked in my introduction, textual criticism and bibliography have never really been critical or ideological theories in the sense that poststructuralism and new historicism are theories. Instead, textual criticism and bibliography are more properly disciplinary practices that simultaneously study and contribute to the dispersion of literary texts.

Emerging from the chaos of textual practices is, if not a theoretical paradigm, at least a theoretical orientation. Since the early 1980s, when the Society for Textual Scholarship was founded (1981) and Jerome McGann's *Critique of Modern Textual Criticism* was published (1983), an extensive effort to reexamine canonized editorial procedures has characterized the incipience of textual ideology, an incipience originating at the moment

51

of the simultaneous success and failure of critical theory. This failure has been marked by an increasing desire for a theory of literature that is more than just a theory. Most critical theories are essentially reception theories: they are about the act of reading, about the interface of text and reader and how that act necessarily incorporates a struggle between the moments of inscription and the moments of reading. The struggle is not so much about the elusiveness of meaning, but about meaning's preponderance and the many ways by which meaning is created by authors, by language, and by readers. What the new textual ideology has done as a way of contributing to this overwhelming sense of textual and semantic space is to show how a work of literature is created by a number of shared, or mutually respected, authorities and show that these authorities change without necessarily abandoning their legitimacy.

What is unusual about textual criticism's place in the sphere of cultural criticism is its relatively confined application to the territory of literary texts. There are reasons for this. Bibliography, including both analytical and descriptive bibliography, has traditionally focused on the book as an inscribed object and has developed both a methodology and a code to describe the text in its absence. It is, in short, *about* reconstructions as much as editions *are* reconstructions. But if one considers that textual criticism is, in the abstract, a discipline that studies the variation, the change, and the transience of culturally encoded sign systems, it seems a little surprising that it has not had the sort of influence on other genres of the arts it has had on literature. The problem is not that textual critics have been unaware of the latent ideological strengths of their discipline. Vinton Dearing shrewdly observed in his *Manual of Textual Analysis* that "the method of analysis described in the following pages may be applied to the transmission and embodiment of any idea or complex of ideas."[2] This was in 1959. And Sir Walter Greg, in his *Calculus of Variants*, sought to describe a genre-neutral approach to documenting difference and variation. The problem in creating a textual criticism for the arts, a textual criticism for painting or sculpture or even conceptual art, instead seems to be a problem of the application of the methodology of textual criticism. It is James Thorpe, once again, who seemed to have his finger on the problem when he cautiously remarked over twenty years ago that literary works were "the sole practicable subject for textual criticism."[3] To the extent that textual criticism is concerned with the preparation of printed editions, Thorpe is justified in asserting that literature is uniquely practical. One could add music too, since, like printed language, it works with an arbi-

trary code of isolable and iterable units. But the methodology that works with a poem by Keats does not easily adapt itself to a sculpture by Rodin. The advantage of this problem is in how it shows us that iterability is only to an extent part of a cultural text, and that it is a condition of non-iterability, a condition of nonrepeatability, that accounts for the unique-ness of this text as a cultural event. Perhaps, then, the less that we under-stand textual criticism to be about editing and editions, and the more we see a form of textual consciousness as fundamental to reading, the less we are bound by the notion of requiring a practicable application of the methodology of textual criticism. Instead of a single reconstructed text, our interest shifts to the diachronic accretion of *un*reconstructed texts: how they are historically situated and resituated, and how the dissemina-tion of those texts is directly and indirectly related to their genre. Just as literature involves the "space" of books (and, increasingly, the space of performances), the space of art involves galleries, museums, and both public and private sites, all of which contribute to configuring and reconfiguring what we too-easily and misleadingly call "the text itself."

To look at the shifting texts and textual spaces of artworks with the same sort of sensitivity and care that we use to look at the shifting texts and textual spaces of literary works teaches us two important things. The first is that art does not consist of immutable objects any more than literature consists of immutable texts. Like other cultural phenomena, the ways that artworks get distributed in the sphere of culture subvert most of the formal distinctions between art and literature: the fact that Keats's publisher John Taylor asked him to clean up the sex in "The Eve of St. Agnes" and the fact that the British Broadcasting Corporation asked Eric Gill to be more modest about the size of the penis on a sculpture he was commissioned to make and the fact that both artists complied with these requests have little to do with their respective media and everything to do with the process of bringing their media before an audience. As a consequence, textualterity is less related to the medium of a work than to the ways or processes in which the work is disseminated. Second, however badly art is served by extant textual-critical practices, we might also ask if this reflects the inadequacy of those practices rather than the inapplicability of the medium. Traditional textual critics might scoff at such a suggestion, but my inclination is not just to push it, but to push it as far as it will go. A close examination of the synchronic variation and diachronic change in artworks reveals just how complicated books and texts really are, and how current editorial practices mask rather than reveal some of those complications. I think this will be

most apparent in expanding our understanding of the nonverbal or bibliographic codes of a text.[4] To speak of bibliographic codes does not so much limit us to semiosis as it presents semiosis as an option or possibility. Perhaps a better way of presenting this option is to speak of bibliographical evidence: that which is neither solely a linguistic code nor a dense code, yet both dense and linguistic, it is displayed by its own display, like the evidence of a crime scene. As evidence these bibliographical traces do not quite declare themselves as evidence, yet they await our claim to them as evidence. That this is complex is precisely the point. Many of the problems that arise in a survey of the manifestations of alterity in art constitute, at least at this stage of inquiry, aporias. It is not so much a need for us to solve them that is important; rather, it is a need for us to be aware that they cannot easily be solved, that as much as textual criticism is a science, whether a historical science or a postmodern science, art is *not* science, not simply a semiotic code, and thus cannot always be subject to formal or nominalistic analyses. Enamored with its parascientific practices and history, textual criticism has only slowly come to realize the limitations of those practices and how closely tied they are to certain *kinds* of literary texts. Most textual research involving the preparation of editions (such as those sponsored by the Center for the Editing of American Authors, the Center on Scholarly Editions, or funded by the National Endowment for the Humanities) tends to engage canonized works, canonized authors, and canonized genres. This is important because textual scholarship is part of the canonizing process; but it also shows how, until recently, textual ideology has had to work with a certain kind of institutional cornerstone: the inscribed canonical text.

The qualification *until recently* is important. One reason there is so much flux in the discipline at the present moment is because textual critics have begun to redefine the idea of a canonical text. The intent is not just to reevaluate the past, but, similar to the way in which revisionists have redefined the literary canon itself, to reevaluate the *conditions* by which we evaluate the past. Both efforts constitute a redefinition of authority and suggest that we instead view literary productions as being socially complex; that is, as representations of the diversity of the human condition in terms of race, class, and gender. This redistribution of authority has been manifest in a number of recent textual studies of distinctly noncanonical media and genres: ethnopoetics and oral literatures, and bibliographical codes.[5] It is not merely that these subjects are largely new subjects for textual criticism that is important, but the way these subjects refract textual practices and

contribute to interrogating the ideological purpose of the discipline. As I said earlier, textual criticism is in an enviable position of exploring its largely unexplored theoretical space. When questions about textual change are related to questions about textual authority, the subject is not automatically literature, but the matrix of culture and society, and in some cases legal rather than moral interpretations of this interface. It seems to me that textual criticism has much to offer to current debates about moral rights and the extent to which artworks may be legally protected from changes by people other than their makers, or the extent to which a private owner of an artwork, like the owner of bicycle, has the right to alter it—a right, one supposes, protected (in the United States) by the First Amendment and challenged (in Europe) by the Berne Convention Treaty, which holds that an author can object to the distortion, mutilation, or modification of a work to which he or she claims authorship.[6] These conflicting rights are, by necessary extension, representations of the conflicting authorities that are manifest more directly in questions like these: What does it mean when a private television owner and producer like Ted Turner decides to colorize a black-and-white film like Capra's *It's a Wonderful Life*? I say "Capra's film," notwithstanding the fact that Turner owns "rights" to the film. But what exactly is owned, and what sort of ontological boundary is there between making a work of art and remaking a work of art? Related questions— related because they too explore textual transience—include the following: What does it mean to 'restore' Leonardo's *Last Supper*, and what is the difference between restoration and conservation? What does it mean for the architect Michael Graves to 'add' a wing on top of Marcel Breuer's Whitney Museum? What does it mean to have to obtain a "Certificate of Appropriateness" in order to remove a rotting Victorian porch from your colonial house on Main Street in the Hamptons?

These are not insignificant questions, and perhaps because they at once take us in two differing directions—the pragmatic and the noumenal— they are not easy questions either. But they are useful because they literalize some of the most difficult problems already extant in textual criticism. Questions about what constitutes a spatial context or what constitutes a cultural utterance are, I think, beneficially studied through examples of art texts rather than literary texts. Books are spaces, of course, but studios, museums, and courtyards are spaces also, and so too are postcards, slides, and related enactments of mechanical (re)production. How do all of these things come together under the rubric of textual theory?

At this point I shall turn to a series of examples of artworks and art texts.

These examples of textualterity are both typical and atypical in their manifestations of transience. Some originate in the Renaissance, but most of the works are from the twentieth century, and a number are contemporary. The very recentness of the contemporary works allows the opportunity to examine documents relevent to their transience—documents that frequently become lost of neglected over time, thereby contributing to the erosion of a work. The presence of these documents—photographs, artists' statements, gallery wall labels, and so on—also helps toward demythologizing the sacred art object by showing how the object is a part of the continuum of its exhibition space, and how that space is in turn part of a larger continuum of ideological space. What follows is basically a discussion about these spaces, their enactments in time, and how our perceptions of culture are affected by the presence of their absence.

Remaking Sculpture: Richard Serra's *Tilted Arc* and Eric Gill's *Prospero and Ariel*

On the night of March 15–16, 1989, following a protracted legal exchange about the rights of the artist and the rights of the public, a rigging crew using torches and cranes dismantled Richard Serra's site-specific sculpture *Tilted Arc* and removed it from its location in Foley Square in lower Manhattan to a storage warehouse in Brooklyn. The sculpture, commissioned by the General Services Administration's Art-in-Architecture program in 1979 and installed in 1981, was removed for a number of different reasons, some of which involved the "public," some of which involved the unspoken opinions of appointed administrative officials in the GSA, and some of which involved the right of ownership and the concomittant belief that one can do what one wants with one's own possessions. These reasons, although important in relation to questions of authority, ownership, and copyright, are not too important in terms of a greater problematic: the GSA's intention to relocate the sculpture to a new site where, in the words of GSA administrator Dwight Ink, "it would not suffer significant loss of integrity as an artwork."[7] Serra, countering the GSA's intentions, asserted that "to remove the work is to destroy the work."[8] From Serra's point of view, *Tilted Arc* no longer exists: stored as it is in the Brooklyn warehouse, the sculpture is merely a ruin, a work of art in the past tense. The question is: who is right? Is *Tilted Arc* a sculpture in transit, a sculpture between sitings, or is it a former work of art with no future—only a past?

At this time in cultural history, when we think of Van Gogh in terms of his latest auction prices and Julian Schnabel in terms of his latest dealer, it is easy to think of a sculpture as a mere object, even a privileged object. I am not so much criticizing this objecthood as emphasizing how it conventionalizes our notion of movement: exhibitions travel, dealers rent works, collectors borrow paintings out of the studio, and (perhaps more so in Europe than in the United States) contemporary art magazines have contributed to creating a new kind of transnational exhibition space: the virtual gallery. Instead of an exhibition of art objects within an architectural space, a virtual exhibition consists of the display of reproductions within the pages of art periodicals. The work is exhibited and discussed in a context that is primarily promotional rather than critical. *Flash Art* (published in Italy with separate editions in English and Russian) features a one-page "Ouverture" that includes a brief profile of the art and artist, a photograph or photographs of the work, and a résumé of the artist; *Galleries* (published in France in both English and French) prints regular features on individual artists (as well as dealers, curators, and collectors, the focus in each case being on the individual); *Artforum* (published in the United States) carries a regular monthly spread entitled "Openings," in which a well-known artist or critic profiles an emerging artist. The most adventurous, however, is *Parkett* (published in Switzerland in both English and German), which prints in each quarterly issue a ten-to-twelve page artist-produced insert and also features regular collaborations between artists and the magazine, even to the extent that the collaborating artists redesign the magazine's layout from spine to the table of contents. All of these virtual galleries perform a significant function in the exhibition of contemporary art, neither merely supplementing nor supplanting actual galleries. In these virtual galleries art can move without ever having moved, can become material without ever having been an object, and can exist in a present that is also a past. The exchanges that occur, and the contradictions that emerge, show how the realities of cultural activity undercut many of the formal distinctions that we assign art. Or to be more blunt: art no longer requires objecthood to be art.

Tilted Arc, or more properly the affair of *Tilted Arc,* is precisely the sort of sculpture-event that puts our ideas about objecthood to test. As objects go, *Tilted Arc* was, and is, big: 120 feet long, 12 feet high, and made of seventy-three tons of Cor-Ten steel. Unlike mere objects, however, *Tilted Arc* was deliberately situated to bisect the courtyard in Foley Square and interrupt foot traffic patterns. Like most of Serra's sculptures, *Tilted Arc*

was not complacent: it did not so much encourage interaction as impose it. People did not simply look at *Tilted Arc* but walked around it, and that walk tended to be intimidating as much as it was long. In his recommendation to relocate *Tilted Arc,* Dwight Ink commented that the sculpture "would be far better appreciated by those who had a free choice of viewing it than those in the Federal Building who find the plaza physically curtailed, and whose view is obstructed by the *Tilted Arc* as they arrive in the morning and as they leave the building at noon and after work."[9] Despite its precarious placement, however, *Tilted Arc* is not an example of the antiaesthetic any more than it is self-consciously stylized as a formal aesthetic. Serra's work instead usually attempts to keep the tension between engagement and disengagement balancing, like the sculpture itself, on some kind of edge. When one is able to walk through Serra's sculptures (such as *Slat* in Paris or *Carnegie* in Pittsburgh or the remarkably poised and engaging *Intersection II* shown in 1993 at the Gagosian Gallery in New York), one is not so much caught by the shadows of the sculptures as engaged by their almost impossible sense of play and paradox. All at once they are technically precise fun-houses and massive steel slabs that weigh a few hundred thousand–odd pounds. This irony was played out at Serra's and Mark Di Suvero's 1993 shows at Gagosian's downtown gallery, where one could observe children drawn into Serra's interiors as readily as to Di Suvero's appendages. But *Tilted Arc* did not offer this sense of play. Its function in the courtyard at Foley Square was to align the two perpendicular buildings and inscribe the site both visibly and invisibly. It was perhaps the most serious of Serra's serious work, and that is precisely what got him into trouble: public sculpture is not supposed to be too serious, particularly if that seriousness is the product of a concentrated disciplinary history. The work was, in this sense, legible without being readable; accessible without being accessed. Between March 6 and March 8, 1985, public hearings were held to discuss the issue of relocating the sculpture, and testimonies—mostly on ontological matters relating to the work's artistic and aesthetic merit—swung back and forth. The bottom line was whether moving the sculpture from its site-specific location would "destroy" the work (as Serra contended) or simply alter it, that is, create a new text. In the end the sculpture was, as we saw, removed from the plaza: neither moved to a new site nor forever prevented from returning to the site for which Serra created it, the sculpture is, in a sense, a sculpture trapped by time.

Trapped by time and freed by time: even in this tautological duplicity, what is clear is that *Tilted Arc*'s permanence is in its impermanence. The

sculpture was designed to be located at Foley Square more or less 'forever' (Serra said that one motivating reason to do the piece was not money but the fact that *Tilted Arc* would be permanently incorporated as an integral part of the "total architectural design" of the plaza and adjacent buildings).[10] *Tilted Arc* has helped remind us, as much as polychromed Greek sculptures have, as much as Leonardo's *Last Supper* has, and as much as Robert Smithson's *Spiral Jetty* has, that permanence incorporates transience into its definition: the polychromed sculptures have lost most of their paint, the *Last Supper*, faded, cleaned, and "restored," is now both Leonardo's mural and our own, and *Spiral Jetty*—a rock and rubble spiral jutting fifteen hundred feet out into Great Salt Lake—is alternately submerged and exposed by waters that have fluctuated since Smithson completed the work in 1970. Whether the changes that occur are the result of unintended natural or unnatural forces (Vesuvius "destroying" Pompeii on the one hand, automobile pollution "destroying" the Acropolis on the other), or human agency complicit with certain intentions (the GSA's effort to remove *Tilted Arc* as one example, and, as another, a man who, protesting abstract art, repeatedly slashed Barnett Newman's painting *Who's Afraid of Red, Yellow, and Blue III* in Amsterdam's Stedelijk Museum in 1986),[11] what is important is how the artworks tend to incorporate these events, retain traces of them, and continue to exist as artworks that are marked by time, marked by the organic environments and social contexts through which they must pass. They are not destroyed even if they are physically disfigured or reconfigured, even if their maker's explicit intentions are subverted. In this historical context Serra's defensive position seems a little extreme, perhaps because of his effort for unequivocal control over the conceptual intentions of the work. This seems to me symptomatic of twentieth-century artists and critics not yet having come to terms with the tenuous relativity of intentions and how a socially conditioned definition of permanence incorporates the *failure* of intentions and their eventual appropriation by people other than the artist. *Tilted Arc* may not be remembered as one of the largest site-specific sculptures Serra has done or New York City has seen, nor one of the most controversial (though it is both of these things), but as one of the most insolently resolute conceptual works of art in the twentieth century. In a paper that Serra presented to the *Tilted Arc* Site Review Panel, a panel convened by the National Endowment for the Arts to investigate the feasibility of resiting *Tilted Arc*, Serra wrote:

It remains to be stated that in the case of relocation of *Tilted Arc,* I will withdraw my authorship. If the steel plates which in their present site establish my sculpture *Tilted Arc* are reassembled, the new installation will not be my work. I will immediately take legal proceedings against whoever accepts this falsification. I have instructed my attorneys to stop such action through litigation.[12]

At one point in cultural history the question of the everyday object becoming an object of art (Duchamp's *Fountain,* Manzoni's *Merda d'Artista*) asked, "Is it art?" But the postmodern version of this question is not content to be a mere tautology; it requires a certain kind of resolution. It therefore asks: "Is there a legally enforceable condition by which an artwork is art, or attributable as such?" From Serra's point of view art is too sacred to be just a commodity: it requires an ongoing, not just originary, acknowledgment of fulfilled intentions to be art. At the moment those intentions are subverted, Serra claims, the work must be dispossessed of authorship, as if its ontological status, its social value, and its commodity value could all self-destruct.

It is an irony—perhaps one of the greatest ironies of an age in love with irony—that some of culture's most self-styled and subversive appropriators have steadfastly resisted the appropriation of *their* appropriations. Andy Warhol, Jeff Koons, and Richard Prince did not just make a reputation by reframing the kitsch of our culture as high art (while, paradoxically, museum shop posters, postcards, and plastic-framed reproductions have reframed high art as kitsch); what they also did was protect their intentions as a unique element concomitant with the transfer their work entails. That is why Warhol's *Soup Cans* are arguably not about Campbell's soup, and why, after his death, Warhol's estate took steps to legally protect unauthorized use of Warhol's images and his name. But the irony here—*Warhol's* images—reminds us that the agent initiating the transfer between soup cans and art is not somebody named Campbell but somebody named Warhol. This seems almost absurd, but in fact it is not: it symbolizes the linear continuity of the transfer of cultural images in a way not unlike editorial remakes of Shakespeare: *Pope's* Shakespeare, *Lamb's* Shakespeare, *Bowdler's* Shakespeare, *Gary Taylor's* Shakespeare. The possessive form, being a sign of agency, reminds us that remaking is one reason why culture is possible, and why art is destined, if not obligated, to remake the past in order to survive it.

As *Tilted Arc* makes clear, however, the question about agency is also a

question about the ownership of agency: who makes a work of art, and who has authority to remake it?

Before the 1980s, few people spoke about the moral rights of artists and artworks. Of course, it is not quite the same thing to say that people have rights and that artworks have rights. The First Amendment protects citizens, not Cor-Ten sculptures, and even if a sculpture is an articulation of its maker, the First Amendment does not necessarily protect it from the First Amendment rights of others. That is why hate speech ordinances designed to curtail and punish offensive speech are frequently found to be unconstitutional: the right to free speech does not by extension protect one from the free speech of others. The right to create art does not, by similar extension, prohibit one from creating a new work by desecrating the first—a principle eloquently exemplified by Robert Rauschenberg's *Erased de Kooning,* which was created when Rauschenberg obtained from de Kooning a drawing (a good drawing at that) and erased it completely. A work like this suggests that art's "methodological field" (as Barthes called it) is also fraught with tensions of a bipolarized magnetic field in which opposing forces contribute to maintaining the flow of energy. One thing that contributes to making art what it is as a dynamic force is that the status of competing forces is resolved in unpredictable ways, even to the extent that the resolution reverses itself and contradicts all logical expectations about moral propriety. This is not a uniquely twentieth-century phenomenon, but part of a historical pattern. In Andrei Tarkovsky's film about Russian icon painters in the fifteenth century, *Andrei Rublëv,* nobody was thinking much about the artist's—or the church's—moral rights when Tartars sacked the city of Vladimir and reduced the church and Rublëv's frescoes and altar screen to smoldering rubble.[13] In a very important sense the smoldering rubble registers a transcendence greater than the church itself was or may have been. We cannot answer our desire for knowledge about the lost iconostasis, and it is this lack of knowledge that creates something more powerful: a myth. Serra is certainly a better-known artist because *Tilted Arc* is now, like the Church of Vladimir, a ruin. Marked by social upheaval and the vicissitudes of their time, the works incorporate history into their evolving status as both artworks and as myths.

When Thomas Bowdler created his infamous version of Shakespeare, he wrote in his preface:

If a presumptuous artist should undertake to remove a supposed defect in the Transfiguration of Raphael, or in the Belvidere [*sic*] Apollo, and

in making the attempt should injure one of those invaluable produc-
tions of art and genius, I should consider his name as deserving never to
be mentioned, or to be mentioned only with him who set fire to the
Temple of Diana. But the works of the poet may be considered in a very
different light from those of the painter and statuary. Shakspeare, inimi-
table Shakspeare, will remain the subject of admiration as long as taste
and literature shall exist, and his writings will be handed down to
posterity in their native beauty, although the present attempt to add to
his fame should prove entirely abortive. Here, then, is the great differ-
ence. If the endeavour to improve the picture or the status should be
unsuccessful, the beauty of the original would be destroyed, and the
injury irreparable. In such a case let the artist refrain from using the
chisel or the pencil: but with the works of the poet no such danger
occurs, and the critic need not be afraid of employing his pen; for the
original will continue unimpaired, although his own labours should
immediately be consigned to oblivion.[14]

What is slightly amazing about this circumspection is that its author, whose
name has come down to us to mean anything *except* circumspection, retains
poise despite his text's pose. Like Lessing in the *Laokoön*, Bowdler drew a
distinction between verbal and visual works of art and emphasized the
formal conditions of these distinctions to provide a rationale for his proj-
ect. This position can be usefully compared with the position taken by GSA
officials in their deliberations about *Tilted Arc*. In the summary of his
decision to relocate the sculpture, acting Administrative Head for the GSA,
Dwight Ink, dismissed the suggestion that *Tilted Arc*'s site-specificity neces-
sarily made relocation impossible:

> The *Arc* was planned very carefully and specifically by the artist for
> the Plaza. In that sense, it is site-specific. I am not persuaded, however,
> that it would be destroyed if it were moved to another compatible place
> with adequate viewing space.
>
> Further, regardless of the careful planning of the artist and the
> high aesthetic value asserted by some eminent artists, I do not believe
> the community must be forever burdened, against their will, with
> what many of them regard as simply a 12 feet high, 120 feet long
> rusted steel wall. At the same time, I do not believe we can accept
> the type of arbitrary relocation which would destroy the integrity of
> the artwork.[15]

THE

FAMILY SHAKSPEARE,

In Ten Volumes;

IN WHICH

NOTHING IS ADDED TO THE ORIGINAL TEXT;

BUT THOSE WORDS AND EXPRESSIONS

ARE OMITTED WHICH CANNOT WITH PROPRIETY

BE READ ALOUD IN A FAMILY.

BY

THOMAS BOWDLER, Esq. F.R.S. & S.A.

VOL. I.

CONTAINING

TEMPEST;

TWO GENTLEMEN OF VERONA;

MERRY WIVES OF WINDSOR;

TWELFTH-NIGHT: OR, WHAT YOU WILL.

LONDON:

PRINTED FOR LONGMAN, HURST, REES, ORME, AND BROWN,
PATERNOSTER-ROW.

1818.

WILLIAM SHAKSPEARE

Fig. 5. Title page and frontispiece from Thomas Bowdler, *The Family Shakspeare* (London, 1818). By permission of the Folger Shakespeare Library, Washington, D.C.

Both Bowdler and Ink have left us with curious and important documents. Bowdler, trying to be philosophical rather than subversive, declares he is doing no harm. Ink, trying to be pragmatic rather than subversive, declares he is doing no harm. What is most interesting is that harm is not really the issue here, but by making it one both Bowdler and Ink deflect attention from what is really happening: that in reconfiguring one text they necessarily create another, and that (contrary to what Bowdler claims) this new text will not efface the old: it will still bear the scars, and hence the traces, of its peregrinations. Bowdler's formal, or code-specific, distinction between a work of art and a work of literature is a distinction accepted by many textual critics today (a very similar point of view is offered by G. Thomas Tanselle in his *Rationale of Textual Criticism*),[16] but this formal qualification, even if it means something, also means nothing: a code tells us little about how it will be socially incorporated, and the act of reading frequently violates and contradicts code-based distinctions.[17] A work of art is singular only inasmuch as it is perceived that way: there could, depending on circumstances, be one *Tilted Arc* or ten *Tilted Arcs;* one *Hamlet* or ten *Hamlets*. A work's accretion of texts is always latent, but rarely is it self-evident, as it is in the apparatus of a critical edition or a variorum edition. That is why *Tilted Arc* cannot be destroyed by being stored or relocated, even if a text of *Tilted Arc* is remade in the act of making a new one. While it is important to acknowledge that textual criticism traditionally works with material facts, it is always searching for an immaterial text, for an archetypal text that may in fact never have existed. Rather than being worrisome, this acknowledgment is the opposite: it registers the significance of the memorial text. The *Tilted Arc* of 26 Foley Square is neither wholly material nor immaterial as a historical text, but something of both, something perhaps greater than it might otherwise have been. Photodocumentation of the sculpture and site, showing the context of the site (or cropped out of the site as a countertext), and photographs of the sculpture's scar in the plaza all take us into a textual history that is in some ways as useful as the traditional textual apparatus because they allow us to see the interface of the editorial act: the act of creation, the act of intervention, the act of erasure, and the tensions concomitant with these acts—all being the sort of things that textual criticism attempts to reveal.

One of the arguments to emerge out of the *Tilted Arc* controversy is that, having sold the sculpture to the federal government, Serra no longer owned it, and the GSA, however much it was impinging on Serra's original conception, had its own right to relocate or physically dismantle the

sculpture. Not a moral right, but a legal right, a right that reflects the legislative position of a consumerist society. In the end this was a deciding factor. When Serra sued the GSA to stop the relocation effort, the court affirmed the GSA's proprietary rights: "Serra has no protected property interest in the continued display of *Tilted Arc* at Federal Plaza," wrote presiding judge Jon O. Newman. "Pursuant to Serra's contract, the sculpture is property of GSA, not the artist."[18] While a decision like this reduces cultural property to the status of mere property, it reflects the necessity of applying an enforceable hermeneutic judgment to the ideological tug-of-war between competing authorities and competing rights.

But this, by all measures of cultural history and the history of cultural patronage, is not new. What is unusual is the protracted nature of the affair, and the fact that it did not begin in earnest until after the sculpture had passed through both public and administrative review and was installed. The tension usually begins earlier and gets settled more easily. Editors frequently asked John Cowper Powys to make extensive excisions from his novels, *Porius* being a good example. And Powys usually, though reluctantly and obstinately, complied, sometimes under the threat of legal implications—something that influenced distinct textual changes between the American and English editions of *A Glastonbury Romance* and *Weymouth Sands*.[19] An even more compelling example is Powys's book on Keats entitled *John Keats, or Popular Paganism*. Powys explained that he wrote it "for" Methuen and submitted the typescript to the publisher in 1910. There was a problem, however, and as Powys explained it to his brother Lulu, Methuen was less than pleased by a few passages that he described as "a few hits at God."[20] It would have been a simple matter for Powys to alter his text and get the book out, but this was not the path he chose to take. In his *Autobiography,* Powys reflected on this situation and remarked: "This work was never published, because, in my absurd pride, I refused to change its more patent extravagencies, but its composition forced me to clear up problems in my own mind."[21] Over time, the book on Keats, one of Powys's first books, became an emblem of his intransigence. Unpublished today, the typescript—lost for many years and recovered after the death of Powys's companion Phyllis Playter in 1982—is no longer just a book about Keats, but a book about Powys's relationship with Keats, and (given his acknowledgment that writing it cleared up problems in his own mind) about Powys's own relationship with himself. To publish the book today according to Powys's intentions would mean not publishing it at all, but to leave it balanced on the precipice of rejection, a rejection

that would affect his attitude toward subsequent texts and subsequent requests for changes. *Maiden Castle* was, as Powys said, rendered ragged, and *Porius* was cut down by nearly a third.[22] Powys thereby learned what practically every artist eventually learns: that art involves exchanges and negotiations as part of the process of bringing it before the public.

It is easy to forget that these exchanges occur, perhaps because most occur quietly and occur with undisturbing regularity, and perhaps because the history of artworks and literary works is composed primarily of objects and texts rather than circumstances. It is, therefore, the object that is remembered, the object that is read and criticized, sold and savored. Sometimes too the exchanges that occur are part of a tacit social-aesthetic contract. Whether the patron in these circumstances is an individual or the Church, the relationship is characterized by an exchange of authority. Caravaggio, for one, did not have an easy time of it, and there is one instance that bears particular consideration in relation to *Tilted Arc*. In 1602 Caravaggio completed a large work entitled *Saint Matthew* for the altar of the Contarelli Chapel in San Luigi dei Francesi. A contemporary historian, Giovanni Pietro Bellori, wrote a biographical sketch on Caravaggio and commented on the incident:

> Something happened which made Caravaggio almost despair for his reputation: the priests removed the *Saint Matthew*, his first public work, from the altar, saying that the figure had no decorum, did not look like a saint, sitting with crossed legs and with his feet crudely exposed to the public. Marchese Vincenzo Giustiniani intervened in behalf of Caravaggio, arranging with the priests to take the painting for himself and to have a second one made which is now there. Giustiniani took Caravaggio's first *Saint Matthew* into his house, placing it together with three other Evangelists by the most celebrated painters of the time, Guido, Domenichino and Albani.[23]

There are of course important distinctions between what happened to Caravaggio and what happened to Serra, and I do not intend to suggest that some of these matters—patronage, site-specificity, and legal contracts—are irrelevant. But I will suggest that Caravaggio's *Saint Matthew,* even after having been removed, even after having been burned (when the United States bombed Berlin in 1944), is not a lost or destroyed painting any more than *Tilted Arc* is a destroyed sculpture. This may to some seem a preposterous claim, and my reason for taking such a position

is to interrogate the conditions by which we claim a work of art is destroyed. Because the material text is always in a state of change, whether that change is continuous or discontinuous, accretion or decay, it does not have inherent priority over the text's immaterial condition, which in fact has far greater stability in memory than the material text has in any museum. If the history of art was merely about material outcomes and formal properties, we would have no need for a history whatsoever. But because history is largely about the interpretation of what is absent, even absent paintings (such as Caravaggio's *Saint Matthew* and Leonardo's *Battle of Anghiari*), the challenge is not so much to reconstruct the absent works as to reflect on their absence.[24] A work of art might be said to undergo greater harm, greater damage, when it is erased from memory and thereby ceases to be a cultural text. It may continue to exist as a material artifact, but its absence from memory and from cultural discourse marks its destruction.

A significant example of this relationship between the material and the immaterial, one that is both point and counterpoint to *Tilted Arc,* is Eric Gill's sculpture *Prospero and Ariel,* which Gill was commissioned to make for the BBC Broadcasting House in 1931. Approximately ten feet high, the sculpture features a nude, cherubic Ariel standing in front of a heavily draped Prospero. Most of Gill's sculptures consisted of public and private commissions: his work varied from tombstones to memorials to gateways to a huge relief panel on the subject of creation for the League of Nations in Geneva. *Prospero and Ariel* was not an unusual work for Gill, and the commission progressed well. Shortly before it was to be unveiled, however, the BBC Board of Governors previewed the work. Everything was fine except for one thing: Ariel's penis. It was too big, or in any case the governors thought it was too big. After a meeting to discuss the issue—authority being provided by a former headmaster who commented that "the lad was uncommonly well hung"—Gill was asked to trim Ariel down.[25] What Gill did in response to this request is a little unusual and worth pondering: he complied. And not only did he comply, he openly acknowledged that the author of a work of art had only limited authority over his texts, the greater authority being decided (as the courts decided in the case of *Tilted Arc*) on the basis of proprietary rights—that is, ownership. In 1936, five years after the *Prospero and Ariel* episode, the English newspapers reported that Michelangelo's nudes in the Sistine Chapel were to be further covered, or rather draped, on papal order as part of a major restoration effort then in progress. Informed of this and asked to comment, Gill wrote to Naomi Walford:

I should like to say just one thing. It is this: that I think you take a much too solemn line with regard to what are nowadays called "works of art." Speaking as a sculptor (artist) I maintain that if a man buys from me a statue and does not like the shape of any part of it he is quite at liberty to remove that part or alter it or do anything he jolly well pleases. All this talk about the sanctity of the work of artists, as though it could be claimed that artists were directly inspired by the Holy Ghost, is, I think, flat nonsense. A work of art of any sort is as much a product of a civilization as of an individual and, is, therefore, a product of the collaboration of both workers and their customers. The artist is not a God kindly handing out his infallible works. And one other thing: Churches and banks, etc. are not museums in which things are kept as curiosities or as objects simply of interest to visitors. If, for instance, the Bank of England came to the conclusion that Mr. Charles Wheeler's sculptures were unsuitable, they have every right to remove or alter them—just as much right in fact as a man has to alter the throttle valves (or whatever they are called) in his motor car, whatever Mr. Morris, Lord Nuffield or whatever he is called, may say. Personally, as you know I think, I am in favour of a much less prudish attitude towards human nakedness, but that doesn't stop me from recognising that people who buy things can do what they like with them.[26]

What is almost extraordinary about this letter is Gill's acknowledgment that the artist's authority must be shared with society, and that collaboration, whether tacit or not, is a necessary condition for artistic production. Authority could at best be a moral law without an agency to enforce it— and therefore useless. Gill may have overstated himself with respect to the throttle valves of his motor car, but he wasn't being merely stoical or passive by acknowledging the unsacredness of art. To the contrary, one can find in Gill's work and writings an unusual consideration for disinterestedness. His respect for the artist as an anonymous maker of "beautiful things" reached for Gill a pinnacle in medieval painting and architecture where selflessness was a distinct virture: work was left unsigned. The work's identity is therefore in the work's perpetual present; not an original or originary past. The work may have been the product of an exchange, or it may have been altered through an eventual exchange, but it does not declare itself nullified by these exchanges. During the recent cleaning and conservation treatment of the Sistine Chapel, it was decided that some of the overpainting by previous restorers would, where possible, remain in

place, thereby retaining traces of the Counter-Reformation in the draped nudes.[27] Ultimately seventeen of forty drapes, specifically those documented as having been added after 1750, were removed.[28] The date is important, because most of the drapery had been added by Daniele da Volterra shortly after the Council of Trent, in 1564, decreed that specific portions of the work were offensive and should be covered. This was roughly fifty years after Michelangelo had created the frescoes, and so the restoration decision was essentially microtemporal: it both "recovered" Michelangelo from subsequent overpaintings while also retaining traces of this important historical reconfiguration of the work. As the textual critic Paul Eggert observed, this amounts to an inconsistent application of principle if the principle is to recover the "original" frescoes.[29] But however inconsistent this is, it shows how the conservation treatment itself is yet another act of historical transience, one that neither more nor less than previous treatments reflects the ideologies and intentions of those interacting with the work.

Ariel's penis is a different kind of problem. Unlike the drapery it lacks an overt presence, which must instead be found in language and in memory. Painting usually leaves us with traces of revision, but not always: Caravaggio, for example, did not draw his underpaintings, so that infrared reflectograms (which reveal traces of carbon) do not reveal pentimenti, and certain organic pigments (bitumen, for example) have very low contrast under X rays because they are composed of primary elements of low atomic number. But when a Caravaggio is restored, like the Metropolitan Museum's *Concert,* X rays reveal the overpainting and contrasting pigments of the act of restoration.[30] In this sense the changes that occur over time are another kind of pentimenti: not compositional revisions, but editorial accretions. The same cannot be said for Ariel's penis: the progression of the work's texts is distinctly linear, and only by incorporating a new technological trick (such as Caen stone dust mixed in an epoxy binder) can this progression be reversed, as in fact it sometimes is when a sculpture is damaged and repaired. But who would attempt to go so far as to restore Ariel's penis according to Gill's intended original text? Like Serra's unreconstructed *Tilted Arc,* the original text of *Prospero and Ariel* is a memorial text of perhaps greater historical import than an editorial reconstruction could offer. That is why, I think, Thomas Bowdler's mythological status as the mother-of-all-corrupters becomes less mythological, and almost prosaic and ordinary, in the context of the preface to his text. The myth, in fact, depends on the text's absence because it is fueled by a

grandiose notion of a great injustice (like the 'destruction' of *Tilted Arc* and the alteration to Ariel). Yet, as much as an immaterial text does not directly tell us enough, our dependence on the material text risks overdetermination, and our new problem, in turn, is not to have a lacuna of textual information, but to be burdened by having too much.

Continuous and Discontinuous Transience

First published in 1962, George Kubler's *The Shape of Time: Remarks on the History of Things* is a work that deserves to be better known by textual theorists. Kubler's direct and indirect subject is time and how it affects the evolution of objects and ideas: how, for example, iconographies shift, symbols acquire new meanings, and stylistic changes are introduced. Categories, which emphasize typologies and finite states, tend to look at stasis rather than transience (a point also made by Foucault in his discussion on change and transformation in *The Archaeology of Knowledge*),[31] and thereby miss the perpetual entrances and exits that occur in the creation of these states and categories. When readers or textual critics focus on an individual text, whether a "best" text or a "final" text, they too miss this transience. The very idea of a clear reading text unencumbered with traces of transience is not so much a rejection of this transience as it is an acknowledgment that both readers and artists alike are frightened by it: it affirms that a text is unstable even before it is read. Like the negative attacks on deconstruction's indeterminacy of meaning, the indeterminacy of the textual state alienates those in search of the security of a stabilized textual product.

In Kubler's discussions the idea most relevant to textual theory is his notion of "drift," which Philip Fisher paraphrases as "unintended changes that occur over time."[32] Kubler's model for drift is linguistic change: how two cognate languages that drift apart will experience semantic shifts that are irregular and for the most part unpredictable, even if they are recognizable.[33] Language, however, can admit only so much change at a given time, or the system is overburdened and collapses. Thus, changes tend to occur slowly in conjunction with the manifest social need and use. When changes are abruptly or artificially imposed, such as changes dictated by war, legislation, language-planning policies, and artificial languages, they tend to be repelled by or discarded by the dominant language unless there is a mechanism to enforce their continued presence.

Unlike language, however, art can sustain sudden changes and retain its newly reconfigured state. The intervention that resulted in the removal of

Tilted Arc is unlike the slow accretion of soot, grime, and moisture-borne salts on Michelangelo's frescoes. The frescoes experienced something closer to Kubler's conception of drift: the changes occurred slowly over decades and centuries, and they were (except for the restorers' over-paintings and treatments) unintended though not unexpected. The re-moval of *Tilted Arc* is different: the changes occurred comparatively quickly, and they were not only intentional, but intentionally concerted and required a large marshaling of ideological force. How then can we compare these two different forms of transience?

One approach is to make a loose distinction between continuous and discontinuous transience. Continuous transience involves slow, linear change of either decay or accretion, whereas discontinuous transience is characterized by ruptures and implosion, or what in pathological discourse is more explicitly described as "trauma." Continuous transience most di-rectly affects the physical text itself, such as in the fading of pigment or the flaking of the binder in which the pigment is suspended. Photographs are excellent examples of potential (and, usually, inevitable) continuous tran-sience. The dyes of C-prints have an average life of fifty to seventy-five years before fading, forcing some museums to now purchase a control print: one goes on display and the second goes into a cold vault. A recently developed technique of color printing known as Cabro II Ultrastable is described as being "truly permanent" and can reputedly be displayed under normal viewing conditions for over five hundred years without color shifts.[34] It's not cheap: five hundred dollars for an 8″ × 10″ print or twenty-two hun-dred dollars for a 30″ × 40″ (the largest size available in 1994). On the other hand, mere expense does not protect artworks from continuous tran-sience in other media. Art collectors who paid extraordinary prices for contemporary art in the 1980s have learned that their investments have entailed an ongoing commitment to conservation: Julian Schnabel's plate paintings of smashed crockery secured to panels with Bondo (an auto body filler paste) have a nasty reputation for dropping off the paintings at the wrong time and place, and the frequent use of fragile or organic elements by other artists (latex, straw, grass) has led to all kinds of problems. Organic elements and artworks situated within organic "frames" (e.g., outdoors) are prime candidates for continuous transience: Michael Heizer's *Double Negative,* a large earthwork that displaced 240,000 tons of rhyolite and sandstone in the Nevada desert, has been slowly eroding and filling in since its creation in 1969–70,[35] and Smithson's *Spiral Jetty,* submerged for many years under the Great Salt Lake, emerged from its watery storage in the

spring of 1994.[36] In this sense continuous transience is not per se bad or negative; Smithson's piece emerged coated with salt crystals and consequently more beautiful than it ever was.

The growth of salt crystals on *Spiral Jetty* constitutes a form of accretion (rather than decay or deterioration) that both makes and unmakes certain works. Oxidation, either in the form of patination or rust, both adds and detracts, accumulates and removes. The rust on the surface of the Cor-Ten steel used to construct *Tilted Arc* is a form of superficial corrosion that protects the steel from structural corrosion. A purely entropic conception of temporal change would involve continuous deterioration and decay, and while this is perhaps true for physics, decay is not inherently pejorative in aesthetic terms, and not all cultural entropy is therefore bad. Less kind things can be said for the inorganic pollutants being deposited by the ton every year by automobiles negotiating the streets of cities like Athens, Prague, or Berlin, or for the organic pollutants deposited on pediments and exposed ledges by pigeons. However diverse these examples may seem, they remind us that the agents of change are not always predictable and that the change itself often occurs so slowly that by the time it is recognized it is too late to reverse its course back to an "original" state. What usually happens, then—and this is how the conservation of Leonardo's *Last Supper* was carried out—is that the agent of transience is neutralized so that the change can be consolidated and (presumably) stabilized and thereby incorporated as an evident historical fact.[37] What is "restored" is not an original state or text, but traces of that text as interpreted by the present.

While continuous transience is almost inevitable and, at its most extreme pejorative state, reduces architecture to ruins, wood sculptures to sawdust (powder-post beetles, comprising the families *Bostrychidae* and *Lyctidae,* do this very well), and color photographs to polychromatic sludge, there is too much unpredictability to the changes themselves to categorize them qualitatively.[38] In his *Diaries,* Paul Klee recounted a moment in Florence:

In the Galleria Antica e Moderna, to see Botticelli's "Primavera." Of course it surprised me at first, because I had imagined it wrongly, from the point of view of quality as well. Colorlessness partly due to wear. This is what contributes the historic element to a picture and becomes a part of it. It is quite a different matter to try to produce new pictures with worn-out colors, like Lenbach. If one loves the patina brought by

the centuries, who knows whether one wouldn't reject the pictures in their original state.[39]

As Klee rightly guesses, the patina of time is something to which people become attached, and this partly explains the ongoing resistance to various conservation and editorial projects: we are exposed to unfamiliar texts, texts we cannot verify as having been real texts or fictional texts, and must realign our faith from the present to a hypothetical projection of the past. It does not in this sense matter whether the text is of Michelangelo or James Joyce: what matters, as Klee notes, is that a familiar text is defamiliarized and emptied of its historical imprint. Sometimes this imprint is quite valuable. In Rome Klee visited the statue of *St. Peter* in St. Peter's, and remarked: "His toes, worn away by kisses, add to the effect."[40] A text like this is a conflation that cannot be undone without also undoing history. When the Soviet Georgia filmmaker Sergei Paradjanov's film *The Colour of Pomegranates* first appeared in London in the early 1980s, the peregrinations of the text added immeasurably to the symbolic surrealism of the story: grainy, faded, and cut almost to the point of incoherence, the film text was reputedly a dupe of a dupe of a dupe that had been smuggled out of Georgia via Iran and had also undergone editing by the shah's censors. When, however, I had the opportunity to view a fresh print of the film at the Pacific Film Archives in Berkeley in 1987, the mystical effervescence of the film was replaced by something else: color and complacence. Like St. Peter's worn toes, Paradjanov's film helps to show how entropy creates history and history creates myth. Sometimes a work of architecture does not become canonized until it becomes a ruin, the advanced state of textual decay serving to function as the primary condition by which the work is brought to our attention. Tintern Abbey is a little like this: roofless and wrecked, its present monumentality is in many respects enhanced because its pose is the pose of a tragedy.

Literary texts, it should be said, rarely experience continuous transience as a material fact. They do of course decay as books (particularly those made from cheap wood pulp in the nineteenth century), and contemporary surrogate texts (electronic texts, microfilms, and microfiches) do not, in a bibliographical sense, replace these texts.[41] The most significant form of continuous transience does not affect the material text (a term I borrow from Peter Shillingsburg),[42] but the immaterial or social frame of that text: what could be reduced to "context," though only at the risk of oversimplifying the complex exchanges that take place within this frame—just as in

Kubler's conception of drift linguistic changes occur both as a result of system-internal changes (vowel drift is one example), system-external changes (coinages are one example), and what sociolinguists might describe as variation changes, where one variant (which exists synchronically) eventually dominates over another variant and supplants it in the course of diachronic change. The frame of such change, being socially imbricated in culture itself (in addition to being a manifestation of that culture) inhibits the possibility of simple causation: the text appears unstable only because so much else around it already is.

What happened to Serra's *Tilted Arc* and Gill's *Prospero and Ariel*, and what happens to most literary texts, is not, like most of the foregoing examples, continuous, but discontinuous: the changes that occur often occur abruptly as the result of intentional human involvement. There are exceptions, of course: the eruption of Vesuvius that buried Pompeii was discontinuous without being intentional. Like earthquakes, this is an unusual instance of what Robert Smithson called "the contingencies of nature,"[43] and these events affect not just individual artworks, but the entire cultural substructure of which they are part. "Archaeology," explained Foucault, "is much more willing than the history of ideas to speak of discontinuities, ruptures, gaps, entirely new forms of positivity, and of sudden redistributions."[44] This is because archaeology (like textual criticism) must work with traces of events, and a trace or a fragment is by definition already a ruptured redistribution. When discontinuous transience does affect an individual artwork, it characteristically works by reconfiguring the work so that it is not quite the same and cannot go back to being what it was. One might argue that this cannot be true for literary works, that to create a new text of the work does not change the work itself. This was Thomas Bowdler's argument, and while it is true in a nominalistic sense, it is not true pragmatically since Bowdler's text will provide a counterpoint that will affect our reading of other Shakespearean texts. We cannot, that is, go back to a stage of pre-Bowdlerian innocence and will as a result of Bowdler read Shakespeare conscious of the fact that he is presumably immoral as much as Bowdler is presumably immodest.

What is especially intriguing is what discontinuous transience tells us about those who rise up and assert themselves as agents of change. We tend to see this as a privileged position: editors prefigure the possible range of our textual encounters; conservators and restorers determine what degree of the past shall remain in the present; curators decide for us the sequences by which artworks are exhibited, and these sequences, in turn,

affect how we read works as individual texts, and how we read them collectively as history. Traditionally, then, the position is one of power and authority, and when this authority is challenged, we see more than just a challenge but an operation by which subversive access is granted to the authority. It is not simply a matter of saying anyone is or can be a cultural critic; it is instead a matter of observing who and in what ways people actually assert themselves on the texts of others, and why they do so. In the autumn of 1991, a man who was described in the *New York Times* as "a crazed Sicilian" walked into the Accademia delle Belle Arti in Florence and, with a hammer clenched in his fist, whalloped Michelangelo's *David* on the left foot. He was not protesting high taxes, discriminatory govern- ment practices, or bad Piedmontese wine. Instead, he is quoted as having said, "I envy Michelangelo for what he managed to make."[45] In the same sense that a criminal investigation seeks to identify the motive for a given crime, the act of textual violence frequently originates with a premeditated intention that does not explicitly foresee the specific material result of the act itself. That is why it does not matter too much whether the Sicilian hit *David*'s big toe or second toe or little toe (he got the second); what matters more, at least for our present purpose, is how his intention preempts the consequences of the act by posing the burden of the past as the violence of the present. Envy certainly was not a reason why a certain United States senator *not* described by the *New York Times* as "crazed" initiated attacks on the work of Robert Mapplethorpe and Andres Serrano, thereby instituting a new conception of art's social power: the burden of the present.

In the end *David* got a patched toe and a glass screen to protect him from what Florence's superintendent of fine arts describes as five thousand visit- ors a year with "psychological problems" who could do damage.[46] What the screen does, however, is incorporate the violence of the past into the text of the present. The quarrier's Band-Aid on *David*'s second toe is hardly as forceful a memorial as the glass screen, for it is the screen that simultane- ously distances us from the text and affects our reading of it. Increasingly we live in an age of enclosure, in the age of the vitrine: it is not just megaicons like Leonardo's *Mona Lisa* and Botticelli's *Venus* that get the protection of bulletproof glass, but even the work of artists like Francis Bacon, who regularly desired that his paintings be "in a frame and under glass."[47] The effect is a little different, though. For Bacon the glass does not so much distance the viewer as literally reflect (and hence engage) the viewer's own image in the work. It is perhaps a slightly sadistic attitude, but it is neither unusual nor inappropriate for an artist who reveled in psychological ten-

sions of the most extreme kind. If the glass in front of Michelangelo's *David* reflects the crowds before it, it too will provide a reflection both of its time and its reason for being there. It won't necessarily be a futile gesture either. When a car bomb exploded in the spring of 1993 and heavily damaged parts of the Uffizi in Florence, the Caravaggios escaped damage because plexiglass panes over the paintings protected the canvas from the flying glass of blown-out windows. Unprotected paintings fared less well: Rubens's *Henry IV at the Battle of Ivy* suffered a two-foot-long gash.

What we learn from the Sicilian's encounter with *David* is that artworks that are subject to changes instituted by violence often assimilate that violence, whether or not they can be restored. "Restoration" is actually a euphemism to define the act of repair. As the conservator Philip Ward observed, "Damage is irreversible; it can be concealed, broken parts can be repaired, and weak parts can be strengthened, but at best the object will only *appear* to be as it was."[48] Once a work has assimilated an act of violence or damage, the work is thereafter read through the violence, even if it was initially accidental. When the Turks used the Parthenon as an ammunition and powder magazine, and a stray spark reputedly turned Greece's greatest architectural edifice into Greece's greatest architectural ruin, it simply initiated what natural disasters often initiate: looting. In his journals and diaries, the painter Benjamin Robert Haydon commented on how English visitors to the Continent in the early nineteenth century had a predilection for mementos: a bit of a pyramid, a bit of a breakwater, a bit of the brandy that preserved Byron's body when it was shipped back to England from Greece—"their natural love of little bits," as he called it.[49] But it was Lord Elgin who showed the world how far the English passion for big bits could go. After the Parthenon was shattered and the Turks showed their resourcefulness by grinding up parts of it for lime, Elgin collected from the ruins a few hundred thousand–odd pounds of metopes and pediment sculptures and hauled them back to England. Whether for good or ill—the removal of the sculptures was probably a bit of both—the Parthenon must now be read through this accretion of history, and the ongoing tension of still-competing authority: Greece wants the marbles returned, and British authorities, fearful that the precedence established by their return would result in the redistribution of already redistributed artworks, aren't eager to comply.

What sometimes happens after an act of violence reconfigures an artwork and the violence is assimilated is to freeze or otherwise memorialize that violence. In the front courtyard of the Cleveland Museum of Art can be found a

text of Rodin's *Thinker,* one of a series of eleven produced by the Alexis Rudier foundry in Paris and cast in 1916. It doesn't look like other casts from the series, though. On the night of March 24–25, 1970, a carefully placed pipe bomb containing the equivalent of three sticks of dynamite exploded beneath the Cleveland copy, blowing off the *Thinker's* feet and sending fragments flying five hundred feet away.[50] The initial response of museum officials was to repair the sculpture by returning it to the Musée Rodin in Paris and, if necessary, to recast the entire piece. But in an unusual appraisal of the event, Cleveland Museum president Sherman Lee took up a suggestion posed by a newspaper editorial and returned the damaged sculpture to public display, describing it as "a symbol of something wrong in our society today, violence and destruction without a purpose."[51] The intention here is balanced by an acknowledgment that the damage was beyond conventional notions of restoration, and the most prudent action involved consoli-

Fig. 6. Rodin, *The Thinker:* Photograph taken shortly after the sculpture was bombed on March 25, 1970. Photograph by C. P. Moore. Courtesy the Cleveland Museum of Art.

dating the damage by trimming the splayed edges and remounting the work. Consolidation essentially involves the stabilization of a transient condition—usually continuous, but in this case discontinuous. Today the cast of the *Thinker* outside the Cleveland Museum is not just Rodin's *Thinker*, but a text reinscribed by American social and political history. Despite the bombing's having happened at the peak of the Vietnam War, no party or individuals subsequently claimed responsibility for the incident. The abstract act of thinking is no longer abstract, but concretely realized by a war whose history and whose memory still haunt us. In a larger context of the work's history this is compelling. Originally the *Thinker* was a twenty-seven-inch-high figure located centrally on the tympanum of Rodin's chaotically imposing *Gates of Hell*. Later, the figure was enlarged to seventy-two inches, and from this enlargement new casts were made, and a new name was given. Reinscribed again by the act of bombing, the already reinscribed text thereby acknowedged the inevitability of its own impermanence and how each text would become, as it were, a pretext for a new one. No longer just an artwork, the Cleveland *Thinker* is also the trace of a certain event in which the event is foregrounded. Memorials, even the Vietnam Veterans' Memorial in Washington, D.C., do not quite do this because they function as emblems of the event rather than as both the event itself and its trace.

A more recent example of how art memorializes violence against itself is David Hammons's large blond and blue-eyed metal cutout of Jesse Jackson entitled *How Ya Like Me Now?*[52] An African-American, Hammons explained in an interview that the work tests our predilection for stereotyping by asking how far Jesse Jackson would get politically if he were white instead of black.[53] Initially the work was a wall drawing done in chalk at the Jamaica Arts Center in New York in 1987, and in 1988 it reappeared (with changes in its composition) in an exhibition entitled *Art as a Verb* at the Maryland Institute College of Art in Baltimore. In both exhibitions the work was titled *How You Like Me Now?* A year later, tellingly retitled *How Ya Like Me Now?* a billboard-sized cutout was installed outdoors as part of a project sponsored by the Washington Project for the Arts. It didn't last long though. Roughly fifteen minutes after the installation was completed, a group of angry African-American passersby, yelling that the image was racist, picked up the sledgehammers used to install the work and quickly deinstalled it. Hammons wasn't around when the incident occurred (he was over three thousand miles away in Italy), so he had no opportunity to explain to the itinerant critics that the work, rather than being racist, was *about* racism. This, however, was significant in its insignificance because the work conflated intention and its immediate presence into a volatile

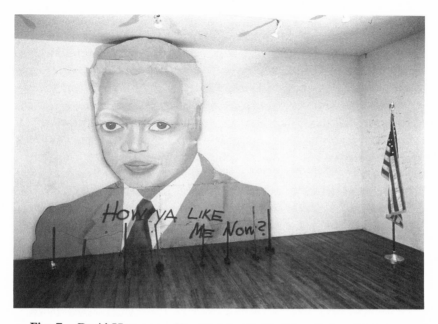

Fig. 7. David Hammons, *How Ya Like Me Now?* Installation, PS 1, New York, 1990. Courtesy Jack Tilton Gallery, New York.

combination: situated beside a bus stop on a vacant lot in downtown Washington, the piece called attention to itself by additional virtue of the fact that a white image of Jesse Jackson was being installed by a contingent of white workers. In other words: a public site was being reinscribed by both race and an institution, thereby removing it from the public's ownership. In Washington, D.C., the property of the public is the property of those who have so little that is private. Washington, it must be remembered, is not even a state: it is, at best, a colony whose citizens pay federal taxes but have no vote in Congress. In this sense it is a city deservedly hypersensitive about its territorial spaces and how they are treated by colonizers, whether those colonizers are political or institutional. The vandals in fact made inquiries about the purpose of the piece, engaged in a brief discussion about it with WPA employees at the site, and finally yelled that because the workers were white they had no right to be doing what they were doing. It was less the work itself than the process of installing it that reterritorialized its racial geometry, thereby metonymizing—albeit unexpectedly—some of the very issues it sought to instantiate. A year later in the autumn of 1990 when Hammons had a retrospective exhibition at PS1 in New York, *How Ya Like Me Now?* reappeared as an indoor installa-

tion, but with changes that incorporated and amplified the vandalism that occurred in the District of Columbia: the sledgehammer dents on the work were left unrepaired, and in front of it, mocking the conventional museum's protective barrier of chrome posts and velvet rope, was a barrier constructed of eight sledgehammers (as posts) and bailing wire. By incorporating the violence of a public-art installation in a way that parodies the overly protected status of private indoor installations, Hammons was able to communicate one of the reasons why public art is subject to increasing violence: its accessibility. Additionally, it substitutes for an act of violence against people by involving representations of people, representations of class, and representations of race. At its most heightened gesture, violence against art is seen as being more tragic than violence against people. When the Uffizi was bombed in the spring of 1993, five people were killed; but it took six paragraphs before the *New York Times* conceded this fact. Even more telling about the *Times* article was a framed list titled "Uffizi Artworks Damaged or Destroyed," which was printed according to the same format in which the *Times* lists the names of people killed in natural or unnatural disasters such as plane crashes.[54] The various ways in which cultural iconoclasm manifests itself—vandalism, mutilation, and (to an extent) theft—are thus important not only for their social and psychological impetus and motives, but for the ways in which iconoclasm ultimately prefigures institutional frames: the work of art is evaluated by museological personnel in terms of its vulnerability, and it is in terms of this vulnerability that conditions of access are granted. Guards are positioned nearby, photo flashes are prohibited, vitrines are engaged, and in some cases scholarship is directly affected, as when works are considered too fragile to be moved or photographed. When this happens the art space recontextualizes the work as, say, the change in a bibliographic context (periodical to book, quarto to duodecimo) alters the textual space of the work. While changes like these are primarily discontinuous, their discontinuity is itself impermanent: change guarantees change. Works of art will continue to be subject to new intentions, conflicting intentions, and unintentional changes, and all of this activity is something that reinforces cultural dynamism by taking us closer, not to the symbols of culture, but culture itself.

The Force of Familiarity

When the trustees for the Guggenheim Museum in New York proposed to expand Frank Lloyd Wright's magnificent spiral museum by building

...oved to safety, some of on iron supports as if in a a room on the eastern lery, which escaped seri-The reason for the move, the museum's director, Tofani-Petrioli, was sim-losion had blown in the e them, exposing them to idity that might gnaw at or to unseasonal rain.

s Shields Helped

apparent during a brief reporters was that the lass shields installed to paintings from vandals ial additions that some aid detracted from their d also prevented flying arring them.

escaped. In the Rubens canvas of the "Battle of :wo-foot gash. In the Nio-culpture, a statue of Nio-:clining position had been the knees.

:cording to a list of dam-/ the Uffizi today, three paintings — two Manfre-n Honthorst — were de-iat remained of them was nvas stripped of pigment ames. Thirty other works some by Rubens, though Dyck as initially reported damaged but would be . Tofani-Petrioli said.

ie called a miracle, the eless collection of Cara-nscathed, while its world-ticellis — in the east wing ross the gallery's central m the area most affected – were untouched.

s to partially reopen the on as possible," Mrs. To-aid. She hopes to open the hich holds works by the Giotto, Botticelli and oth-16th century.

I the principal obstacle to gallery was the fact that :case — situated in the west wing — had been ed. "If there's no exit, you t have thousands of peo-: and going out the same ector said.

e, the gallery reckoned A neonle a day visited the

Building destroyed
Site of blast
RUBENS ROOM
Damaged paintings
EXIT STAIRCASE
Staircase to VASARI CORRIDOR, where paintings were destroyed
MICHELANGELO ROOM Cracked walls, damaged roof

A workman with a broken window frame near a Roman-age statue, "Discobolo," at the Uffizi Gallery in Florence, Italy. The statue and the window were damaged by a car bomb blast outside the building.

Reuters

Uffizi Artworks Damaged or Destroyed

FLORENCE, May 28 (AP) — Following are the artworks destroyed or damaged by a car bomb out-side the Uffizi Gallery, as listed by the museum:

Paintings Destroyed:
Gerrit van Honthorst: "Birth of Christ."
Bartolomeo Manfredi: "La Buonaventura" (also known as "Card Players") and "Ciclo Vito"
Paintings Damaged:
Sebastiano del Piombo: "Death of Adonis."
Gregorio Pagani: "Piramo and Tisbe."
Rubens: "Henry IV at the Battle of Ivry" and "Portrait of Philippe IV of Spain."
Claude Lorrain: "Port With the Villa Medici."
Bernini: "Head of an Angel."
Cristofano dell'Altissimo: "Portrait of Giovanni Della Casa."
Van Honthorst: "Adoration of Child" and "Sup-per with the Lute Players."
Manfredi: "Tribute to Caesar" and "Dispute with the Doctors."

F. Rustici: "Death of Lucrezia."
Artemisia Gentileschi: "Judith and Holofernes" and "Saint Catherine."
Guido Reni: "David With the Head of Goliath."
Empoli: two still lifes
Rutilio Manetti: "Massinissa and Sofonisba."
G. B. Spinelli: "Parable of the Wedding Gift."
Bernardo Strozzi: "David Celebrated by the Chil-dren" and "David Placates the Wrath of Saul."
Nicolas Regnier: "Scene of a Game."
School of Caravaggio: "Disbelief of Saint Thom-as" and "Liberation of Saint Peter."
Valentin: "Dice Players."
Michel Borgognone: "Battle of Radicofani."
M. Caffi: two paintings titled "Flowers."
Rogier van der Weyden: "Deposition."
Statues Damaged:
Hellenic "Dying Niobe."
Roman "Head of a Young Man."
Copy of Roman-era "The Discus Thrower of Mirone."

the art works, the demonstrators who gathered outside the gallery today seemed to have other things on their

"People might seem calm, but they're anary" said Francesco Di Pie-tro, a protester waving a banner of the

Signoria outside the Uffizi. "This is not crime. It is politics. There is a war between people who want change and

and frighten peop change."

The charge was c protesters, but in Ro again blamed the Ma

"We have hit the parts of the state and is why it has stepped i he said in Parliame edged that many Ital "obscure forces wan peaceful renewal," a would not be the fir Mafia linked up with organizations."

The bombing pro casts that Italy was c the so-called "years o 1970's and early 1980 claimed scores of liv cres and bombs are c Eugenio Scalfari, ed daily La Repubblica. said a banner headlir newspaper La Nazior Some Florentines selves that the bomb man tragedy too.

"It is true: this is a said a Florentine jou patrimony, which all with affection and i been damaged and o also true that today

ghters were killed in that

a great tragedy involving firefighting crews this s ever produced," said In-:etary Bruce Babbitt, who the scene early this morn-almost never happens, and is these guys can handle anything. But going after a risk-free."

ed all Interior Department ly their flags at half-staff. i, which have shaken the are still fighting the fire, nore baffling because they e most elite firefighters.

all been trained enough like this are not supposed " said Hawk Hawkins, a rvice Smokejumper who mber of his friends in 's fire. "We always know scape — you look for the eas. The saying is: 'One black. Always keep one black.'"

: from people who sur-ate that those who died did seeking escape routes rts of the forest that had urned.

ce for Their Lives

id it was an uphill race, a ir lives, and it was all over i five minutes," said Gov. r, who arrived here on night.

started here on July 4, a dry lightning strike. For onth, this arid part of the ntains has been extremely :arlier in the week, 80-Is helped fuel fires else-re the temperatures had ll above 100 degrees. As of there were 34 different ing 150,000 acres burning the West, according to the e Agency in Boise, Idaho. st 24 hours, the fire in prings got little attention . But on Tuesday, the fire e edge of this resort 60 miles west of Aspen. oint, Federal officials de-eople, then added 21 fire-Wednesday. But it was

AREA OF DETAIL
UTAH
COLORADO
KAN.
ARIZ.
NEW MEXICO
OKLA.
TEXAS
0 Miles 100

The New York Times

Firefighters trying to protect Glenwood Springs, Colo., were killed by a fast-moving blaze.

Firefighters Dead or Missing

Special to The New York Times

Following are the 14 fire-fighters for the United States Forest Service who are dead or missing after a fire near Glen-wood Springs, Colo.:

BECK, Kathi, Eugene, Ore.
BICKETT, Tami, Powell Butte, Ore.
BLECHA, Scott, Clatskanie, Ore.
BRINKLEY, Levi, Burns, Ore.
BROWNING, Robert, Grand Junction, Colo.
DUNBAR, Doug, Redmond, Ore.
HOLTBY, Bonnie, Prineville, Ore.
JOHNSON, Rob, Redmond, Ore.
HAGEN, Terri, Prineville, Ore.
KELSO, John, Prineville, Ore.
MACKEY, Don, 34, Hamilton, Mont.
ROTH, Roger, 30, McCall, Ida-ho.
THRASH, James, 44, McCall, Idaho.
TYLER, Richard, Grand Junc-tion, Colo.

commander of the firefighting effort here.

"It sounded like the crews were on

crews looked for escape routes.

"At the time of the blowup, it was still a relatively safe fire," said Mr. Lee. Helicopters tried to drop fire retardant on some firefighters who had hunkered down on the ground, but the wind and force of the fire-storm made it ineffective, officials said.

In one instance, a firefighter pulled a woman from the ground where she was hiding in a hole, forcing her to get up and keep running. That saved her life, said Mike Mottice, the Bureau of Land Management director in this part of the state.

One survivor, Brad Haugh of Gyp-sum, Colo., said he had simply outrun the fire. "It crested the hill and head-ed down the other side," Mr. Haugh told a Denver television station. "It doesn't travel downhill as fast as it does uphill, so I was able to get out of there."

Mr. Lee said the explosive winds had come out of nowhere and had not been in the forecast. But other fire-fighters scoffed at that, saying that whenever a cold front moves through an area that has been hot and still, it is almost always accompanied by high winds.

One of the lessons of the Mann Gulch blaze, which Norman Maclean wrote about in his book, "Young Men And Fire," published posthumously in 1992, was that firefighters should not be dropped into steep slopes when winds are high and unpredictable.

Mr. Maclean also made the point that the firefighters who seemed the most invulnerable to accident can have their lives snuffed out in a minute by a fire that essentially blows up. He wrote about the effect of canyon winds on fires and how the winds can produce a firestorm that seems eerily similar to the fire here.

The blowup happened between 4 and 6 P.M. Rescue crews arrived on the scene shortly thereafter. The fire, covering more than 2,000 acres by then, was threatening homes in the fringes of Glenwood Springs. More than 100 people were evacuated, but most of them have since returned to their homes.

By this afternoon, fires were only smoldering in the mountains above the town, although a few fresh blazes

worst and most unpredictable way.

The disaster was the latest blow for this community, which has had a se-ries of tragedies in the last 15 years. In 1985 a natural gas explosion killed 12 people. Four years earlier, 15 peo-ple died in a mine explosion.

"It's a great thing that these fire-fighters tried to help us," said Nor-man Gould, a Glenwood Springs resi-dent for the last 20 years. "But when you lose a life or a number of lives, a spirit goes and that just drains you."

Decades Later, Echo of

By RICHARD PÉREZ-PEÑA

It is as if the same units that stormed Anzio or Gallipoli did so once more with a new generation of soldiers, just as powerless as those who fell the first time to escape the slaughter .

The date July 6, 1994, will from now on be paired with Aug. 5, 1949. The fire that killed at least 12 fire-fighters outside Glenwood Springs, Colo., on Wednesday bore a ghoul-ish resemblance to a fire 45 years earlier in Mann Gulch, Mont., that killed 13 and indelibly altered the way forest fires are fought.

Many of the elements were the same, two generations removed: the steep slopes of the Rockies, a deceptively small and tame fire whipped into a holocaust by tricky winds, and the Smokejumpers, the elite parachute-jumping firefight-ers of the Forest Service.

In 1949, the Smokejumpers were a novelty, an 8-year-old unit that was considered more than a bit crazy by more traditional firefight-ers. The men were chosen in part for their youth because parachute jumping was rough business. Seven of the 13 who died were college students. One of the three survi-vors was 17.

On the hill where they died "are white scattered markers where the bodies were found, a special cluster of them just short of the ton where

red terror closed in wrote Norman Macle about the Mann Gulc Men and Fire" (The Chicago Press, 1992)

"The bodies were were young and thoug cible by others and They were the faste had in getting to wh danger, they got ther the magic realm be and earth, and when they almost made a .

Started by Lig

On one of the ho memory, they start Gulch, headed for a li ed fire that had cons acres. The flames wooded face of the rocks and prairie g the other.

As they climbed th grassy side, the fire vide, igniting the tind and starting a race t win. As in the fire r wood Springs, the fire forced to run uphill to of flame. As in Wed the flames in Mann by gusting winds, bea est firefighters call charging holocaust a backs. "A blowup to

Fig. 8. (Upper) "Uffizi Artworks Damaged or Destroyed." Excerpt repro-duced from the *New York Times*, May 29, 1993.

(Lower) "Firefighters Dead or Missing." Except reproduced from the *New York Times*, July 8, 1994.

an annex, practically everyone in the art world, and plenty of others outside the art world, initially decried the project. When a building or an artwork achieves the status of a cultural icon, its familiarity is to a large degree a part of the work itself, and to defamiliarize the work with changes, even if pragmatic, is unsettling. Eventually the Guggenheim annex was built after several proposals were reproposed and themselves made familiar, but a similar plan for Michael Graves to design an annex for Marcel Breuer's Whitney Museum has yet to come off, partly because the annex is so big—bigger than Breuer's original building—that it swallows up what people know as "The Whitney." The feeling of defensiveness is important because it locates the viewers' conception of the work's intention in the original architectural scheme, and there is a tendency to see this original plan as an underdog in the brutal search to find new space in a city that has nowhere to go but up.

But what happens when the original architectural scheme is no longer extant? What happens when the work is a conflation of differing intentions of differing people at differing times? This is frequently a problem with literary texts, and attempts to unimbricate this imbrication in favor of original intentions (assuming they can be identified, and they usually cannot) are not easily carried out. The same sort of problem in an architectural text is neatly contained in a story about a building rather more modest than either the Guggenheim or the Whitney: Richard and Elizabeth Lear's house at 128 Main Street in East Hampton, New York.[55] The Lear house is not atypical in any conspicuous way. Like most of the houses around it, it was built in a colonial style in the 1790s. Later in the nineteenth century—again like most houses around it—a porch was added. When the Lears bought their house in 1986, they did a few renovations to restore some of the colonial ambience: thirty-six-inch colonial shingles and a colonial front door were added. They also hired a contractor named B-Team Demolition to remove the rotting Victorian porch, which wasn't colonial by any measure. This was simple enough. But a man named Robert Hefner happened to be driving by when the porch was being demolished, and this would otherwise have been insignificant were it not that Mr. Hefner had a degree in preservation and also happened to have the job of policing East Hampton's architecture. A person cannot take a porch down in East Hampton without possessing a "Certificate of Appropriateness." But Mr. Hefner was too late: by the time he got a stop order and returned to the site, the porch was completely dismantled.

While this incident has intrigue on many levels (the Certificate of

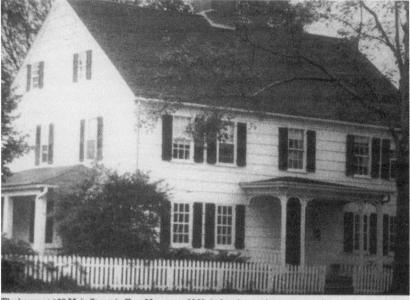

The house at 128 Main Street in East Hampton, N.Y., before its porch was removed.

Fig. 9. Lear House, Easthampton, New York. Photograph and caption reproduced from the *New York Times,* July 20, 1990.

Appropriateness is particularly compelling), the problem I wish to isolate is how the porch consolidates my discussion on continuous and discontinuous change by being a symptom of both: it was a Victorian embellishment (discontinuous change), and it had rotted to the extent that it tilted to the side (continuous change). By attempting to restore the house, the Lears simply oriented their efforts around one temporal aesthetic (the microtemporal), while Mr. Hefner, in seeking to preserve the house, oriented his effort around a conflated temporal aesthetic (the macrotemporal). It is not perceived this way, however, because Mr. Hefner's defense of the Victorian porch is read as a defense of a certain eclecticism, whereby the porch is a signifier for a historically located social activity. (Quoted in the newspaper, Mr. Hefner described the porch as a relic of the "Boardinghouse Era, when residents expanded houses, taking in tourists who would sit on the porches.")[56] The question not asked is whether a stylistic ideology was being imposed over the Lears' house, or whether the house at 128 Main Street had in fact functioned precisely as Mr. Hefner describes. Inasmuch as the argument can be reduced to competing authorities, it pits one time

frame against another, restoring an eighteenth-century colonial house or preserving a Victorian emendation from the nineteenth century. Any "conservation" at this point would involve constructing a facsimile or replica, and thereupon become an emendation to a lost emendation. That the Lears' house is just an ordinary house on Main Street and not the Taj Mahal does not make a difference: the questions here ask us what constitutes authenticity and what constitutes intentions—questions that even textual criticism, with centuries of discussion about these matters, cannot easily answer.

What is most interesting to me is how the Lear house makes manifest the distinction between restoring and preserving—a distinction that applies to eclectic editing's efforts to restore a text's intended state, as opposed to historical editing's efforts to conserve a record of different intentions manifest at different times—including, presumably, those of the editor too. Restoration involves temporal dislocation, whereas preservation tries to consolidate both continuous and discontinuous transience within a living present. Like those reluctant to add to (and hence alter) the Guggenheim and the Whitney, the sense of familiarity has an indistinctly psychological role to play. We think of, say, Tintern Abbey and Stonehenge as examples of cultural history, yet we do not go quite so far as to consider putting a roof on the Abbey or righting the tilted and fallen stones on Salisbury Plain any more than we consider rebuilding the Parthenon, or even reattach the detached metopes. Yet, because our modern concept of cultural history is relatively young (to the extent that it is modern *and* history), we realize that their status as cultural icons is dependent on their presentness as ruins. They may have been canonized as cultural icons at other times for other reasons, but as modern contemporary cultural icons their status *depends* on their being ruins, and so efforts are consequently made to preserve the ruins qua ruins.

This, in fact, partly explains why Leonardo's dark masterpiece of perplexity, *Mona Lisa,* has never been cleaned. To do so would, as Louvre director Pierre Rosenberg observed, "create a national scandal,"[57] or perhaps something even worse that he does not care to admit: his nineteenth-century predecessor at the Louvre, Villot, lost his job when he tried cleaning a number of works, as did Sir Charles Eastlake, who lost *his* job as keeper of the National Gallery in London in 1847 when he committed the same crime.[58] Still, *Mona Lisa* will some day be cleaned (perhaps differentially rather than totally), and that day may not be far off. The untrimmed edges of the painting reveal a bright blue sky that in exposed portions of the work

is muddy green. This muddy Mona is the *Mona Lisa* we know, the familiar text. It is memory, not of the past, but of the present *as* the past that defines this familiarity. The past, not surprisingly, is romanticism's own, a romanticism defined by what the early-nineteenth-century collector Sir George Beaumont called a love for brown paintings, and what Delacroix (of all people) called "that good black, that happy, that rather dirty quality."[59] Rosenberg's decision not to go forward with either restoration or invasive conservation (and instead opt to carefully monitor the work and engage in preventative conservation) is what could be described as an extratextual editorial policy whereby the policy is decided primarily by the current social reception of the work rather than anything inherently good or bad about the text's physical state. Writers are not afraid to rewrite Shakespeare in comic books, and directors are not afraid to remake his plots for the stage, but one reason they can do this—aside from formalist distinction about iterability that holds there will always be unremade texts to preserve the Shakespearean standard—is because we *expect* it of them. We do not hold a notion of a single *Hamlet,* and so find it engaging to see how *Hamlet* can be reworked, whether it is being reworked by the Royal Shakespeare Company or by a group of elementary school children. But we do not expect *Mona Lisa* to be reworked in the same sense, in large part because we know (as Rosenberg acutely knows) that, after cleaning the oxidized varnishes, we cannot go back to the muddy green of our current present. Restoration is less about the recovery of history than it is about the production of history. The argument is at once rational and irrational since cleaning *Mona Lisa* would not really take us backward; instead, when a work is restored, we go ahead to an *image* of going back—what is essentially a temporal illusion. In relation to art and architecture, the processes of cleaning, restoring, conserving, and preserving collectively comprise an abstract ideology about textual transience. Just as literary editing enjoins a number of different methodologies for different works of different epochs and genres, art editing is similarly text specific. This is one reason *Mona Lisa* hasn't been touched, while Michelangelo's Sistine Chapel and Leonardo's *Last Supper* have both undergone extensive (but differing) treatments, all of which have instigated controversy. The art historian James Beck severely criticized the restoration of the Sistine Chapel, a fifteen-year project that was completed in 1994, on the grounds that Michelangelo's frescoes were a combination of both *buon fresco* (in which pigment is applied to the wet plaster) and *a secco* (in which additional pigment, sometimes in a tempera or glue base, was applied after the *buon fresco* had set); the cleaning, Beck

claimed, erased much of the *secco* work (embellishments that included shadows), thereby effacing a significant part of Michelangelo's text.[60] Even worse, Beck claimed, the harsh cleaning had removed the subtle *secco* overtones and exposed excessively bright colors by way of a process that constituted a form of "chemical deceit."[61] Showing that Michelangelo's contemporaries had never considered him a colorist, Beck argued that the colors being recovered had never been exposed in the first place. There was, of course, "grime" covering much of the fresco, but the degree to which grime was a pejorative condition among contemporaries is questionable, since the production of candle soot was expected under normal viewing conditions. By categorizing various kinds of darkening agents (soot, glues, organic salts, and *secco* overpainting) under the rubric of grime, the proponents of radical cleaning (such as Beck's chief antagonist, Kathleen Weil-Garris Brandt) conflate the complex nature of the work's evident and presumed aberrations.[62] Even when the grime is in fact grime, sometimes in the form of dust or soot bonded to the surface, the very idea of bonding becomes elemental to the work, the bonding being, as it were, chemical, temporal, and aesthetic. As Mostafavi and Leatherbarrow argue in their brief study on architectural transience, *On Weathering,* the entropy caused by weathering tends to construct a finish that is not inherently good or bad, and sometimes it is both good and bad with respect to aesthetic and structural considerations.[63] Weathering decenters our way of looking and evaluating something in terms of both its historical and contemporary functions. The ways in which this weathering occurs are, it should be noted, a product of complex environmental conditions that are themselves continuously in a state of change, whether these conditions are responsible for exterior weathering or interior weathering. The Sistine Chapel, it might be said, has undergone this sort of interior weathering, for it has been affected by the evolving conditions of its interior environment: light, moisture, heat, and human traffic have all contributed to this. The problem, then, involves deciding the extent to which diachronic accretions should be removed or not removed, and the extent to which authorial intentions should constitute a rationale for conservation treatment. These are not new questions in editorial theory; but they are, to a large degree, new in conservation theory. Brandt's implication that restorations of the Sistine Chapel are intended to 'recreate,' 'excavate,' 'recuperate,' and 'restore' Michelangelo's version of the text is troubling in that it presumes all of these things without clearly demonstrating what Michelangelo's version was.[64] This is rather like trying to edit a text according to the author's intentions without knowing what

those intentions explicitly were. Even if we did know that Michelangelo intended to use bright pigments to compensate for the viewing distance (the vaulted ceiling is almost seventy feet above the floor) and limited illumination provided by (primarily) candlelight, this intention would need to be counterbalanced by that of evolving lighting conditions; artificial lights, particularly the white light of halogen lights, create a very different context for the work today. This is not bad, but it is important because the continuous realignment of constituent elements of the chapel as an installation holds in abeyance the possibility of a resolution. The very idea of the artist's intentions being a locus of conservation efforts cannot substantiate itself among the conflation of different intentions of different participating authorities at different times. Artists, like authors, are subject to the vicissitudes of the social enactment of their work—something that involves negotiations with subversive and competing authorities. The frequent defense of the artist's intentions by art historians and restorers has a familiar sense of déjà vu about it: it marks the absence of art history's own conception of literature's intentional fallacy.[65] It marks, at the same time, the presence of a rhetorical voice of authority that functions not so much to verify an intention as to engage a presumed or hypothetical intention as a counterpoint. Even Beck's argument, while compelling, only reluctantly and pessimistically acknowledges the psychological need of restoration's parascientificism; how, as a part of the great scheme of cultural transience, restoration itself engages discoveries that verify its own sense of progress, just as editorial revisions to Hans Walter Gabler's edition of *Ulysses* established sufficient precedent for a new copyright. Like editing, restoration draws attention to the act itself, an act that cannot escape its own discontinuous eventhood, its own ideological present. Since editing is a socially historicized activity—we edit texts knowing that our editions will be edited in the future by someone else's ideology—it is clear that texts of art and architecture are historicized in a similar manner. Thus when we look at *Tilted Arc,* the Sistine Chapel, or the Lear house, we can no longer look at them as mere objects, and we know that to do so is to remove them as objects from the transience that defines textualterity, on the one hand, and the cultural condition, on the other.

Chapter Three

The Textual Event

Déjà Vu: The Textual-Critical Tradition

One of the more compelling paradoxes about works of literature and art is their simultaneous ability to be objects and events—to be, as it were, both present and absent. As objects they are forever present in their timelessness, and as events they are forever absent in the timeliness, text displacing text in their inexorable transience. One reason that we tend to overlook change and discontinuity in art is because of the conventionalized terms with which we describe it. The phrase *work of art* is a genitive construction that may be paraphrased in different ways, most of which suggest an aesthetic object. But if the object is, as we saw, unstable in its objecthood, and if this instability threatens art's status as a timeless icon (or literature's status as a verbal icon), what practical or even impractical recourse do we have in describing this phenomenon?

One possible approach to this problem is to acknowledge the general indeterminacy of cultural signs by describing them as texts. Unlike post-structuralism's emphasis on indeterminate signifieds, however, our concern is with indeterminate signifiers, with texts that are a priori unstable whether they are verbal or visual texts. The approach, however, has problems. One of the most used, abused, powerful, and consequently overdetermined words in our critical vocabulary is the word *text*. As a critical term it is enormously convenient and conceptually versatile and can present itself as a physical model: the text as a text(ile), the text as contexture, the text as a word or the world. In almost every instance of use, whether it is merely a substitute for the word *book*, a representation of written discourse, or a euphemism for the metalevel imbrication of language and culture, the word *text* almost without fail sounds right, supplanting a vague uncertainty with a certain vagueness. Yet for all this semantic trammeling, its

89

appeal is precisely in its ability to dislocate itself from a condition of fixedness, thereby metonymizing that which it represents.

Textual criticism has historically worked in the opposite direction—that is, *toward* fixedness. This is almost a little ironic, because it is textual critics rather than poststructuralists who initiated research into the instabilities of literary texts. But the *kinds* of instabilities each respective school of thought studies are incongruent: deconstruction has taught us about the author's (and reader's) instabilities and discontinuities vis-à-vis language; textual criticism has taught us about the instabilities and discontinuities of texts themselves. There is an immense difference here. Traditionally, textual studies has involved stabilizing a work of literature as an ordered set of texts. This is both useful and understandable, perhaps because our institutionalized critical industry has instituted its own kind of ordering of literature in various sets and subsets that are variously classified by genre, period, author, and so on. Order, in short, seems to make things easier: it allows us to move beyond the act of ordering to other issues that build upon the distinctions we make. This is both tempting and beguiling, since it promises a certain good: it promises to deliver us from the chaos of reality and answer our desire for such deliverance.

The ordered and organized literary signifier has thus been the desideratum of textual criticism and bibliography, but actual textual practices have not always acknowledged the implications of semiotic "order"—an order that threatens to deceive us and return to disorder. Such order is substantiated by the presence of a physical text, which in turn is a reflection of the Anglo-American textual tradition of seeing the text as a physical object, as a book, a manuscript, a holograph, a galley proof.[1] This is partly because bibliography is acknowledged as the study of books as physical objects, but it is also—more importantly—because such texts are what Jerome McGann calls "determinate" representations of a work's overall instability; they provide us with specific, concrete, historical, and institutional evidence that in turn guides us toward understanding that instability.[2] There is a tendency here not toward the humanistic and *psychical,* but toward the *physicalis* of objectivity. McGann's point is also suggested by Peter Shillingsburg when he emphasizes that "a text is contained and stabilized by the physical form [of a document]."[3] But it is even more emphatically stressed by William Proctor Williams and Craig S. Abbott, who explain in their *Introduction to Bibliographical and Textual Studies* that "the basic commodity for a literary scholar is the text, which is physically embodied in letters written, impressed, or transferred onto a surface."[4] This emphasis

on objects, commodities even, like soybeans and pork bellies, is not un-usual, particularly if we consider the etymological force of the word *litera-ture* as *littera*, a letter. In another sense, however, if the business of texts and the business of literature is defined by that which gets written and printed, we are also saying—by default—that oral literature (which in some respects is a contradiction in terms) is not literature, nor can it be literature until it has written texts. Even postmodern oral poetry is, as Jerome Rothenberg observed, mediated by print by appearing in print[5] — a fact undoubtedly true for David Antin's "talk poetry" and Allen Gins-berg's tape recorder poems. This may seem a priggish matter, but it is also a serious matter in cultures with linguistic systems that do not get written down—American Sign Language poetry or Native American literature being good examples of what can be lost or disparaged by being different.

The idea of the text as an object is, I would like to suggest, the legacy of the boundaries of the Anglo-American textual tradition. Sir Walter Greg and Ronald McKerrow, as well as Fredson Bowers and G. Thomas Tan-selle, were all working within a somewhat narrow range of literature—Anglo-American works written between (roughly) 1560 and 1960—and this exposed them to a certain set of writing and publishing conventions. Within this set of conventions they produced an admirable program of admirable approaches to the vicissitudes of textual transmission. Just as Saussure changed linguistic theory by emphasizing the synchronic study of language, the early textual scholars emphasized the synchronic activity of book production, which in turn made diachronic and typological studies more viable. In essence, textual criticism is a metachronic activity, both in time and out of time; its activity retrospective, and, in many ways, canoni-cal. We do not, for example, have a postmodern textual theory to deal with postmodern texts and genres—sound poetry, video poetry, and perfor-mance art, to cite a few—simply because textual criticisim is for the most part dependent on an institutional view of canonical authority (usually for practical reasons that are also, unfortunately, economic reasons: it's easier to get a grant to edit Hawthorne than it is to get a grant to edit Johnny Rotten). The idea of the text as an object is thus bound to the idea of the text as a *literary* object, and only insofar as textual theories consider texts outside canonical traditions will we arrive at a less medium-governed idea of textuality.

Such interdisciplinarity might be expanded even beyond the socioeco-nomic conception of text production that characterizes Jerome McGann's work. For McGann a poem is not itself an object, but "a unique order of

unique appearances," a network of human actions and human forces that can best be characterized as a historical event.[6] Like that of his spiritual mentor, Mikhail Bakhtin, McGann's work calls for a closer look at the human element in poetry, the manner in which poetry (and literature in general) is shaped by the human condition, and the extent to which literature is a part of larger, socioeconomic systems. What I have to say in this chapter might be regarded as an attempt to take this notion further by considering how human languages, and the modalities of those languages (written? spoken? signed?), affect textual structures in the domain of the creative arts—poetry, painting, or performance, to name but a few.

When we theorize about textuality in this broader sense, we begin to realize that although texts manifest themselves as objects, they are also more than objects, and particularly more than literary objects; they are also (to take one position) signifiers, in which case we are confronted with additional questions that are less germane to textual criticism and bibliography than to semiotics and philosophy: what are the semiotic boundaries of a text? How is a text of a poem different from—or like—a text of a painting? Traditionally, semiotics has been understood as a kind of mediating discourse on the relationship between language and art—it informs many of the interartistic comparisons in Wendy Steiner's *Colors of Rhetoric* for example—but in our case the arguments and answers offered by semiotics, or the more nominalistic philosophy of Nelson Goodman, leads us toward further questions that are not only germane to texts, but to the very idea of literature as literature, or art as art.

Inasmuch as the previous chapter was monologic in its exposition of examples of textual transience, this chapter is dialogic in its engagement in a theoretical exchange about the implications of those examples and the problems involved in categorizing them. Were this a dinner party instead of a book chapter, one would find sitting around the table Fredson Bowers, Jerome McGann, Jacques Derrida, Nelson Goodman, Peggy Phelan, and Arthur Danto—a fairly eclectic gathering. At times it may seem that I am unduly harsh in my criticism of textual studies (as a critical school), and at times I am. It is not that I disparage the achievements of the Anglo-American textual tradition; rather, I lament what seems to me the ideological closure of that tradition—a closure that is based on the consequence of decades of editing institutionally qualified, canonized works of literature. The questions I bring up are intentionally provocative; for years textual critics lamented that readers of literature take their texts for granted, and

my position now is that those same textual critics might perhaps be taking their conception of textuality for granted.

Iterability

In textual studies, the notion of iterability (*iterare*, to repeat; *iterum*, again) is present at levels that include the iterative function of language and the implied iterability of texts. We might think of repeatability as being a universal quality in textual studies, where efforts are made to produce or reproduce a particular text that lends itself toward a kind of scholarly utilitarianism. Even our critical discourse includes the terms *reprint* and *reissue*, although neither can be taken literally: reprints do not always reprint, inasmuch as they may include intentional or unintentional intrinsic changes or reflect the extrinsic influence of political and economic conditions. A reprint, one might thus say, is *motivated:* it does not necessarily exist for the same reasons as that of which it is a reprint. What this suggests is that the philosophical foundations that underlie the concept of iterability in textual studies are vulnerable and open to question. Language is iterative to the extent that it is a socially shared code; but are utterances of language, or units of utterances (such as texts) iterative also? In the section that follows I shall investigate (briefly) the iterability of language in literary discourse and what I believe to be the noniterability of texts. The resources for my argument are somewhat diverse, and in this respect they reflect the fact that iterability is a transdisciplinary issue.

The iterability of language is presupposed by being a precondition of language: it is a symbolic system comprising learnable and repeatable symbols. This is a typical feature of many semiotic systems and not in itself surprising. Repeatability allows us to formulate utterances that, as part of a shared social code, are understood within the realm of that code's usage and (if one follows Derrida on the matter) sometimes even beyond the limits of code itself.[7] It is important to remember that language is composed of units that signify in an interactive and (both) linear and nonlinear manner: the phoneme, the morpheme, the word, the phrase, the sentence: these are units that do not necessarily signify exclusively at their own level, but at recombinant levels as well. Hence, we might say that the iterability of these units is essentially paradigmatic; yet it is paradigmatic only in theory, only in an ideal vacuum that is free from the actual conditions of articulation (either spoken or signed) and writing. Derrida's position—a

controversial position—is that, as he says in "Signature Event Context," "A writing that was not structurally legible—iterable—beyond the death of the addressee would not be writing."[8] We can "read' "an utterance beyond the death (i.e., presence) of the addressee, but what are we reading? Or, as Robert Scholes frames the question in a reply to Derrida's postulates: "We would have made a sense *for* the marks, but would we have made sense *of* them?"[9]

What Derrida is suggesting is that although language is conceived as being paradigmatic—like a kind of semantic Lego kit—in actual practice, our utterances (constructions, buildings) are more properly syntagmatic. They may survive the death of the addressee, but in a special way: they become desyntagmatized, lifted from the context of articulation, but do not cease to function. What happens is that the utterance—whether written or otherwise recorded—is recontextualized, or, as Derrida says, "grafted,"[10] and such grafting is omnipresent: language deceives us as to how its iterable presence (written words, marks, inscriptions) do not translate to an iterable intention, or meaning. The original boundary of an utterance—the moment of its inscription—becomes null, but not void. We merely graft it, decontextualize it, and recontextualize it so that the utterance gives way to its new location: it becomes, so to speak, the resident of a particular (and new) discourse community. And so on.

What Derrida doesn't do in "Signature Event Context" is give us a satisfactory definition of "the moment of inscription"; nor, for that matter, does anyone else. Inscription can be taken to mean a moment of writing by the author, the moment of publishing, or the moment of reading—or any point in between. A moment like this defines itself rather loosely and metaphorically as a moment of stasis. Such a moment is not the singular representation of a work of literature (or art even), which is instead more of a series of moments of inscription, some authorial, some not, some authorized, some not—yet all of them are realities to the extent that are scripted, (a)scribed, and, more particularly, read. Moments like these are best characterized not by what they say, but what they do not say: they leave us with a disembodied, decontextualized text that does not mean anything unless bound to an agent of meaning—an interpreter.

Yet in an odd sense Derrida seems to me to be onto something quite germane to the tradition of textual criticism. Historically, textual criticism has tried to qualify moments of inscription according to their relative authority and establish a hierarchy of inscriptions according to authorial intent. It does not (from my point of view) matter whether these efforts

succeed or not; indeed, there's no way to know. Nor does it matter whether the editions produced are judiciously emended texts, facsimile texts, scholarly texts, or condensed texts, for they all constitute further moments of inscription. This is where Derrida's point strikes home: a moment of inscription is no more than a moment of inscription. It may be a significantly reformulated moment, like Bowdler's 1807 edition of Shakespeare (nine other editions by Bowdler would appear by 1850), in which case even Bowdler's moment of inscribing Shakespeare is a moment of presence; in essence, unique, and in its uniqueness, telling. The text's often-cited maligning of Shakespeare is a historical argument about truth values, and such an argument cannot exist except by comparison with other moments of inscription—the textual other. A play by Shakespeare (or by anyone else) cannot claim final authority because it cannot claim to be finished at any point: just as there is no consensus in editorial theory as to what constitutes the final intentions of a work, there is no consensus (as far as I know) in philosophical theory as to what constitutes a finished work of literature.[11] At one point Nelson Goodman asserts in *Languages of Art* that "the composer's work is done when he has written the score,"[12] but the corollary to this statement—"the poet's work is done when he has written the poem"—will not do because a work at this point is unrealized as a social commodity. Even if we take publication as a moment of completion, then we must also consider the fact that further publication, or even withdrawal from publication, controverts this moment. In Colombia in 1992 Gabriel García Marquez withdrew from publication all of his books as a protest against the proliferation of unauthorized reprints and piracies. It could not therefore be claimed that his work was not finished (even finished according to the author's intentions) simply because no authorized texts were in print. Because such aporias are always latent, I am inclined to concur with the general thrust of Jerome McGann's work: instead of viewing literature, or artworks, as finished productions, we might instead view them as works of fluxion that experience stasis or duration in a particular edition or a particular exhibition space. Yet, what is particular about a particular edition or particular exhibition space is ultimately undermined by its instability: it is particular primarily in our conceptualization of it as such, not by virtue of its implied or physical context. For McGann there are no final or finished works, but only final or finished texts; no final work of *Hamlet* or Keats's ode "To Autumn," but final (and particular) texts of *Hamlet* and Keats's ode. These texts redefine Derrida's original moment of inscription as a series of moments of inscription: they

are utterances, writing acts, and by the time they reach us—no matter how generous an editor is in explaining those texts—they have already, in varying degrees, broken free from those moments: they drift. A work of literature thus cannot be stabilized any more than a sculpture or a building can be stabilized: the relocation that threatened (and subsequently re-textualized) *Tilted Arc* and the additions that threaten Marcel Breuer's Whitney Museum are not in this sense any more threatening than the next editor to face *Ulysses* or *Hamlet*. Timelessness is an illusion to the extent that there is no timeless text: *a* text is of *a* time.

The value of Derrida's argument is that it reminds us that although language *(langage)* is iterable, this iterability begins to rupture when applied to utterances *(parole),* even when those utterances are written. We move further and further from the moment of inscription and are attached to that moment by a small thread of words that is at once both the residue of that moment and our bond to it. Textual criticism and editorial theory do not really help us here; scholarly editions imply that texts are not only repeatable but that they can be reconstructed along the lines of authorial intentions, and such reconstruction draws attention to itself as being *about* construction. Scholarly texts are a part of the social institution of professionalized literature (again: a moment of inscription), and these texts serve all kinds of social, economic, and political purposes as much as Galignani's pirated texts ever did. This may seem a harsh thing to say, but I am not trying here to apply value judgments to particular texts, since our culture is a culture of textual democracy. This is one reason *Reader's Digest* can condense *Tom Sawyer* and sell the book in suburban grocery stores with considerable, and perhaps even enviable, success. On November 12, 1991, *Reader's Digest* placed a full-page advertisement in the business section of the *New York Times,* promoting the remarkable success of "the art of *editing* with care and sensitivity": "Global sales of Condensed Books and Today's Best Nonfiction topped 22 million last year—the result of publishing books with local content, in the local language, tailored to local readers all over the world."[13] Of course, if this is cultural democracy it is also cultural imperialism (which is one reason the ad appeared in the business section), but it is precisely this tension and its manifestations (art/money, the United States/the world, unabridged text/condensed text) that underscore the tensions in *all* forms of textuality. If two texts are different, they are essentially equal in their differences because those differences—and the interpretations we bring to bear upon them—are individual in their context: one text cannot be more individual than another.

One possible objection to this is to say that a facsimile edition is one way to repeat a text. My response is that this too will not do, for a facsimile is at best an illusion of iterability: it draws attention to itself as something *factum simile,* as something *much like* an "original," where $X_1 \rightarrow X_2$ but $X_1 \neq X_2$. Similitude is deceptive, but it is not without important cultural meanings. In my introductory discussion about Walter Benjamin's "The Work of Art in the Age of Mechanical Reproduction," I pointed out how Benjamin had overlooked the importance of variation in the process of reproduction, and how variations are not necessarily visually discernable—photographs get reprinted with changes produced by different exposures, papers, and chemical processes, to cite a simple example. Or to cite another: books are sometimes reprinted according to conditions related to their demand, and the demand itself is a product of complex social and economic conditions. The texts themselves rarely explicitly comment on these conditions, but they often retain, in one way or another, traces of them, sometimes in supposedly insignificant bibliographical details like dust jacket design. The notion that mechanical reproduction guarantees standardization is one of the myths of textual reproduction: it suggests uniformity that does not necessarily exist. Reproductive technologies are themselves endlessly diverse, and (because they involve a human element in the control of those technologies) ultimately reflect the vicissitudes of the human condition—precisely the "presence in time and space" that Benjamin felt they lacked.[14] This is the fundamental lesson that bibliography and textual criticism have taught us in relation to printing technologies: that technology itself does not displace the effects of being human. Moreover, technology does not displace the need for different kinds of reproductions—facsimiles, reprints, paperbacks, electronic texts, and so on. Instead, it is technological reproduction that is largely responsible for making these variations possible. When, for example, an effort is made to re-create a specific text or version of a text, and when this effort is made both linguistically and bibliographically, the resulting text does not so much re-create the original version as create a virtual text. A black letter facsimile is such a text, and all texts that attempt to displace their temporality are, by definition, virtual texts. Yet, inasmuch as they embody the technology and intentions of a certain present, they are actual texts as well and may some day and by some means become a subject of another editor's virtual text. One way to imagine this is to think of an antique table for which a replica is made. Eventually the replica *itself* will become an antique that is subject, like its antecedent, to replication.

A more nominalistic approach to literature might suggest otherwise, and Nelson Goodman is one person who might not be swayed by this argument. Goodman is one of our most important philosophers in dealing with interartistic issues, and he has a knack of asking particularly difficult questions that we otherwise might (and often do) take for granted. One of his questions that bears upon our argument goes like this: why is it possible to make a forgery of, say, Rembrandt's *Lucretia,* but not Haydn's *London Symphony* or Gray's "Elegy"? Goodman's response is that certain fundamental differences underlie the notion of a literal, or re-presentative iterability in the arts. He explains:

> Let us speak of a work as *autographic* if and only if the distinction between original and forgery of it is significant; or better, if and only if even the most exact duplication of it thereby does not count as genuine. If a work of art is autographic, we may also call that art autographic. Thus painting is autographic, music nonautographic, or *allographic.*[15]

Like music, literature is described as allographic because it is "amenable to notation."[16] "Notation" in this sense suggests the presence of some kind of semiotic system, whether that system is primarily symbolic (as language), or symbolic and indexical (as music), or symbolic, indexical, and iconic (as dance notation). With the presence of a notation system, each forgery is not a forgery but merely another instance of that work. As Goodman puts it, we need only verify the spelling of a work to produce "an instance" of the work.[17] He emphasizes the business of spelling and punctuation because, I think, he sees the printed or inscribed texts as strictly symbolic representations of oral utterances, and in the process glosses over comparatively complicated forms of literature, particularly uninscribed oral genres.[18]

One response to Goodman would be to offer a clarification of the terms *work* and *text* and use the foundation of such clarification to reorient his argument. At times Goodman uses the two terms interchangeably, thereby conflating the distinction between texts as ideas and texts as enactments. As I discussed earlier, texts can be described along the lines of Derrida's "moment of inscription," and such texts do not always comply with a conception of correctness or finality. It cannot be concluded on this basis that the texts in question, simply by failing to comply with an ideal model of the work, fail to be a text of the work: Bowdler's Shakespeare on the one hand, or a "bad" quarto of *King Lear* on the other. Where for Goodman a

change to the linguistic or paralinguistic elements of a text (spellings, words, titles, and to some extent punctuation) would create a new work, changes to extralinguistic elements (paper, binding, and publisher) would not alter the work. Here, I think, the textual-critical tradition of distinguishing between a work, a version, and a text is a useful turn. The general premise is that literature, and the act of producing literature, is a process in which the literary work is represented by a series of successive texts, each with its own historical, semantic, and aesthetic value. This is quantum textuality: it is about how cultural objects are figures in a system of discursive trajectories. Contrary to my discussion about the distinction between continuous and discontinuous transience in the previous chapter, what is important here is the *fact* of transience, not its quantification. As Jerome McGann explained in his *Critique of Modern Textual Criticism*, textual dynamism can be generically described as "a series of specific acts of production."[19] The work is a series, and the series is comprised not of acts of compliance, but acts of variance. In this sense a literary work—be it a poem, a play, or a letter to Auntie Em—is an assemblage of texts, a polytext of seriated texts and versions.[20] This formulation can be expressed by the equation

$$W \rightarrow T_1, T_2, T_3, \ldots T_N$$

where W = work and T = text. It is important to note that the work is not equivalent to the *sum* of its texts (which would create some kind of hybridized eclectic text), but instead is an ongoing—and infinite—manifestation of textual appearances, *whether those texts are authorized or not*. The conflation of textual making and textual remaking guarantees that the proliferation of culture depends not so much on an author's explicit intentions, but on the tension between those intentions and the subversion of them. It is thus impossible to say that the work of, say, Shakespeare's *Tempest* exists as anything more than a Platonic form or idea; and it is ideal in its implicit acknowledgment of the impossibility of the ideal. It is a concept, but not a concept limit; a class, but not a compliance class, for its boundaries are not prescribed. It is therefore difficult to say where Shakespeare's text ends and the Other's adaption begins, because each new text is in a sense an adaption. Pre-twentieth-century stage texts altered Shakespeare's plots extensively—more so than many contemporary comic books do—yet we do not consider these to be adaptions as long as they work within the genre of stage production. The comic books seem more prob-

lematic and disconcerting because they expropriate Shakespeare for a new medium and genre, and it is the medium and genre that seem to subvert the work more than the linguistic changes that may or may not have occurred. This is important because it reminds us that any description of textual dispersion must consider not just linguistic change, not just bibliographical change, but change to the entire infrastructure of the art form. The Shakespeare that appears in comic books is not implicitly a superficial or derogatory spin-off. Like mid-nineteenth-century mass-produced texts (especially Charles Knight's pictorial edition of Shakespeare), the comic book versions derive from a complex set of relations between illustration technology, literacy, ecomomics, and what seems to be a need to continually test the viability of canonized authors by exposing them to a wide range of genres and bibliographical contexts. These bibliographical contexts can sometimes draw a very fine line in terms of their differences. Peterson's editions of Dickens's works included an "Illustrated Octavo Edition" (cloth, reduced from $2.50 to $2.00), an "Illustrated Duodecimo Edition" (cloth, $1.50 per volume, but each text was two volumes, thus $3.00 per title), a "People's Duodecimo Edition" (cloth, $1.50), a "Green Cloth Edition" ($1.25, or green paper, $1.00), a "Cheap Edition. Buff Paper Cover" (75¢), a "Cheap Edition for the Million" (25¢), and a "New National Edition" (full set, seven volumes, black cloth at $20.00, half calf at $30.00).[21] The 'work' of Shakespeare's *Tempest* is therefore inclusive rather than exclusive: it is defined by accretion. *The Tempest,* that is, is a work, and a copy of the First Folio represents one text of that work, just as a copy of Knight's illustrated edition is another text. Nor is it necessary to exclude performances from this formulation. Where a series of performances is based on a specific text (what Goodman might call a score), and given

$$W \rightarrow T_1, T_2, T_3, \ldots T_N$$

then we might say that

$$T_x \rightarrow P_1, P_2, P_3, \ldots P_N.$$

What is important about such formulas is that they remind us we do not normally conceive a book in terms of itself as a work, but in terms of its texts, or in any case the specific texts with which we have had encounters. We might perhaps speak of a work in terms of its extratextual myth, for works do indeed reach a stage where they are discussed as realities that we

have not experienced in a more literal sense; that is, we speak *about* them, but not *of* them. Yet it seems to me that much of our critical discourse (and our "creative" discourse as well) depends upon our encounters with specific texts.

If then we consider a work as a nontangible idea represented by a sequential series of texts—whether these texts are inscribed or performed, whether they are authorized or not—then we might be able to make more out of Goodman's original question. Is it possible to make a forgery of Gray's "Elegy" or any other work of literature? The question is important because it asks us if the iterability of language is an explanation for (as Goodman sees it) the iterability of texts. Given the above discussion, my response to Goodman is two-tiered: it is not possible to make a forgery of Gray's "Elegy," but it is possible to make a forgery of a particular text of Gray's "Elegy." In this sense literature in the broad sense is an allographic art, but literary texts are more properly autographic in their autonomy.[22]

Suppose, for example, I wanted to forge Keats's "Ode to a Nightingale" and wrote out the poem, with a pencil, on a piece of greenish paper (as I am doing now). In itself the poem I have inscribed does not purport to be any text of the poem other than that which I have written: it is simply another instance of the work, another text among the hundreds or thousands of such texts. In this respect Goodman is right: I cannot forge Keats's "Nightingale" ode.

Suppose, however, I wanted to make a forgery of the fair copy of Keats's poem that is in the Fitzwilliam Museum in Cambridge. Using early-nineteenth-century paper and ink that were found locked in a vault beneath St. James Place, let us suppose that I manage to replicate Keats's admirable scrawl and (we will assume my luck is *really* with me) surreptitiously replace Keats's holograph with my forged transcript. Bingo. Some years later a young D.Phil. candidate at Oxford visits Cambridge and notices one of the *t*s doesn't look quite right, and, after careful palaeographic inspection using infrared photography, earlier photostats, and Robert Gittings's *The Odes of John Keats and Their Earliest Known Manuscripts,* concludes that the MS is a forgery. Troubled Fitzwilliam officials review their records and find that another Keats scholar had consulted the holograph some years back. They send out a legal posse that of course catches me, and, in court, I stammer the truth: "N-N-Nelson Goodman made me do it."

What we learn from this is that the uniqueness of texts passes for Goodman's condition of something that can be forged (he admits in *Languages of Art* that performances can be forged),[23] which more emphatically

says that texts are not iterable. Such a conclusion requires us to maintain our sharp distinction between a work and a text, and this is a distinction that Goodman's otherwise thoughtful analysis overlooks. Even if we grant Goodman this distinction, his argument is caught up in what exactly he means by a "correct copy" of a poem: he would have to impose a standard of correctness, in which case a "deviant" copy—one with, say, a misplaced comma—would not be another instance of that work, but a completely new work.

Another way of looking at the question of iterability is to examine Jorge Luis Borges's story entitled "Pierre Menard, Author of the *Quixote*," which runs like this: A friend of Menard, enumerating his publications and manuscripts, notes the inclusion of the ninth and thirty-eighth chapters of the first part of *Don Quixote,* and a fragment of chapter 22. Not Cervantes's *Quixote* (which was written in the seventeenth century), but Menard's (which was written in the twentieth). Menard, says his friend, "did not want to compose another *Quixote*—which is easy—but *the Quixote itself.* Needless to say, he never contemplated a mechanical transcription of the original; he did not propose to copy it. His admirable intention was to produce a few pages that would coincide—word for word and line for line—with those of Miguel de Cervantes."[24] This indeed is exactly what Menard did, and did successfully. The story proceeds:

> It is a revelation to compare Menard's *Don Quixote* with Cervantes'. The latter, for example, wrote (part one, chapter nine):
>
> > . . . truth, whose mother is history, rival of time, depository of deeds, witness of the past, exemplar and advisor to the present, and the future's counselor.
>
> Written in the seventeenth century, written by the "lay genius" Cervantes, this enumeration is a mere rhetorical praise of history. Menard, on the other hand, writes:
>
> > . . . truth, whose mother is history, rival of time, depository of deeds, witness of the past, exemplar and advisor to the present, and the future's counselor.
>
> History, the *mother* of truth: the idea is astounding. Menard, a contemporary of William James, does not define history as an inquiry into reality but as its origin. Historical truth, for him, is not what has happened; it is what we have judged to have happened. The final phrases—

exemplar and advisor to the present, and the future's counselor—are bra-zenly pragmatic.

The contrast in style is also vivid. The archaic style of Menard—quite foreign, after all—suffers from a certain affectation. Not so that of his forerunner, who handles with ease the current Spanish of his time.[25]

The two *Quixotes* are thus, notwithstanding their identical spelling and punctuation, quite different works—or are they? Pressed to respond to the question by his colleague Richard Wollheim, Goodman is reluctant to concede that two identically spelled inscriptions ought to be considered instances of different works.[26] It is a difficult position: for Goodman to say that they are different works, he would also be saying that two iterable inscriptions are ontologically different—and this is, as he admits, either untenable or an aporia. What is possible here is that the inscription is iterable, but the inscription as an utterance is not. If literature (or in a broad sense human communication) boiled down to mere spellings, we would have to concede agreement with Goodman. But we can't do this because literature is not mere spellings, and Borges's story makes this its central point. The two *Quixotes* are overtly different: Cervantes's is quite at home in its enunciation of the vernacular; Menard's, in contrast, seems strangely archaic. Cervantes's *Quixote* is rhetorically straightforward, while Menard—contemporary of Bertrand Russell and William James—writes with a certain kind of philosophical and pragmatic reserve. Their differ-ences arise not from the moments of our reading (though this may be so), but from the moments of their respective inscriptions, and only later from our investigation of those moments. The works are ontologized—that is to say, contextualized semantically—by the temporal history that sur-rounds their composition. In an excellent discussion of the story, Arthur Danto adds:

It is not just that the books are written at different times by different authors of different nationalities and literary intentions: these facts are not external ones; they serve to characterize the work(s) and of course to individuate them for all their graphic indiscernability. That is to say, the works are in part constituted by their location in the history of literature as well as by their relationships to their authors, and as these are often dismissed by critics who urge us to pay attention to the work itself, Borges' contribution to the ontology of art is stupendous: you

cannot isolate these factors from the work since they penetrate, so to speak, the *essence* of the work.[27]

From the discipline of philosophy, Danto's point of view seems to me informed and right; from the angle of literary criticism he is perhaps more vague, but certainly no less right. The critics whom he implicates for extolling us to pay attention to the work itself are no small lot: they constitute a tradition that began (in its most concerted form) with the Prague structuralists (in Europe) and the New Critics (in America), and gained momentum, as well as an inimical presence, with Euro-American structuralism and poststructuralism. Yet, in urging us (as either literary critics or art critics) to locate the ontological "essence" of a work with that work's history, Danto is implicitly (and I suspect unconsciously) guiding us toward new historicism and the work of one of structuralism's most important antagonists, Mikhail M. Bakhtin.

Bakhtin's name is hardly new to the field of textual criticism; McGann, particularly, has found it purposeful to cite from Bakhtin's work, and behind those citations is a much larger theoretical framework. The insights that Bakhtin adds to textual philosophy are not only germane, but germinal as well: they constitute, in their professedly antiformalist stance, one of our first discussions on the text as a discrete social and historical utterance. One of his essays, fully titled as "The Problem of the Text in Linguistics, Philology, and the Human Sciences: An Experiment in Philosophical Analysis," is particularly useful in that it directly confronts two of the issues that I have been dragging along through this chapter: the iterability of language and the illusion of iterability of texts. Bakhtin writes, "[B]e-hind each text stands a language system. Everything in the text that is repeated and reproduced, everything repeatable and reproducible, every-thing that can be given outside a given text (the given) conforms to this language system. But at the same time each text (as an utterance) is individ-ual, unique, and unrepeatable, and herein lies its entire significance (its plan, the purpose for which it was created). This is the aspect of it that pertains to honesty, truth, goodness, beauty, history."[28] It seems to me that the two profound truths of this statement (that the language of a text can be repeated, but that the text as an utterance cannot) are marred by Bakh-tin's attempt to claim a third truth: that the "entire significance" of a text lies within its uniqueness as a social utterance, as an act of communication. This position is illustrative of Bakhtin's inflexibility toward formalism and structuralism, and the absolutism of his historical hermeneutics is also

manifest in McGann's work (I shall have more to say about this later). This problem is disconcerting, but not in a manner that turns one away from Bakhtin; it instead pulls us closer to the ideological edge on which his ideas move. A bit further into his essay he takes up (unknowingly) a hypothetical position vis-à-vis Nelson Goodman and the two *Quixotes*:

> Two or more sentences can be absolutely identical (when they are superimposed on one another, like two geometrical figures, they coincide); moreover, we must allow that any sentence, even a complex one, in the unlimited speech flow can be repeated an unlimited number of times in completely identical form. But as an utterance (or part of an utterance) no one sentence, even if it has only one word, can ever be repeated: it is always a new utterance (even if it is a quotation). . . . The utterance as a whole is shaped as such by extralinguistic (dialogic) aspects, and it is also related to other utterances. These extralinguistic (and dialogic) aspects also pervade the utterance from within.[29]

Given Cervantes's and Menard's *Quixotes*, Bakhtin would, on the basis of this position, unhesitatingly pronounce them different works, and he would do so for reasons similar to Danto's: they are separate utterances, tied by "dialogic relations" to their historical circumstances, and different in their relation to those circumstances. The emphasis on the extralinguistic nature of these dialogical relations also serves, to an extent, to delimit the range of those relations: Bakhtin seems perfectly willing to grant that that relationship cannot be closed ("A context," he wrote, "is potentially unfinalized; a code must be finalized").[30] Bakhtin's inclination here brings him as close to Derrida and Barthes as he can possibly come. Why? Because the deconstructionist conception of the text as a text(ile) composed of weavings is in its own way dialogic, but not in a manner solely exterior to language: it rather works *in* language, and between language and the world. Derrida's position is that the interweaving *(Verwebung)* of language combines both the discursive and the nondiscursive, both language and "other threads of experience" into a cloth, into a text(ile), that is inextricable and for the most part unweavable.[31] Such a text is related to social history, but it is not related to social history alone: it is related to other texts as well, and their semantic fusing and fraying. A text is thus intertextual, "caught up," as Foucault says, "in a system of references to other books, other texts, other sentences: it is a node within a network."[32] In practice the textile is more controlled (Robert Scholes, for example, points

out a kind of hermeneutic centering in Derrida's writing); but this does not seem to matter much here. Bakhtin's position is one that suggests that the utterance's singularity is protected by the utterance's volatility: we can never go back to that utterance with complete assurance, can never, literally or conceptually, conceive it in totality. Thus we face a nihilistic aporia in proclaiming a text is never complete. Bakhtin seems to lean in this direction when he asserts that "Dialogic boundaries intersect the entire field of living human thought,"[33] and as boundaries go those are pretty big. If the natural boundaries of a text can never be located (as the moment of inscription can never be recalled), by what rule or rubric do we create artificial boundaries for texts in the creative arts?

One answer is that textual boundaries are projections of our social and political identities; that they are in a sense mental conceptualizations of historical spaces. For McGann, for example, there is no such thing as a text without a context, and it is only by a combination of historical evidence and our interpretation of that evidence that this context is circumscribed. In other words, textual boundaries are not the product of reality, but of our reading of representations of reality. In summarizing the work of McGann and Donald McKenzie, John Sutherland has written: "The force of McKenzie's critique, like McGann's, is that it specifically controverts the faith of modern bibliography in the reproducibility of the 'essential' text, if only institutionally approved procedures are followed. There is, for McKenzie and McGann, no ahistorically essential text to reproduce. The task of McKenzie's 'sociology,' as he sees it, is in any case not reproduction but the reinsertion of the text into the critical moments of its historical and political existence."[34] This is a good basic overview of the situation, but I think it can be taken further. I would venture to say that not only can we not reproduce an essential text, but we cannot reproduce *any* text. To be able to reproduce a text would suggest, in Goodman's allographic terms, that a text is composed of an ahistorical, neutral language: it suggests that language alone constitutes a text. And it further suggests that speech events or writing events can be replicated in a manner in which a photographic negative can produce several photographs. But this won't do, either for texts or for photographs as texts, because we would in this case have to say that photographs likewise have no historical contexts, which is obviously false: as for literature, it matters how they are printed, where they are printed, how they are mounted, where they are exhibited, and where they are published.

Consider, for example, a 1992 exhibition at the National Gallery of Art

entitled *Stieglitz in the Darkroom*—an exhibition of seventy-five prints produced by Stieglitz that reveal, among other things, how prints produced from a single negative vary widely, and how this variation was integral to Stieglitz's conception of photography as a medium. "Every print I make, even from one negative, is a new experience, a new problem," Stieglitz wrote. "Unless I am able to vary—add—I am not interested."[35] If negatives are regarded as scores, and photographs as interpretations of the scores, Stieglitz was no hermeneut in his darkroom: he was, in a sense, a poststructuralist before poststructuralism. Experimenting with different photographic processes in the early 1920s, Stieglitz told a friend, "I do nothing according to the instructions. If I follow them I might as well throw cans of paper into our blazing fire."[36] The range of Stieglitz's experiments encompassed not just the commonplace—cropping the image, reorienting it, resizing it, and changing exposure times—but also included a wide variety of different paper and chemical processes. Stieglitz worked with platinum processes, silver, palladium, platinum-palladium, and platinum toned with gold, mercury, or uranium. He also used dyes. Sometimes too he worked directly on the negative, and some (but not all) prints received extensive postprinting treatment that affects their status as individual texts: some were spotted, recut, and retitled. Stieglitz also experimented with finishing prints with waxes and varnishes.[37] Finally, exhibitions themselves were part of the process that began with the photograph, and Stieglitz was sensitive (as Georgia O'Keeffe would be) about how his work was mounted and framed. He kept reprinting and reworking some negatives for decades. There is, therefore, a remarkable amount of physical and semantic space between a negative and a mounted print. But it is not limitless any more than it is limited. As the photographer and filmmaker Hollis Frampton remarked in a subtle and intelligent essay on Eadweard Muybridge in the early 1970s, "A photographic print is not, after all, a unique object, but only a member of a potentially infinite class of 'related' interpretations of a negative."[38]

Stieglitz's attitude toward the negative and the sense of possibility it afforded him was neither eccentric nor typical: photographers vary considerably in their approach to the medium, so it is not quite a simple matter to say that prints made by anyone but the photographer alone are spurious. Edward Weston continued to reprint his work up to a point when his failing health no longer permitted him to do so, yet he allowed his two sons, Brett and Cole, to take over: he was still alive, and to a large extent his intentions were being fulfilled, so what are we to make of the

differences between the prints? Photo technology has evolved in complexity to such a degree that a great number of contemporary photographers depend on collaboration with laboratory personnel in order to achieve results they want—the point being that the process of photo production is so individual that it is precisely this individuality that is critically attractive: it fragments our generalizations about the medium, just as textual criticism fragments our generalizations about literary texts and redistributes authority on a text-by-text basis.

It should be clear, then, that each time we "reproduce" a text—whether we do so in an edition or in an apparatus of an edition—we do not reproduce that text at all but rather print it in another new and different context. By changing the extralinguistic component—for example, the publication—we change the extratextual community and, hence, the interpretative strategies that are brought to bear upon that text. The audience changes, and as the audience changes, assumptions about the text change as well. This is true for poems as much as it is true for paintings or performances. Few critics today would hesitate to acknowledge the different interpretative consequences of exhibiting an Anselm Kiefer painting at the Marian Goodman Gallery in midtown Manhattan and exhibiting the same painting on the wall of the Podunk town library. The empirical reality of textual displacement is sufficiently unexceptional to be a commonplace critical consideration, and the fact that it is commonplace is one of the reasons its importance is overlooked. What is significant here is the theoretical implication of displacement rather than the mere fact it should instigate different readings of a work. This implication has already been introduced: what is the semiotic boundary of a text—say, the Kiefer? Or the *Quixote*? By arguing that the text extends beyond its physical presence in language, we are saying that a text includes what is extralinguistic, even what is supposedly extratextual. In short, we are proposing a model of a text that is as radically unstable as our interpretations for that text. The free (or floating) signifieds that characterize some models of deconstruction are now matched by equally free (or floating) signifiers; and in concurrence, we find ourselves agreeing with Derrida that the presence of a text as an object belies the absence of the text as an utterance of another time and place. That is to say, the fixedness of a text is as illusory as the fixedness of an interpretation; neither is final, neither is authorial. Such a proposition threatens to upset the very foundations upon which the textual-bibliographical tradition is based.

Perhaps it is just as well that this happens. Textual criticism has placed a

considerable amount of faith in the idea of a definitive edition, particularly as much of this faith is placed in the textual apparatus, which is often said to allow us to "reconstruct" authoritative and collaborative versions of a work. But inasmuch as an apparatus is most often based on authority—the author's drafts, proofs, and revised reprints are usually given the greatest consideration—the apparatus is by default concerned with the filiation of the *author's* authorship. The phrase is by no means redundant. What the apparatus rarely does is orient itself around nonauthoritative dimensions of text production, even if it occasionally provides nonauthoritative versions of a work. There are more limitations as well. The *printed* apparatus, for example, ostensibly does not have the practical capability of providing oral texts. It cannot, therefore, claim to provide all authoritative texts where such texts are both available (as recordings) and absent (in the apparatus). Also significant is the fact that the apparatus rarely provides a comprehensive account of extralinguistic and bibliographical evidence, and textual critics are just now beginning to effectively make use of this evidence, as in Jerome McGann's work on Emily Dickinson's manuscripts, and George Bornstein's work on Yeats's layouts, title pages, and cover designs.[39] What an apparatus essentially provides are surrogate texts that appeal to the iterability of language, but not of texts as historical events. My position here might come across to editors as unusually hard, in which case I can only say that we need to be more realistic about what an apparatus can and cannot do. Perhaps its greatest benefit is that the apparatus is indexical in its reference to, and summary of, texts; we still have the onus of chasing after them on our own. But an apparatus, or for that matter an edition, that purports to "reproduce" a text is an apparatus that lies. To re-produce is to reenact. And this won't work because the word *reenact* is an oxymoron: we can no more print the same text twice than we can step in the same stream twice. To reprint—even in facsimile—Shelley's *Adonais* merely adds another pearl onto the string of textual enactments. Bowers's Hawthorne does not reproduce or reenact Hawthorne any more than Menard's *Quixote* reenacts Cervantes's. Nor does it matter (as it seems to matter to Goodman) if two texts are alike in all physical respects, whether perceptual or inherent: their difference is instead one that is ontological.

Let me illustrate for a moment how this might be. Suppose that one should stumble upon a press operation locked away in a forgotten warehouse. Still set up in type, with original inks, paper, and binding equipment, is Ernest Hemingway's *Torrents of Spring*. Suppose now that one were to follow through on this discovery and print and bind several vol-

umes of the book: physically they would be absolutely identical to those
distributed from the initial imprint. Are they identical texts, however? My
answer is that they are not. The volumes are transposed ontologically by
their historical context: they are *extensions* of their discovery as texts in
progress. That is, their stasis as texts in progress is unbound by their
discovery. They become texts only inasmuch as they are discovered and
printed. Where this historical truth is hidden, we cannot decide if the texts
are identical or not, in which case one may just as well make a killing
selling them at bookfairs. To borrow from (and adapt) Arthur Danto's
argument in his *Transfiguration of the Commonplace,* we cannot vouch that
holy water is holy water except by our belief as such.[40] Whether the water
is actually tap water or Evian water does not seem to matter so much as our
belief that the water, having been blessed, is transfigured from a substance
of quotidian consumption to a substance of religious signification. Chemi-
cally it is still the same stuff, just as the Hemingway printed in 1926 is
materially the same as the Hemingway printed in 1989. Hence, we cannot
reproduce, reprint, or reenact a text: each act of textual production is an act
of sequential (even rhizomic) production.

This brings us vis-à-vis what is perhaps the most important aspect of
textuality: that *a work of literature is ontologized by its texts;* it is identified as
literature, or as being of a particular genre, by its particular textual manifes-
tations. Literature does not define itself as literature; it is rather we who
undertake this task of defining what we come to know as the highbrow
and the lowbrow, the good and the bad, the canonical and the non-
canonical. One particularly good example of this surfaced quite recently in
the *New Yorker.* In an extended essay on the Great Plains, Ian Frazier tells
how, after a night's sleep at a truck stop, he awoke in the morning to find
(as he describes it) a stock truck parked beside his car, and "on the truck's
door, in big letters, a poem."

> Buck Hummer
> Hog Hauler[41]

Buck Hummer certainly seems real, and the poem certainly is real, but
what surely isn't real is Buck's consciousness of having a poem on the door
of his truck. On that door, Buck's statement is both illocutionary and
perlocutionary: it advertises and solicits, and, one supposes, the stock
truck's text of this poem contained an address of sorts, and perhaps even a
phone number. Frazier's text of "Buck Hummer" doesn't do this, however,

because it doesn't have to: it rather announces itself as a poem. If the hog-hauling business picks up for Buck as a result of his truck door being reontologized in the *New Yorker,* then he's in luck. Offers to publish his future truck doors might be slow in coming, and understandably so be-cause Buck Hummer is not the author of "Buck Hummer / Hog Hauler"; rather, Frazier is. Buck merely wrote the door; Frazier wrote the poem. What is important here is that the poem stands in relation to literature as Marcel Duchamp's *Fountain* stands in relation to art. As a readymade (or more precisely, a readywrit), the poem becomes a poem only by virtue of Frazier's transcription and his offering of it as such. We accept it as a poem just as we accept the fact that Duchamp has transfigured (to use Danto's phrase again) a urinal into an artwork. For all we know Buck Hummer might not even exist—a point that explicitly contradicts the first sentence of this paragraph. The Buck Hummer of the truck door, the Buck Hum-mer of *New Yorker* fame, and (presumably) the Buck Hummer of the *Yellow Pages* present different texts that are also defined by our perception of their contexts. If this is an extreme example, it has the benefit of showing us how much semantic and historical information is couched within the indi-vidual texts of a work of literature; and it emphasizes (as the two *Quixotes* emphasize) that these differences do not necessarily have something (if anything) to do with the spelling or punctuation of texts: they extend themselves to the extralinguistic, extratextual context of that text, in which case the *New Yorker* and the door of Buck's stock truck are two very different vehicles for literature—and hogs.

Objects, Events, Outcomes

Earlier I mentioned that textual criticism and bibliography have histori-cally sought to provide an organizing principle in literary studies, and this principle is normally reflected by an emphasis on authority and reliability in scholarly texts and editions. Much of this authority has been found in, or contrived from, the representation of authorial intent, whether these intentions are "final" or "original" or compounded in some way. As I pointed out in the first chapter, it seems to me beneficial to our interests that we qualify (but not quantify, or stratify) this authority along the notion of alterity—as differences—and seek to explain what those differ-ences mean and why they are there. Freed of the burden of intentionality, texts become, as we saw, radically unstable, tenuously tied to a historical frame that is at best ephemeral and in many ways irrecoverable. And this is

to some a problem because it controverts the faith we have invested in modern textual criticism and bibliography, particularly in editions we use and have come to rely upon. Perhaps, however, this departure, or this shaking of our faith, is precisely what we need: something that will replace textual security with textual cynicism. The idea of a physically objectified text offers a false sense of security by being advertised as objective, and since we can hold it in our hands (say, a book or a MS), we find additional comfort in its tangibility. This tangibility is also an economic reality. As a commodity for mass production, the book trade works within the limits of certain practical restraints, just as editors themselves must contend with the limitations of print media. The modality of cyberspace will not so much change this basic principle as impose its own limitations and thereby emphasize how objecthood is both a technological and economic convention. But objecthood is by no means a defining element of literature, or (by extension) language. Speech may become objectified in a recording or (in a more limited way) in a printed text, but it is not in itself a physical entity. C. S. Peirce's semiotics is grounded in the basic tenet that "A sign, or *representamen,* is something which stands to somebody in some respect or capacity."[42] There is no indication of physical fixedness here, nor is it present in Saussure's semiology. The sign (or signifier, as I have been calling it in accord with more widely accepted European usage), is structurally free and may or may not take any kind of permanent embodiment. It need only be, in the words of the Prague structuralist Jan Mukařovský, "a reality perceivable by sense experience" in order to have life as a signifier.[43] Hence, the evanescence of speech, of gestures, or of performances poses no problems for semiotics. Logic would tell us that no art form—no poem, no painting, no dance—can exist without a text comprising a semiotically endowed signifier, even if the boundaries of that signifier are indeterminate. One could even argue that silence—as in John Cage's *4' 33"*—is itself a text, or in any case textual, and give further validity to his statement "silence is sound."[44] Though Cage's work is tangential and not the norm of the canons of textual traditions, it is just the kind of thing textual critics need to begin thinking about. When Williams and Abbot argue that textual embodiment consists of "letters written, impressed, or transferred onto a surface,"[45] one wants to add that not only does the surface itself matter (as in Blake's prints and Dickinson's manuscripts), but—to take Cage's reversal seriously—so too does the white space between the letters and words, particularly when that white space has a paralinguistic function. This is a sensitive matter when typographical boundaries are subject

to manipulation, as in the décollage poetry of Tom Phillips and Ronald Johnson, or in the "text art" of Jenny Holzer, where the appearance of her aphorisms on disused theater marquees and digitalized electronic baseball park billboards means everything to her words. Holzer's art looks passive in books and in galleries. It is considerably more engaging when intermingled with porno shop marquees on New York's 42nd Street, and the reason is simple: Holzer's art is *about* the relationship between a text and its frame. Thus, our expansion of the description of textual boundaries is one that must go inward (to the tangible) as much as it must go outward (to the intangible): we need to have a description that bears signification in whatever form it appears.

Since literature by its definition (but not its etymology) includes the idea of verbal constructs (whether aesthetic or nonaesthetic, whether conceived, contrived, or appropriated), then it seems imperative that a definition for a text be able to include various modes of the literary experience: oral performances, particularly, and sign language poetry, as well as dramatic performances and performance art. Performance art like Karen Finley's is an underdog in critical theory in part because of its inexorable transience and in part because the text cannot be abstracted away from the performance or the performer: it reiterates and complicates Yeats's question about separating the dancer from the dance.[46] Yet contemporary performance has an extraordinary conceptual tug that has been increasingly utilized by both visual artists (Andrea Fraser, and to an extent Sophie Calle)[47] and performing literary artists who conjoin poetry, music, and rap at venues like New York City's Nuyorican Cafe—the City Lights of the 1990s. The interdisciplinarity of performance art is particularly suited to textual studies since performances by their very nature exist in different states. Because performances are overtly detached from the apparent (but not real) fixedness of books, they force us to quite directly confront their emphemerality and describe it in a way that is part of the scheme of textual semiotics.

One way to do this is to describe a text in terms of the speech act, or perhaps more usefully, as an event. Bakhtin's idea of the text as an utterance, McGann's idea of the text as a dynamic event, and Derrida's abandoning (and reformulation) of the moment of inscription, all move in this direction, and much can be said for their positions. Paul Ricoeur, in an essay on literary ontology that was published in 1974, perceptively suggested that because literature consists of discourse, and since discourse occurs as an event, then literature is by consequence a "language event."[48]

Such language events, like Bakhtin's theory of the utterance, retain their singularity in their (arguably) irrecoverable history, whether that history is spoken or written. In this respect the speech act is not structured in any way fundamentally different from the writing act: both emphasize the unbounderied "space" of the act, as well as the act's location in time—what Bakhtin calls "chronotopicity."[49]

Because such events are articulatory, their phenomenology is oriented toward the production, not the reception, of signifiers. This small point needs to be stressed. Traditional schemas for phenomenology, whether in philosophy (such as Husserl's and Merleau-Ponty's) or in literature (such as Fish's and Wolfgang Iser's) stress the perceptual aspect of the phenomenological experience: it constitutes *the moment of recognition* of the signifier/signified, a process of relational discourse in the reader's mind. Discussing Stanley Fish, for example, Stephen Mailloux wrote that a sentence is not "an object, a thing-in-itself, but an *event,* something that *happens* to, and with the participation of, the reader."[50] The event is a moment of encounter: the text meets the reader, and the reader in turn decides (or as Husserl puts it, "reduces") the text's essence. In a way the text is absolved of its textuality; it becomes absorbed by (and by default possessed by) the reader, which in turn gives rise to Fish's lemma: "[T]he reader's response is not *to* the meaning; it *is* the meaning."[51] This perhaps oversimplifies the realities of text production and text reception, but this simplification conveniently outlines the significance of the phenomenological event at both ends of the linguistic sign. Even if reading ultimately involves composite ironies—text production as reading, and reading as text production—these ironies are themselves subject to eventhood as well.

In all of the quotations I have just cited the word *event* is pivotal. But just what is an event? This is a crucial term, and it is difficult too. Are events objects? Not really, although they can be described as objectlike, or paraobjects. We tend to objectify events (such as Christmas, the Fourth of July, or Shakespeare's birthday), giving them the religious or cultural status of objects; yet they are not physical entities. At this point we again realize that a definition of a text as an object is not going to work in the long run, however well it has served us in the past. Considered empirically, events do not consist of matter, nor are they in a conventional sense entities. Since an object suggests a kind of retainable entity, an event is more of what the linguist George Lakoff describes as a "conceptual" entity.[52] A conceptual entity is not, as it seems to imply, an oxymoron: the

space it displaces is a *mental* space, and texts—all texts, whether spoken or written—occupy such space. Although this mental space is central to critical ideology, whether that ideology belongs to Derrida or Fish, it does not normally concern textual critics and bibliographers. But perhaps it should. A physical text, say, the holograph of Keats's nightingale ode, occupies, simultaneously, different dimensions of space: literal space, mental space, and (as we discussed earlier) historical space—and none of these locations is entirely discrete. This helps us understand how the concept of an oral text (like oral literature) fits into this paradigm; and even if the acoustic signal of the speech act is not literally an entity (how many dimensions do displaced molecules occupy?), this does not matter. What does matter is that Homer reciting the *Iliad* or Johnny Rotten ranting at Wembley are both creating and producing texts that are also events—not objects. Because events are temporally discrete, they are finite in a useful way. Yet because events take place in space, they are in another sense infinite, since, for example, we can never know the full setting in which Homer and Rotten might have been performing, even if we ourselves are (or were) a member of the audience. The beauty of such texts is that their literal space and their historical space are largely concomitant by being an extension of the present; and as we witness them, we become a part of this extension, a part of the text itself. If such texts have a problem (some might call it an advantage), it is that they cannot be replicated; there is no going back to an event that, gone once, is gone forever. Since textual studies is by its nature a retrospective activity, this partly explains why oral texts and oral recordings do not find their way into editions. Occasionally they squeak into bibliographies, particularly when the recordings themselves are canonized (as in the case of Dylan Thomas's). But these cases are rather exceptional. Exceptional too are critical discussions of oral textual events, perhaps because—as the artist Julian Schnabel once uttered in a rare insight—it is difficult to examine and talk about a text one cannot go back to for a second look.

Events, however, can be recorded, if only to a degree, using any of the various technologies available. Recordings constitute a form of selective memory: they cannot record the speech act. At its best a recording reconfigures an event without abandoning its auditory and/or audiovisual modality. Yet, this reconfiguration is substantial. As Peggy Phelan observed, "To the degree that performance attempts to enter the economy of reproduction it betrays and lessens the promise of its own ontology"—an ontology that depends on disappearance and memory.[53] If the process of

recording is therefore said to be flawed, it is flawed only as much as *all* processes of textual transmission are inherently flawed. As for photographs, the probability for variation within the sequence is very high for recordings: an audio text is subject to digital displacement as a digitalized photo text is subject to pixel displacement, thereby introducing an element of intentionality into the latent and actual transformations occurring. In this sense the process of transmission is flawed not simply because it cannot reenact or reproduce a textual event; it is flawed because it fails to guarantee what it promises in etymological terms. Memory must replace the material because it is memory that is more truthful than the material reenactment. The material text does not so much re-present as represent or substitute for that which it cannot be. This is hardly insignificant from a critical or sociocritical perspective because, as Phelan says, the shift from an audiovisual event to an audiovisual recording involves a shift from performance to product. Recordings, books, and manuscripts are not just objects, however: they can also be described as outcomes of events. If speech is an event, the recording of it is an outcome. If writing is an event, the recording of it (i.e., the MS, the TS, the computer disk) is an outcome. While some events have outcomes by their very nature (writing, for example), others may have deliberate outcomes (a performance that is recorded), while others do not specifically have outcomes (an unrecorded performance). The text as an outcome is not necessarily better than the text as an event; they are different, both physically and ontologically, and furnish their own kinds of critical playgrounds. The outcome is particularly unusual (and from the hermeneutic point of view, desirable) because it tends to recall the event that produced it, whether that event is historical, sociological, or compositional. Such theories constitute a nostalgia for the moment of inscription: they want to go back. Whether we can actually arrive at that point of recall, or trace it through what Barthes calls "the myth of filiation,"[54] is a big question. Here, however, we move outside the critical text into critical theory—at which point the disinterested textual critic can go no further.

It is an ironic way to size up the situation: is there such a thing as a disinterested critic? The notion of textuality is recessive against a foreground of critical theory: Jerome McGann stands out not as a textual theorist, but as a political historicist; Hershel Parker not as a textual theorist, but as a hermeneut. They may claim they are textual theorists, but only inasmuch as their textual theories serve their critical programs—and it is, consequently, their critical programs that assert an institutionally political

shadow over their textual work. In a very important way, this is what is perspicuous about textual criticism: the identity of editors is revealed through the choices they make. They cannot hide. Earlier I suggested that Bakhtin marred the persuasiveness of his argument of the text as an utterance by saying that the *entire* significance of a text lay in the "dialogic relations" with its individual history. This strikes me as being unnecessarily coercive. Along nearly identical lines McGann has written in *The Beauty of Inflections:* "[I]f we are to understand how poems mean—if we are going to gain knowledge of literary productions—we must pay attention to a variety of concrete historical particulars, and not merely to 'the poem itself' or its linguistic determination."[55] Textual theory helps one do just that: it helps reveal the complex compositional and production aspects of literature and how these aspects are part of larger historical, political, and economic structures. But textual theory can't necessarily tell us how language works per se, in which case McGann's light treatment of the "linguistic determination" of a poem seems to overlook abstract semantic issues as much as it is generous to concrete historical issues. If, as McGann says, we are to understand *how* poems mean, then perhaps we also need to understand how language itself means—and this is precisely where Derrida has chosen to locate himself. Linguistic determination wouldn't be such a difficult thing were we not so overwhelmed by linguistic indetermination. We can hardly be expected to make sense out of a poem if we can't make sense out of the most basic relationship between a signifier and its signified—a questionable relationship that gave Derrida the basis for grammatology, the gram as *différance* replacing the sign. It seems to me that whatever assumptions we make about texts and textual histories, our assumptions are guided the kinds of literary (or even linguistic) questions we are asking. Literature after all is an art; its medium is language; language is both cognitive and social; and there is, simply, no way any one critical theory is going to tell us how all these things coalesce. Like literature itself, criticism thrives on a kind of discursiveness engendered by alterity, and explorations like McGann's, Bakhtin's, and Derrida's—explorations that have something new to say—constitute the critical discourse of the perpetual present. Literature is not a study of truths, not a study of falsities, but a study of disguises. If it were a study of truths and suchlike operations, we would imply that literature is also a study of closure; and this, clearly, is not the case.

We should also remember that the noniterability of texts means that textual displacement is a temporal (and hence spatial) issue: it presents the literary critic (confronted with numerous authorial and nonauthorial

versions of a single work) or the art critic (with numerous re-presentations of a single work) or the performance critic (with numerous instances of a work's performance-texts) with an overwhelming sense of the burden of textual history. This is daunting, and at the same time it is good: as our awareness of the numbers (and kinds) of textual states and modalities increases, so too do our interpretative possibilities. There is in fact something fundamental to how textual consciousness—an awareness of the textual histories of the poems, plays, and novels we are discussing—informs literary criticism, perhaps because it makes real the endless diversity of historical spaces in which literature occurs, just as it makes real the different modalities in which language occurs. Yet these possibilities can only be the product of our own initiative. Texts do not come to us; we must go to them. This is why the various editions that are produced by scholars and by hacks are important, and I say this without intending to demean the professional respectability of critical editors or imply that their work is comparatively futile. The editor in search of the perfect editorial paradigm, the editor who doesn't even have a paradigm, and the editor resigned to unediting texts are all fundamentally editors whose work reflects and refracts their own temporal and ideological dislocations. The problem I am trying to identify is elsewhere—not in editing itself, but in the rhetoric of editing, or more precisely in our conceptualization of what constitutes an edition or a text. An edition, like a text, is merely a site of passage of a work of literature: a site in which instabilities are both made and made manifest. In terms of cultural history, everything that Fredson Bowers says about Hawthorne's texts is important, and equally important is what *Reader's Digest* has to say about *Tom Sawyer*. Here of course I am speaking as a theorist about practical matters, but there is nothing so practical in the study of literature as texts themselves. Their abundance, on the one hand, and their stark differences, on the other, combine to affirm the fact that cultural production will always remain one step beyond cultural control. There is no way to prescribe a general editorial theory for all texts because there is no way to prescribe a general social theory for all the people who produce them. Texts will continue to be edited for scholars just as they will continue to be edited for nonscholars, and this is a reality not to be merely treated with stoical indifference (or even derision), but as something that ought to be welcomed, even praised. The manifestation of a text represents an affirmation of belief—something that art must ultimately be if it is to be art. The differences that texts reveal amongst themselves and that distinguish themselves from each other are the prod-

uct of an uncentered alterity: there is no correct text, no final text, no original text, but only texts that are different, drifting in their like differences. By exploring, but not stratifying, these differences, we begin to understand how textual dynamics can be broken down into a phenomenology of text production, and such recognition marks the emergence of textualterity.

Chapter Four

Textual Space

Colors present themselves in continuous flux, constantly related to changing neighbors and changing conditions.

—Josef Albers

Site-specificity is not a value in itself. Works which are built within the contextual frame of governmental, corporate, educational and religious institutions run the risk of being read as tokens of those institutions. One way of avoiding ideological co-optation is to choose leftover sites which cannot be the object of ideological misrepresentation. However, there is no neutral site. Every context has a frame and its ideological overtones.

—Richard Serra

My best shows are the ones I've put on in airports, for customs agents at four in the morning, after an eight-hour flight.

—Francesco Clemente

Textual Spaces: An Introduction

One day in the fall of 1907 when the poet Rilke was making repeated visits to an exhibition of Cézanne's paintings at the Salon d'Automne, he wrote to his wife, Clara: "Today I went to see his pictures again; it's remarkable what an environment they create. Without looking at a particular one, standing in the middle between the two rooms, one feels their presence drawing together into a colossal reality."[1] What is striking here is Rilke's attention to the exhibition's space and how he configures his own relation to it. By standing between the two rooms he was able to position himself at the center of a composite space, *among* the paintings, not merely in front of them. It is not that he ignored the paintings as singular entities (in other letters his comments about them are equally compelling), but that he did not limit himself to seeing the paintings as mere objects. One imagines him

continually making spatial assessments, looking not just at Cézanne, but at Cézanne vis-à-vis Cézanne in his two rooms, Cézanne in the salon among the Belgians (who were having a retrospective in adjoining rooms), Cézanne and his spectators ("you know how much more remarkable I always find the people walking in front of the paintings than the paintings themselves," Rilke wrote to Clara[2]). Cézanne was for Rilke rarely alone, not even with Cézanne himself: there is, as we read the letters, a feeling that some kind of textual displacement was continually taking place as he read the paintings.

There is, I think, something to be learned from Rilke's unparadigmatic, almost naive, approach to reading and the way in which it directly engaged the physical space of Cézanne's exhibition. Reading is an activity most closely associated with language and literature; yet, despite a long and troubling history of critical inquiry that reaches as far back as the Greek sophists and extends to cognitive semanticists today, it is not altogether clear what phenomena define this activity.[3] It is true, of course, that there exist formal differences between language and the paralinguistic status of painting and other visual codes of signification. These differences are sometimes quite important, but they are also potentially misleading because they are *formal* differences, whereas art and literature are more than merely formal codes: both their production and reception are socially anchored activities. This seems so unexceptional as to be superfluous: we *know* that all cultural activity is social. Yet we often ignore nuances of text production, in part because our institutional approach to culture is based on the uniformities of canonical authors, canonical texts, and canonical genres and media. As a result, our paradigms about textual space work around the notion of canonical space (*canon,* a rule; *kanne,* a cane; *canna,* a reed— what is, therefore, straight)—a space defined not by examples and counterexamples, but by the residual legacy of the study of linguistics and semiotics. Because of language's iterability, literature thus has the illusion of occupying spaceless space: that is why textual critics say that a text can be a faithful representation of the work (or "reconstitution" of the work, to use G. Thomas Tanselle's term)[4] if it presents certain words and certain marks of punctuation in a certain order. As we saw in Borges's *Quixote,* however, the space of literary texts cannot be read apart from a social space, whether that space is the author's, the editor's, or the reader's. When looking at art we are often particularly aware of what we might call concrete, or material, contexts and backgrounds. One cannot attend a contem-

porary blockbuster exhibition of Van Gogh or Gauguin or Seurat without recognizing the complex weight of these exhibitions: the queues, the timed-entry admission tickets, the audio tour guides, the potted plants, the five-pound catalogs, and the inevitable effect that other spectators have on our encounters with the art.[5] This does not merely apply to the museum as a critical space; it also applies, as I suggested earlier, to virtual galleries. Jackson Pollock's initial critical exposure involved appearances in popular magazines like *Life* and *Vogue* and, in these appearances, foregrounding and backgrounding texts of the paintings. Thus in the famous *Life* magazine spread in August 1949, Pollock is photographed by Arnold Newman in front of *Number Nine* (thereby foregrounding the painting), while in Cecil Beaton's equally famous fashion spread in *Vogue* entitled "The New Soft Look," the paintings *Number 1, 1950* and *Autumn Rhythm* are blurred and out of focus behind very much in-focus models, thereby back-grounding the paintings.[6] For the reader of these magazines (as for the reader of any exhibition), the movement between the work's grounds is characterized by the instability of each ground. As in classic studies of figure-and-ground illusions (the "multistable" image portrayed by the duck-rabbit image or vase-silhouette image), the ground is "fixed" by the reader's own movement or self-reference.[7] But here the important question is: what mode of reading is *not* fixed by the reader's peregrinations, either literally (in relation to the text being read) or figuratively (in relation to the reader's historical knowledge)? To his credit, Rilke provides us with a narrative eye that is unembarrassed at making excursions into the textual spaces around him. He seems to epitomize Walter Benjamin's ideal strategy for experiencing a new city: not to have a map and find one's way, but not to have a map and lose one's way. It is, in fact, a kind of critical opportunism that seems to me the deciding factor: the will to go out into the dark spaces inhabited by a text, particularly those spaces that are ephemeral and best characterized as "installations."

Here the matter gets even more complex: what exactly is an installation? In conventional arts discourse, the word *installation* is used to connote a wide array of meanings varying from the act of mounting or hanging an exhibition (to install and deinstall a show), to a synonym for exhibition (an installation is thus simply an exhibition), to a genre of art in which the work is installed in relation to a given space (installation art). The installation of an artwork, like the installation of a literary text, is in all of these apparitions essentially a *pose,* at least in the sense that it constitutes a certain visual alignment of the work vis-à-vis its surroundings. To pose (the etymology of

which, according to Partridge, rests on the Latin *ponere,* "to put or place or set") involves a close relationship with art's most fundamental forms of agency: to compose, to transpose, to juxtapose. A pose is, above all, self-conscious of the fact that it is a framing at the same time it is being framed, either by a camera or a gaze. The pose is thus the culmination of the act of preparing to be seen: "to put or place or set [to be seen]." It is most real, perhaps, in its figurative state (defined in the OED as "to set up *as,* to give oneself out *as;* to attitudinize").

To attitudinize? Well, yes, and precisely so. The sense of a certain attitude being characteristic of the pose is crucial, and the genre of installation art has something to say about this in a rather oblique way. The conventional art installation does not presume to do more than fill or otherwise occupy an institutional space, even if that space is occupied by no material object or objects. In 1990, Laurie Parsons exhibited at Lorence Monk Gallery in New York an installation that consisted of absolutely nothing at all. The art was that there was no art; and the exhibition announcement, which consisted of a standard mailer with the gallery's name and address, was otherwise devoid of information about the exhibition: no name of the artist, no title of the exhibition, no exhibition dates. Like Robert Barry's 1969 exhibitions entitled "Closed Gallery" (Gallery Sperone in Italy and Gallery Eugenia Butler in Los Angeles both remained closed for the duration of the show), Parson's exhibition was thus about the presence of absence as much as it was about the absence of presence. Either way, the exhibitions by Parsons and Barry remind us how installations involve conceptually filling an institutional void, thereby inscribing that void as a poem might be said to inscribe a page. Installation is thus about the act of simultaneously inscribing and reinscribing a space, turning it into a palimpsest of inscriptions that cannot easily be dislocated from their site of inscription. We are thus left with a conflation of both verbal and the nonverbal signifiers that refuse to disclose the totality of their function in relation to other functions: the pose of an attitude.

Summarizing this phenomenon in terms of contexts is helpful, but it is also misleading because it appeases our desire for a fixed location by substituting an unfixed location that is otherwise fixed by discourse—by, that is, the certain uncertainty of the word *context* itself. It is a simple matter to acknowledge that a poem in the pages of a periodical like the *New Yorker* (on the one hand) or *Bomb* (on the other) is contextualized as much as a painting exhibited at the Pace Gallery uptown (57th Street highbrow culture) or Colin De Land's ironically named American Fine Arts (residual

Lower East Side ambience). What is more important, I think, is that the space in which we categorize the galleries is continuously in flux. In the summer of 1993, American Fine Arts moved one block from 40 Wooster Street (the South Soho fringe) to 22 Wooster Street (both within and beyond the Soho fringe); later in the same year, Pace Gallery "moved" by merging with Wildenstein, further anchoring Pace within mainstream history: it became, by virtue of this union, an institutional site of two different canons: that of blue chip contemporary art (Julian Schnabel, Robert Ryman, and Agnes Martin are all represented by Pace), and that of Wildenstein's nineteenth-century traditions (of which Paul Gauguin is most prominent). American Fine Arts, in contrast, is continuously trying to evade this history by way of limited advertising and self-conscious effacement: the Teflon gallery. As James Meyer presciently observed in a recent exhibition catalog at American Fine Arts, "much of the work is not 'American,' is not 'fine,' it is not always clearly legible as 'art.'"[8] This movement characterizes the failure of categories to be everything they want to be in terms of facts and figures and territories. Meyer's catalog itself metonymizes the irreducibility of the gallery's movement by being published in the self-effacing format of a xerox. The gallery is thus situated by way of an ethos devoted to what might be called grandoise understatement: a context that is not so much a place but a process.

Given these considerations, the sort of textual consciousness Rilke reveals in the process of reading, reading around, and reading into Cézanne is an activity rather than a certain kind of knowledge. It constitutes a form of semantic exploration that is always at the edge of possibility and, at the same time, always at the brink of embarrassment. Perhaps because of this double threat—mere possibility enjoined with potential embarrassment—the most adventurous textual forays are also the most private: criticism becomes reduced to the form of a diary or an epistle to oneself, both being well-worked Derridean genres. Rilke's critical narrative comes close to this: the letters he wrote were to his wife, Clara. "To" or "for": the dative case emphasizes the direction of Rilke's prose, which moves continuously toward Clara but is never, for those overhearing Rilke in editions of his letters, returned. These are Rilke's letters, Rilke's mental excursions; not Clara's. They are at once fragments of a correspondence and the whole of a monospondence. Their tentativeness as compositional events somehow reflects Rilke's awareness that Cézanne's exhibition was an event too. If each day in which he visited the exhibition presented a reconfiguration of what he saw, ultimately the closing of the exhibition would continue, not

end, this process: "[T]he Salon no longer exists," he wrote to Clara; "in a few days it will be replaced by an exhibition of automobiles which will stand there, long *[lang]* and dumb *[dumm]*, each one with its own idée fixe of velocity."[9] This remarkably unusual displacement (an exhibition of Cézanne giving way to an exhibition of automobiles) is also striking in that it registers Rilke's despair at contemporary cultural turns. It does not matter to Rilke that the cars are not yet there; they *will* be, and so they are already present as fictions—"long and dumb." This is a perfect phrase, a phrase that unveils the irony of Cézanne's unlong and undumb paintings—each, we might assume, with its own unfixed idea of velocity. Here Rilke gets outside the two rooms without leaving the two rooms, thereby providing Clara with a most improbable intertextual comparison: Cézanne and automobiles. The Salon d'Automne was an aesthetic showcase, and the shock Rilke expresses is that of realizing that the exhibition space is neither privileged nor sacred as it is presumed to be. The salon took place in the Grand Palais on the Champs-Elysées: not quite a museum, yet more than a gallery, the Palais was perhaps most like a *Kunsthalle*. Built in 1900 for the Paris Exhibition, the Palais represented a stage (or forum) for human progress, its doors functioning as a proscenium arch behind which could be seen images of an incipient modernism. Cézanne, whose fractured planes displaced those of impressionism, gives way to the automobile, which enacts its own displacements by altering modes of transport. Thus the Palais functioned as an institutional space benign to both forms of displacement: it metonymizes the fact that displacement was not merely aesthetic, nor technological, but the very premise by which the nineteenth century became the twentieth.

Rilke's observations here are perhaps most successful as criticism because they do not balk at what some might call the end of the text. The boundary of time that closes Cézanne's exhibition does not also close Cézanne's text. There is, furthermore, an unmitigated sense of play occurring—a continuous assessing and reassessing of Cézanne in the space of two rooms in the salon. Nothing, it seems, is too unimportant to notice; and nothing, it also seems, is inherently significant. It is a curious matter that this sensitivity toward a text's latent significance is also prevalent in both deconstruction *and* textual criticism. Both, that is, share a tendency to interrogate a text in relation to itself (a kind of intratextuality), and in relation to that which lies beyond it, including the conditions of being written, published, and read. Rilke's textual consciousness is pragmatic and experiential; there is no ideological blueprint that outlines his critical approach. He speaks what he feels,

not what he ought to say. Yet his approach is one that makes maximum use of the physical space inhabited by Cézanne's texts—the sort of physical presence that evokes an allusion to the grammatological geometry of written texts.

A more self-conscious form of this sensitivity can be found in critical adaptions of textual criticism. One particularly instructive example of textual consciousness occurs in Helen Vendler's study of Keats's odes, where she suggests that there is something meaningful behind the initial publication of the "Ode to a Nightingale" in the *Annals of the Fine Arts:* "The point I want to make is that Keats, in printing *Nightingale* in such a journal, defined it as a poem about one of the fine arts."[10] Both Vendler (who is frequently accused of being a formalist) and Jerome McGann (who is never accused of being a formalist) also note that the "Ode on a Grecian Urn" was first published in the short-lived *Annals,* and as a consequence they both locate their interpretive discourse within the context of the *Annals*'s emphasis on Romantic and classical art.[11] Like Rilke engaging himself with the Cézannes, this sort of critical behavior is opportunistic: it works from the space of available realities by which we relate a text to a context, whether that context is located in history (where Vendler and McGann find it), or whether it is located in the reader's present (where Rilke finds it).

Yet the extent to which the author/artist is responsible for these contexts is difficult to judge. The genre of site-specific installations presupposes certain contextual intentions, but this does not always apply to paintings hanging in galleries and museums or poems appearing in periodicals. An intention may lead us to a context (and thereby explain it), but the inverse is not necessarily true: that is, a context does not explain its origins where those origins are hidden from us by the space of language and/or history, as they almost always are. For this reason there is something troubling about the assertiveness with which Vendler and McGann base their respective claims that by publishing the odes in the *Annals of the Fine Arts* Keats was "defining" (Vendler's word) their semantic locus. Were it clear that Keats himself had voluntarily sent the poems to the *Annals,* this thesis would not be so problematic; but it's not clear Keats actually arranged for their publication in the journal, and evidence suggests that the person responsible for this was his friend, the painter B. R. Haydon, who had previously published several essays in the *Annals* and was a close friend of the editor, James Elmes.[12] To say that Keats "decided" (McGann's word this time) to publish the "Ode on a Grecian Urn" in the *Annals* is very different than saying that

the ode appeared or was printed in the *Annals*. But even supposing that we put aside what Keats thought, wanted, or intended, publication of both poems in the *Annals* provided a certain conceptual framework by which contemporary readers read them. This, to me, is the critical juncture because the *Annals*'s concern for "High Art" (Haydon's phrase now) is immediately lost on a generation of college students reading the poem in a context associated with high criticism in Jack Stillinger's edition of Keats. We can, of course, use the apparatus of our Stillinger to track down variants of the poem (assuming we have the Stillinger text equipped with the apparatus; one of them, the 1978 text, has it, one of them, the 1982 text, doesn't), but this framework is "open" and does not, like the *Annals*, present a tightly boundaried context. Sometimes this context can be very tight indeed: Keats's lyric, "Hither, hither love," overtly carpe diem and permeated with male eroticism ("If I die and wither / I shall die content"), somehow seems innocuous and innocent in Stillinger's edition, particularly as it appears among Keats's early work with two thematically related poems. Yet the poem's sexual reality seems anything but innocuous in the context of the American magazine in which it first appeared: the *Ladies' Companion*. Or the second one: the *Ladies Pocket Magazine*.[13] These are early instances of Keats's assimilation into the popular culture of romance and kitsch, a trend that would peak with the 1892 publication in a St. Louis music magazine called *Kunkel's Musical Review* of an advertisement for "Dr. T. Felix Gouraud's Oriental Creme or Magical Beautifier," an advertisement very much in possession of a very Keatsian byline: "A Skin of Beauty is a Joy Forever."[14] It was, moreover, an advertisement that appeared on a page exclusively devoted to advertisements: for pianos, organs, music scores, Barr's Drygoods, Erker's Optical goods, Mermod & Jaccard's Jewelry, Namendorf's Umbrellas, Issacs' Wallpaper, St. Jacobs' Oil for Rheumatism, Scott's Emulsion of Cod Liver Oil, and the Emma Bust Developer. In America, it seems, Keats was popularized before he was canonized, and the only way we can acknowledge this contrast with the *Annals*'s aura of High Culture is by looking at the publications in which his poems were appearing and the audiences they were reaching—even expropriated fragments of his poems in advertisements for Dr. T. Felix Gouraud's Oriental Creme.

What examples like the foregoing show us—the Keats who slips in and out of almost unaccountable textual spaces, the Cézanne who slips in and out of the mental spaces of Rilke's shifting mind—is that textual fluxion is not

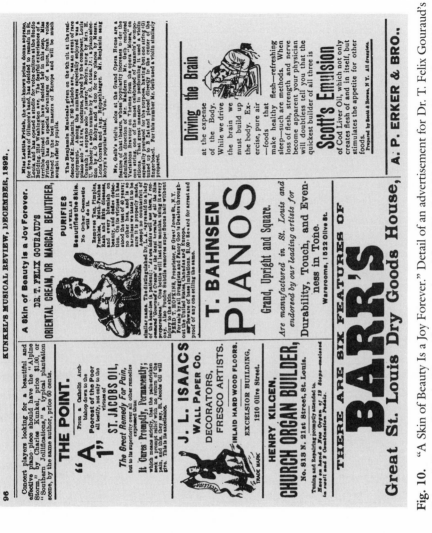

Fig. 10. "A Skin of Beauty Is a Joy Forever." Detail of an advertisement for Dr. T. Felix Gouraud's Oriental Creme of Magical Beautifier, reproduced from *Kunkel's Musical Review*, December 1892.

so much unusual as it is germane to the life of cultural texts. While this fluxion is usually a form of transience—the gaps, ruptures, and drift that we investigated in earlier chapters—it is sometimes the flux of spatial relations: the space of different periodicals and publication sites for Keats, the space of two rooms, the space of the spectators, the space of the Grand Palais for Cézanne. Just as transformations involve different kinds of temporality, the reterritorialization of art involves different kinds of textual space, including the intertextual and intratextual. But by what means might we circumscribe or otherwise be precise in our descriptions of this space? If a text is said to inhabit certain social, political, and economic spaces and partakes of a determinate form, where does this determinism begin and end? Where, for example, do the texts of Keats's "Nightingale" ode begin and end? Or Cézanne's paintings, a problem that Rilke seemed to solve simply by establishing himself in their midst and thereby solved nothing? Why are we prone to use topographical metaphors—McGann uses "bibliographical environments,"[15] Peter Shillingsburg speaks of "performance fields,"[16] and there is an echo of Rilke again: "what an environment they create"—to describe the spaces in which texts manifest themselves? Can these spaces be encircled somehow (by history? by the reader?) or is the use of metaphorical terminology an implicit acknowledgment that we cannot establish the boundaries of textual activity?

My initial feeling—and as author of this work I can't avoid getting ahead of myself here—is that these questions are, to a large extent, epistemological aporias whose answers can be reached only by continuously reframing the questions themselves in the process of subjecting them to examples and counterexamples. As a consequence, my approach in the sections that follow is discursive, circumlocutionary, and at times intentionally provocative, precisely because my intention is to open, not close, debate on the questions I have posed.

Textual Boundaries and Contextual Frames

Where does a text begin and end? As we saw in the previous chapter, this simple question is also our most difficult: if a text has a determinate state, then it would necessarily follow that we should be able to localize the text. But where? The implied iterability of language suggests that we would end a text where language ends, but Keats's "Nightingale" ode shows us that this doesn't go far enough. It is a poem that remakes itself in the process of being remade by its ongoing exhibition sites—the *Annals,* the 1820 vol-

ume of Keats's odes, and Stillinger's highbrow academic edition. Thus we cannot say that a text begins with its first word and ends with its last word. Or that a painting is circumscribed by its frame. Or that a frame is circumscribed by the room it is in. Or the room is circumscribed by its building, and the building by its site (on the one hand) or its institutional stewardship (on the other). As we try to fix a definite boundary around a text, our efforts take on the apparation of drawing circles in water, each circle slowly drifting out from our figurative stylus. By jockeying for a position among the Cézannes, by returning and returning to reposition himself among the texts, Rilke somehow conveys his own sense of doubt (how am I to position myself among these texts?) and his uncertainty about the paintings' implied uncertainty (how do the paintings position themselves among their audience?). What I would like to do at this point is undertake a top-down approach to the question of textual and paratextual boundaries by examining a few previous attempts to discuss these issues. Since the question being posed is loosely semiotic—by asking if we can localize a text we are engaging in an argument about the status of signifiers, not signifieds—I would like to make an effort at theoretical play before moving on to a number of examples that exemplify some of the difficulties in establishing textual boundaries beyond those discussed in my introduction to this chapter.

One important discussion on textual space can be found in the essay by Mikhail Bakhtin discussed in the previous chapter, "The Problem of the Text in Linguistics, Philology, and the Human Sciences: An Experiment in Philosophical Analysis." It is a long and wandering essay, and Bakhtin never finished it. The problem is partly its generative nature: Bakhtin sparred with several issues—boundaries, intertexts, space, and time—and seemed to find that this kind of shadow boxing did not lead to the definite conclusions to which he aspired. Partly because the essay is unfinished, and partly because it is described as an "experiment," I think we should read it with tentativeness that is willing to risk contradiction, the same sort of tentativeness that Bakhtin revealed in writing it. Much of the essay's impact is bottled up in one imposing proposition: "In order to understand [an utterance], it is first of all necessary to establish the principal and clearcut boundaries of the utterance."[17] There is nothing amiss here: as a purveyor of caveats, Bakhtin sounds almost like Fredson Bowers in the 1950s or Hershel Parker in the 1980s warning us that if we are to engage in textual excursions, we have the responsibility (to authors and to ourselves) to know where we are going before we go. The point is to evince our

familiarity with the site of the text's authority in relation to other sites. Somehow this makes perfect sense because Bakhtin's desire for a kind of textual topography, a textual Baedeker, is the sort of thing that would seem both obvious and reasonable. But to place caveat beside caveat: what is reasonable is not always possible. Textual critics are fond of speaking of texts as individual instances of a work (which in fact they are); but when they speak of texts as physical instances of a work, they are presupposing (without defining) what exactly constitutes the physical boundary of the physical text. This is one of the most troublesome imbroglios facing textual criticism. Historically, the "clear-cut" boundaries of literary texts have been imposed by the practical constraints of editorial theory and publishing conventions (a text of Keats's "Nightingale" ode has to end somewhere so that it can be "reprinted" in an edition). But the textual space of an edition is an artificial space, a product of certain academic conventions guided both by pragmatic and economic realities. Were we to say that a text can be circumscribed by physical features, as a painting might be circumscribed by its frame, then we are positing, perhaps arbitrarily, a boundary of our own: it is less germane to texts per se than to the activity of perceiving them. Thus one could argue that a frame does not demarcate space but merely establishes an illusion of space.

Perhaps our biggest problem here is our tropes: spaces suggest boundaries, boundaries imply demarcation, and demarcation connotes categories. The very terms with which we engage in discourse about cultural texts thus tend to oversimplify their status as overlapping and interwoven signifiers. Additionally, the less definite notion of *context* is troubling in its own way. While a context or a contextual field might be said to manifest itself in physical forms (documents, social archives, oral narratives, drawings, letters, and so on), the process of relating these texts with other texts engages metaphysical (i.e., cognitive/semantic) processes. History cannot be relied upon to provide us with answers about contexts because history is itself composed of language—fiction on fiction, so to speak. Not so suddenly, then, we find ourselves in the midst of deconstruction's essential argument: the methodological field—what Barthes calls "a multi-dimensional space"—of intertextuality.[18] Bakhtin himself came to realize this problem, and I think this partly explains why his essay "The Problem of the Text" is, if shadow boxing, a case of the shadow pulling off a close decision. At one point he writes:

> We are interested primarily in concrete forms of texts and concrete conditions of the life of texts, their interrelations, and their interactions.[19]

Soon, however, he runs into trouble:

> But how are the firm boundaries of the utterance determined? By metalinguistic forces.
>
> Extraliterary utterances and their boundaries (rejoinders, letters, diaries, inner speech, and so forth) transferred into a literary work (for example, into a novel). Here their total sense changes. The reverberations of other voices fall on them, and the voice of the author himself enters into them.[20]

And in closing he comes close to engaging Derrida's claim that there is nothing outside the text:

> Words and forms as abbreviations or representatives of the utterance, world view, point of view, and so forth, actual or possible. The possibilities and perspectives embedded in the word; they are essentially infinite.
>
> Dialogic boundaries intersect the entire field of living human thought.[21]

Although there is no overt allowance for the reader, Bakhtin recognizes, I think, that the boundaries of utterances are unedged, that the idea of a boundary is actually a contradiction of itself. Thus it would seem that the goal of establishing clear-cut boundaries is impractical. On the other hand it is perfectly realistic to desire a sense of place—the topos by which one does not map a location but unmaps it and gets lost in it as a means of becoming familiar with it.

A metaphor frequently used to describe this activity is that of *framing*. Framing suggests circumscription, but unlike the word *context*—which retains both the notions of text and texture—framing suggests something finite. For Irving Goffman, whose *Frame Analysis* (1974) constitutes the first lengthy examination of the frame as an analytical tool, its fundamental purpose is to identify elements that constitute the organization of experience. The frame is thus not a set of natural phenomena, but merely those phenomena that are part of the viewer's conscious and unconscious perceptions. Perceptions, however, imply a relativity that is contradicted by the implied positivism of the frame. Clearly, a painting is contained within a frame, but the audience looking at this painting will see beyond this edge of the frame to that which lies beyond: the paintings beside it, the labels on the wall, the carpet on the floor, the spider web in the corner. These are

merely the physical constituents of the frame beyond the frame; what about those that lie out of sight?

One instructive and useful discussion on this subject can be found in an essay on the film frame by Gerald Mast. Mast contrasts the film's frame as one that is "constantly shifting," while that of a painting, or, say, the proscenium arch of the theater, is more stable and finite: "[W]hat is inside the frame of a painting is the painting and what is outside it is not."[22] The nominal empiricism of this distinction seems quite true; Mast even suggests that such frames function analogously to milk cartons: "[W]hat is inside the carton is milk and everything outside it is not." This seems untroubling enough. But knowing that the milk is inside the carton does not validate it. Can we trust that the milk in the carton is OK to drink without reading the sell-by date on the carton, and what can we know about the sell-by date without also looking at the calendar? The physical boundary is clearly defined: it localizes the milk and serves a particular pragmatic function. But that function is good only in relation to other functions, such as knowing whether or not the milk is good to drink. In other words, intertextual relations are to some extent necessary, and this in turn points the way to textual inter*dependence*. Mast's milk carton analogy forces us to consider how much the physical notion of a frame plays in our reading of texts, whether those texts are paintings or milk cartons, poems or cereal boxes. Beyond the physical boundary of the milk carton lies a huge and telling compendium of issues that tell us, if we want to know, a good deal more about the contents of that carton: cows, for example, and the farmers who feed them, and the social, political, and economic factors relevant to milk production and consumption at a given place at a given time. Simple.

And perhaps not. As Mast says, frames enclose, but their enclosure (like the kind offered by the New Critics) is one that belies the history of that which they enclose. A frame is simultaneously a physical border and a permeable membrane: we use it to localize a text, and then map that locale as part of a larger, more worldly text. The activity is beneficial, but only inasmuch as we realize its limitations and its lack of an exclusive territorial boundary. These are, as I mentioned earlier, imbricated boundaries: they overlap. Such boundaries are fundamental to the arts, particularly architecture. We might for example speak about how a building is situated—how, as Witold Rybczynski says, it is the specificity of a fixed place that distinguishes a building[23]—and in doing so we realize how a building, like a painting or a poem, breaches its physical frame to encompass a sense of place, and how in turn that topos is part of a larger

landscape. When Francesco Clemente says that his best shows are those he puts on for customs agents at four in the morning after an eight-hour flight, he is not being flip.[24] Most of his work deals with various aspects of psychosexual identity, and it is precisely the act of unveiling this identity as the works are exposed from their wrappings that is so important: the exhibition is a performance, a striptease for an audience unprepared for what will come next. It is not the viewer who passes before the paintings, but the paintings that pass before the viewer. In Larry Gagosian's New York gallery, one is prepared for Clemente's surprises: that is a condition under which one passes through the gallery door. But this condition does not hold for Clemente's exhibitions before customs "collectors," an exhibition that is underscored by its monetary purpose: here it is the artist who pays money for the privilege of exhibiting his cultural commodities. What we find hard to accept is that the topography of exhibitions like this is not exclusively physical, even though we can see and touch the texts themselves; we can own them too, as we can own Van Gogh's *Irises,* although we cannot own the idea of Van Gogh's *Irises,* nor its network of intertextual associations. This, as I have already mentioned, is a paradox that can be solved only by acknowledging that it cannot quite be solved. Both literary and nonliterary works of art exist as real objects in real spaces, yet they are not immune to the influence of real ideas in mental spaces. By acknowledging this paradox, however, we are better prepared to examine the vicissitudes of those real spaces in which texts manifest themselves. This, I think, is the point at which certain theoretical paradigms have now arrived: it is by reverting to concrete textual spaces that they can better substantiate the tensions implicit in art's status as a cultural practice and thus validate criticism's aspiration for knowledge. Textual critics have known this for many years, but only recently have they come to value what was previously devalued as lacking authority; and both historians and critics of art, working with a subject matter once considered inappropriate for textual criticism, are beginning to acknowledge that artworks are themselves texts, and that these texts are subject to being read much in the same way that we read literary texts.[25]

Artworks and Art Texts

Before I reinitiate my discussion on subjecting artworks to textual analysis, I would like to begin by emphasizing the need to remember that there are

certain unique characteristics of art and literature as sign systems, and these differences partly explain why textual critics spend most of their time hanging out in libraries instead of museums.

The fundamental distinction lies between those sign systems that are isomorphic (like language and music) and those that either lack isomorphism (oral languages) or are what art theorists like Nelson Goodman would call "dense" sign systems (painting, sculpture, and so on). The distinction here is not between linear and nonlinear systems, but between systems that possess some kind of conventionalized writing and those which do not. Some languages and certain languagelike codes have notation systems and recombinant units (music, for example, and to some extent dance), and textual criticism is essentially a study of these units, a way of describing and differentiating them, and, with a cohesive methodology, a way of documenting their shifting presences. What is important to remember is that textual criticism historically uses only the documents of notation, but not the performances for which they may or may not have been created (e.g., oral recordings, musical performances, and so on). Writing is arguably both a performance and a score; but a performance, unlike a score, lacks the same kind of iterability: we cannot transcribe suprasegmentals, gestures, and intonations with the same sort of ease that we punctuate sentences. For most of us this probably doesn't matter, but for some of us it does; and since performance texts constitute an important mode of textual distribution, they should be a part of our textual consciousness, if not also a regular part of our editorial documentation in the construction of textual stemmas.

Precisely the sort of problems one encounters in trying to initiate or apply a textual analysis to dense sign systems can be observed in a recent National Gallery exhibition of Jean Siméon Chardin's three paintings entitled *Soap Bubbles*. In a brief catalog essay, Marcia Kupfer writes:

> The exhibition brings together the three known versions of *Soap Bubbles*—all original works (or autograph replicas) by Chardin himself—now in the collections of the National Gallery of Art, the Metropolitan Museum of Art and the Los Angeles County Museum of Art. This focus sheds new light not only on Chardin's practice of self copying, but also on innovative aspects of his art.[26]

If we think of an "autograph replica" as something analogous to a holograph fair copy of a literary text, then we would immediately recognize

that these replicas are not mere replicas, or even copies, but multiple texts of a single work. The idea of multiple texts in art might strike some people as being odd, but it was a habit of Chardin (and others) to undertake a number of separate executions of one primary composition,[27] and in *Soap Bubbles* the differences are to be found in the exact size of each painting, and in other subtle but distinguishing features: the relative transparency of the bubbles, the size of the chip on the stone ledge, the presence of honeysuckle vines (conspicuously absent from the Los Angeles text), and in Chardin's own signature ("J. S. Chardin" in the National Gallery and Los Angeles texts, "J. Chardin" in the Metropolitan text). What kind of textual apparatus can help us here, what kind of textual genealogy can we prepare for these three available texts? Conceivably one can get down to brushstrokes and tonal values if one wants, but one cannot isolate an iterable unit. Art theorists have long sought a minimal unit that corresponds with the phoneme in language, but their efforts have repeatedly failed.[28] This explains the tendency to refer to dense sign systems. Lacking an isomorphic code, then, differences are transfigured (even transmodulated) to language because they are described (as I am doing here) via the medium of language. The one present alternative is to present photographic records of all three texts, as the exhibition catalog does. But this merely provides surrogate texts and does not isolate or otherwise identify the differences in the texts. Additionally, because the texts have been reconfigured into a different medium (the photograph) and their size and context altered (I can carry the photograph in my pocket and even write on it), we find ourselves in the midst of some kind of textual chaos since the photographs themselves become additional texts of the artwork called *Soap Bubbles,* part of the unceasing process of textual production in a society marked by the production and consumption of cultural goods.

The Chardin example is useful in a number of ways. It shows us that certain aspects of textual production in art and literature are more closely related than we have traditionally thought, while at the same time the sort of practical solutions that textual criticism has developed for literary texts do not readily adapt themselves to dense sign systems. This, however, should not impede our attempts to more generally discuss the implications of text production in the arts. Although the standard catalogue raisonné (which provides information about the provenance and exhibition history of individual artworks) can be described as a form of bibliographical indexing, its usefulness in critical discourse is underutilized, as,

say, the usefulness of definitive editions with variant states is frequently overlooked by literary critics. Textual critics have a particular tendency to whine whenever literary critics (particularly deconstructionists) use spurious texts, but the gesture could be returned to textual critics when they engage in theoretical discussions about art, for in such discussions they frequently make analogies that are disengaging, facile, or simply wrong. As much as textual theory depends on concrete examples (a point emphasized by Jerome McGann in the introduction to *The Textual Condition*),[29] a textual theory of art must operate under the same premise. To depend on nominalism (as Nelson Goodman does) or on semiotics (as Wendy Steiner does) leads to a theory of codes that is useful but not in the end useful enough. Textual criticism, we must remember, is about codes only insofar as they are *engaged* codes, and it is the act of engagement (aesthetically, socially, and economically) that makes them unique, and therefore of critical interest.

At this point the important question to consider is one that I posed earlier: is there a fundamental difference between artworks and literary works when we consider their placement in networks of artistic production and dissemination? As sign systems there is no question that differences exist. But how do we regard the production, the distribution, and the reception of these sign systems? This seems to me a question that has received only modest inquiries. G. Thomas Tanselle, for example, has argued that a painting exists in one place only—it cannot, he claims, be in two places at one time[30]—and at first one wants to agree. But in the end one cannot, because Tanselle's position is too ideal to survive the consequences of mechanical reproduction and technical transformation. As I mentioned earlier, artworks get reprinted in a wide variety of media, and it is usually a reproduction, not the "original," upon which our familiarity with a specific work is based. We read these reproductions because they have become assimilated as a mode of cultural consumption: mass consumption of mass culture, so to speak. It may matter to an art historian that the original of Michelangelo's *David* is kept indoors (to protect it from adverse atmospheric conditions), but it does not necessarily matter to people viewing a copy in the courtyard of Palazzo Vecchio, particularly if they are unaware that the copy is a copy. They are still going to look at it, swoon over it, take pictures of it, and show those pictures to unsuspecting neighbors—even G. Thomas Tanselle. The very existence of a copy represents textual dissemination at work and poses its own cultural questions: why is there a need for a copy, and what does the existence of this copy

mean in relation to Michelangelo, the "original," and the societies that both created the copy and view it?[31]

Tanselle, however, is not alone in believing that artworks and literary works are fundamentally different, and for this reason I would like to tease the problem a bit more. Not too long ago both Peter Shillingsburg and James McLaverty offered a question that is particularly relevant here: "If the *Mona Lisa* is in the Louvre in Paris, where is *Hamlet*?"[32] My problem with this question is that in answering it we have spent more than a fair amount of time looking for *Hamlet* while accepting, without question, the presupposition that Mona is sitting alone in the Louvre. Like Tanselle, both Shillingsburg and McLaverty take the position of equating the artwork and the art object (*Mona Lisa* is therefore a particular painting in the Louvre) while acknowledging that *Hamlet* is not a thing, or an object, but a class of objects. While it is true that there is a painting called *Mona Lisa* in the Louvre (where she is also called *La Joconde,* an important difference), it would be misleading to accept that the painting is an autonomous object. I would guess that most Americans could identify *Mona Lisa* in a lineup of other paintings (as I would also guess most Americans have no idea who or what *La Joconde* is), and they could do so not because they have been to the Louvre but because of their experience with textual 'reproductions.' I want to bracket the word *reproduction* at this point because, like the textual-critical term *reprint,* we must acknowledge that there is no such thing as re-production. Even forgeries of paintings, like piracies of Byron's poetry, have unique textual histories. To ignore them or marginalize them would be paramount to ignoring and marginalizing the entire human context by which art is made and consumed, as well as factors relating to its status within specific societies.[33]

What I am suggesting is that artworks and literary works, though perhaps intrinsically different to a nominalist, are extrinsically similar in the sphere of social and economic systems: in both cases our perception of the work is an extension of the historical and physical space inhabited by a specific text of that work. Suppose I were to write an essay on *Mona Lisa,* and suppose I chose to use as my "critical text" a postcard. I can imagine textual critics would frown at this apparent folly, as if I had chosen to write on Shakespeare using Bowdler's texts. But Bowdler, we must remember, is anything but unimportant as an editor of Shakespeare, and Mona's image on postcards reflects, like Bowdler's Shakespeare, a mode of cultural dissemination that fits a conspicuous social need.[34] The very fact that this need exists also reflects how society, culture, and technology adapt to each

other—the very matrix that gave us the foundation upon which bibliography and textual criticism exist. My essay on Mona would thus reflect the fact that her appearance on a postcard invokes a reading quite different than that invoked by the text in the Louvre. We are traditionally inclined to think of how an artwork transforms the space it inhabits—more literally how a painting "fills" a room—but we must also consider how a text is transformed by that same space. In the Louvre *Mona Lisa* does not sit alone but in the presence of guards, a humidity controlled vitrine shielded by two panes of three-layered bulletproof glass, dark walls, a roped barricade, innumerable viewers jostling for a better view, and the constant hum of camcorders: one cannot read the text without the presence of other readers. It's not exactly Bloomingdale's during a sale, but it's not what we call a neutral ambience either. I might argue then that the Louvre text of the *Mona Lisa* is not a mere painting, but a performance, a mise-en-scène in which the cultural status of the work is reflected in how it is presented and received. This is neither more nor less important, I would say, than Wordsworth publishing in quarto as opposed to duodecimo. I suppose it would matter to a curator whether a *Mona Lisa* at hand is Leonardo's *Mona Lisa* or a forgery; but a question like this is important only to a particular audience for particular reasons and does not eliminate other social encounters with the work and thus does not demonstrate that the painting itself is the work as well: we will always see the work, think about it, write about it, and compare it with other works on the basis of our textual encounters, and not solely from the point of view of the "original." To speak of the original as being privileged in art has some of the same overtones as championing the author's intentions in literature.

Understandably perhaps, both the art world and the literary world are strongly attracted to the psychological power of the notion of an original, which implies a kind of firstness, and hence primacy. The three Chardin paintings are sometimes viewed as troublesome because none of them bears the marks of being worked, of being a draft: there is none of the hesitation, doubt, or uncertainty that one finds in, say, the draft of Keats's "Eve of St. Agnes." X rays do not reveal what is known as pentimenti, or evidence of compositional revisions. There is merely the final finished product; and not just one, but three, all, it seems, templated from some lost original. One could argue in this case that the original is not the thing to hang on the wall of a gallery, but rather remains in the studio to be looked at, studied, perhaps even destroyed. For some of us it is texts like

these, full of tensions, that are more telling and interesting than finished products: they are texts that reveal the angst of uncertainty and unself-consciousness that is concomitant with evolving aesthetic forms. The values that we attach to these texts vary; for some they mean everything, for others they mean nothing. The kinds of aesthetic, social, and political questions that constitute cultural scholarship thus cannot be answered on the basis of one textual state, and so we find that the sort of texts we deal with are ultimately guided by the kinds of inquiries we are making. Neither the final product(s) alone nor the original(s) alone can do the job.

There are other ways of looking at shifting boundaries and multiple texts in art. During the 1980s the autonomous art object underwent fragmentation as conceptual artists from the 1960s refabricated and reconstructed artworks that had either deteriorated or (because of their size or fragility) did not travel well. The two key words—"refabricate" and "reconstruct"—are frequently used in critical discourse related to 1960s conceptual and minimal art.[35] Neither word, like the textual-critical term "reprint," is semantically honest. We know, for example, that reprints do not literally reprint since the circumstances to which they owe their existence are, as I mentioned earlier, unique. When an artwork is refabricated it similarly owes its existence to some unique condition, whether or not that condition is the product of authorial intent: *David*'s double, for example. And it is not just the presence of refabrications and reprints that is important, but also, in some instances, the absence of them (like the extremely long delay in preparing a paperback of *The Satanic Verses*) that is, or ought to be, of equal concern.

If writers are painfully aware of the hazards that exist between completing a manuscript and its appearance(s) in print, artists too should be aware of similar conditions that exist between making and exhibiting their work, particularly work that is not produced by the hand of the artist but is instead fabricated by others drawing on instructions provided by the artist. A large number of sculptors from the 1960s, 1970s, and 1980s fall into this category. The ideal situation is one in which there is a sense of control over how the artwork is ultimately configured and exhibited (one thinks here of how both Mark Rothko and Clyfford Still both felt extremely reticent about exhibiting their work with other artists and sought instead to create autographic environments in which their art, and only their art, was exhibited). Rothko, in fact, is a pivotal figure in the transition between the 1950s (which abandoned the easel for the mural) and the 1960s (which abandoned the mural for the installation), because it was Rothko's

commissioned mural installations (the Rothko Chapel in Houston commissioned by the DeMenils, and the uninstalled Seagram Mural Project) that embraced the ideals of both decades and emphasized a growing concern for the total sense of presentation, as well as the artist's role in controlling or otherwise having the right to veto the presentation.[36]

One such instance recently occurred in 1989 when ACE gallery in Los Angeles exhibited a copy of a large galvanized steel sculpture by Donald Judd. The original was in the collection of the Italian industrialist Giuseppe Panza; but rather than ship the sculpture to America, Panza "loaned" it to the gallery by authorizing a copy to be made, without Judd's consent or knowledge.[37] When Judd eventually learned about the sculpture's new text, he both sought and succeeded in having it destroyed. In addition to sending letters to the major art magazines explaining his position, he also took out a quarter-page advertisement in one of the most influential of those magazines, *Artforum:*

THE FALL 1989 SHOW OF
SCULPTURE AT ACE GALLERY
IN LOS ANGELES EXHIBITED
AN INSTALLATION WRONGLY
ATTRIBUTED TO DONALD JUDD.

FABRICATION OF THE PIECE
WAS AUTHORIZED BY
GIUSEPPE PANZA
WITHOUT THE APPROVAL
OR PERMISSION OF
DONALD JUDD.[38]

Judd's desire for control is understandable, but documents suggest that Judd never sold Panza the sculpture in question, but rather what the legal scholar John Merryman describes as "license to create the work under certain circumstances."[39] From the textual-critical standpoint it is precisely these different texts and the "certain circumstances" that are so vital in documenting the textual history of a work, whether that work is a poem or a minimalist sculpture.

Part of the problem here is the nature of Judd's work. Though an inveterate perfectionist, many of his sculptures are made in such a way that one cannot distinguish between an original and a copy on a purely material basis, and this makes ontological arguments moot. Judd might disagree, claiming that he could tell the difference; but that is like saying Michel-

angelo could pick out the impostor *David:* it separates the texts but does not negate them. The question is not which text is authentic, because both texts are authentic in relation to the circumstances that created them. The question is instead why more than one text exists, and what this means. Art historians, like textual critics, frequently see themselves as guardians of the "purity" of cultural texts; but when they insist on the repression or unimportance of forgeries, copies, and unauthorized texts, they become, in effect, censors of cultural history. Judd may have succeeded in destroying the ACE gallery text of his galvanized steel wall, but he did not and cannot destroy the reasons the text came to exist in the first place.

Lately, the art world has been treated to several public denials of authorship.[40] It seems to me if we asked why we are facing so much unauthorized textual proliferation (one thinks of Byron somehow) we could probably find some interesting answers related to the hypercommodification of art in the 1980s—something that reminds us that art is more than a mere cultural activity. Art is business, and the 1980s celebrated the pinnacle of this Warholean ideology by making business art. When Donald Trump purchased the Plaza Hotel, he took out a full-page advertisement in the *New York Times* extolling his artistic intentions with the landmark hotel by supplanting the discourse of business with the discourse of art: "I haven't purchased a building, I have purchased a masterpiece—Mona Lisa."[41] This may not seem too important just now, but I would hazard a guess that some kind of textual analysis of individual artworks will play a significant role in interpreting the social and economic status of these works when they are studied at some future time. Judd's advertisement, in fact, is just the sort of document that taps history on the shoulder. Imagine the editorial consequences of a similar advertisement by John Keats in the *Annals of the Fine Arts:* "Removal of the quotation marks at the end of the 'Ode on a Grecian Urn' was authorized by the Editor without the approval or permission of John Keats." Judd may be an audacious artist, but that audacity is just the sort of thing to make a difference.

It is this sort of audacity, however surprising it may seem, that is also a decisive aspect in preserving evidence of more unusual textual deviations in recent years. One particularly intriguing example can be documented in the French artist Daniel Buren's response to the *Bilderstreit* exhibition that was organized by the Ludwig Museum, Cologne, in the spring of 1989. Reacting to widespread complaints that the exhibition favored artists represented by Cologne's commercial galleries, Buren sought to withdraw his work from the exhibition. But because Buren did not own the works in

question (copyright laws in the United States and Europe do not protect art against unauthorized display as they protect literature against unauthorized publication), Buren had no direct recourse. What he did, instead, was make a public statement announcing that the work of his exhibited in *Bilderstreit* was "a Fake for as long as it is not taken out of the exhibition."[42]

Buren's position offers an unusual but extremely important insight. The idea that a material work can be authentic in one context and inauthentic in another opens up new considerations about the domain of textual space and how space may be represented as time ("a Fake *for as long as* it is not taken out of the exhibition"). Normally space is literally conceived, but because it is so difficult to circumscribe the boundaries of this space, we find it convenient to reduce it to images of time, which are markedly more finite and effectively conceptualize themselves as events. Historical space thus becomes represented as an accretion of histories made up of an artwork's association with social and political spaces. Since artworks owned by a collector or museum generally lie outside the artist's control, and since legal stipulations (including moral rights as defined by the Berne Convention and applicable copyright laws) offer only limited protections (most of which apply to unauthorized reproduction),[43] Buren's exhortation establishes a kind of ontological slippage: the Buren that is not a Buren will eventually revert to being a Buren. It is not the painting per se that constitutes the text here (in fact, when Buren issued his statement he was actually unaware of which of his works were to be exhibited); instead, the *Bilderstreit* exhibition itself constituted the textual frame by which the works were read and, more importantly, unread.

At this point I would like to explore related spatial problems by discussing once again the work of Richard Serra, whose sculpture entitled *Square Bar Choker* was exhibited at the Donald Young Gallery in Chicago during the summer of 1989. *Square Bar Choker* consists of two pieces of hot-rolled steel: a large plate, roughly $60'' \times 60'' \times 2''$, which bisects a corner of the gallery, and a $9'' \times 9'' \times 60''$ bar that is placed on the top edge of the plate and leads into the corner, thus locking the sculpture's balance by securing it to the intersecting walls. One could argue, as Serra himself might, that the sculpture both begins and stops here: that it is a study of the balancing, the rigging, the propping, and the locking of weight, as well as the psychological effect of weight. All of these issues are briefly mentioned in an essay Serra wrote as part of a catalog of his work made between 1987 and 1989,[44] and these issues also typify the arrangement to which Serra's work

aspires: the appearance of tenuous balance that is, when established, not tenuous at all. "The pieces aren't unsafe," remarked Serra in an interview; "the pieces have never fallen over—any of them—once they've been erected."[45] The danger instead exists when the sculptures are erected and dismantled by professional rigging engineers, and the score thus far suggests the difficulty of Serra's work: one rigger installing a sculpture at the Walker Art Center in Minneapolis was killed in 1971, while another lost a leg at the Leo Castelli Gallery when a piece keeled over during removal.

That there is a degree of risk involved in the process of installing Serra's work is not unexpected, particulary when dealing with works as large and as heavy as sixty (or more) irregularly displaced tons.[46] It is by no means easy, and it is partly by working primarily with one master rigger—Ray La Chapelle—that Serra is able to conceive, and achieve, the results that he wants. It is the riggers, in fact, who are a crucial cog in the collaborative process, because it is they who neturalize the physical tensions in the work. When an installation is completed, what remains is not the tension itself, but the illusion of tension: the uncertainty. It is an art considerably more complex than is generally acknowledged, in part because Serra has a way of diverting attention from the art to Richard Serra: he once published an overarching advertisement in *Art in America* (as part of an exhibition at the Leo Castelli Gallery) in which he declared (in response to the removal of *Tilted Arc*) "The United States Senate dictates censorship" and "The United States Government deprives artists of moral rights," among other rantings.[47] This is probably Serra's most troubling side as an artist, and it has the effect of inhibiting people from engaging in Serra's work with the sort of seriousness it deserves. There is, I think, something rigorous, even brilliant, about the way Serra's aesthetic demands an impeccable precision that can be found in the work of few other artists. That is one reason why *Tilted Arc* was removed: it worked too well by fitting its space too well. In a sense, everything Serra does is about getting the right balance and the right fit: even in his large drawings (which were recently shown at the Dawing Center in New York in the spring of 1994), there is this feeling that even in a work of immense dimensions every millimeter matters. Whether it does or it doesn't matter is not the point; it's the feeling that it does. That is precisely why the installation of *Square Bar Choker* at the Donald Young Gallery requires careful consideration. Unlike *Tilted Arc, Square Bar Choker* depended primarily on balance and friction to stabilize and secure itself. In order to protect this arrangement the installation was configured in a way that self-consciously guided the audience: a small sign

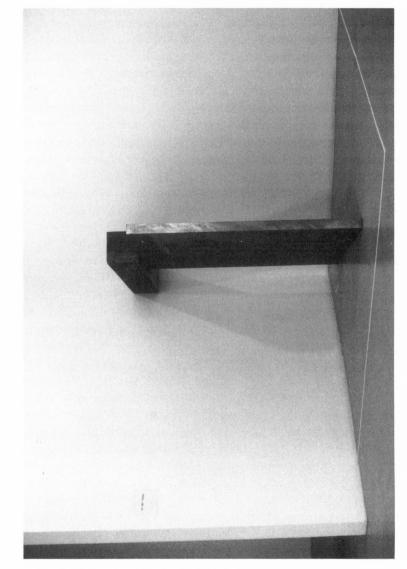

Fig. 11. Richard Serra, *Square Bar Choker*. Installation, Donald Young Gallery Chicago, 1989. Photograph by Diane K. Brentari.

on the wall informed visitors not to touch the sculpture, while a strip of white tape on the gallery's gray concrete floor established a boundary that implicitly warned visitors not to pass beyond it.

The sign that tells us not to touch the sculpture is strategically placed immediately to the left of the installation (where our natural point of reading begins) at eye level. As we approach the sculpture, we find that the sign interrupts the gallery's minimalist ambience; we do not expect to find language here. The sign thus pulls us aside to read its message, dispel it, and get back to the sculpture. But we find that we cannot dispel it, either conceptually (because it establishes an imperative about how we are to experience the sculpture) or literally, for its location is one that, though not dominating the installation, remains a part of it: the sign is either beside the sculpture or, more tellingly, behind it, while the tape—a reminder of the sign's warning—defines the front boundary. The sculpture is thus boxed in, or framed, by the warning that we are not to touch it.

Perhaps this is one of the piece's intentional ironies. Serra tells us that his sculptures are safe, but the tape on the floor tells a different story, and the tape in this instance was not atypical: three other Serra sculptures with which I have had recent personal contact (at the Lawrence Oliver Gallery, Philadelphia, in 1988; the Hirshhorn Museum, Washington, in 1990; and the Pace Gallery, New York, in 1991) were similarly separated from the audience.[48] The distance is disconcerting because the conceptual weight of *Square Bar Choker* is not in the steel we cannot touch, but in the sign and tape that tell us not to touch. Were the steel plate and bar actually made of papier-mâché, our perception of the piece would not be altered as long as this fact is hidden from us. We all know that art lies; what we don't know is *when* it is lying and *when* it is telling the truth. Our desires are stymied by being told we cannot investigate further, and we become further stymied when we realize that our desire to touch the sculpture means so much. And so we retreat into a position of acquiescence, into a position in which our interpretation depends to a great deal on our faith in the art, and in the language that frames it. Sometimes the warning is posed in a way that almost deliberately dares us to touch the sculpture, as if to dare us to *believe* the warning. In Canada's National Gallery of Art in Ottawa is another Serra installation (*Davidson Gate,* 1970) that consists of two upright 8′ × 8′ steel plates that are balanced on their edges and wedged into opposing corners of a small room. There is, however, no tape on the floor. Instead,

there is a bilingual (French/English) wall label at the room's entrance; the English portion reads:

Warning / Attention

Great weight & delicate balance are essential features of this work. Do not touch, nudge, push, or otherwise test the steel plates.

Children must be accompanied by an adult.

Of course, we can go ahead and disregard the "Do Not Touch" sign and actually touch the sculpture, as some of us no doubt will. Touching is the capitulation of desire: it elides the distance between eye and object, thereby completing the continuum between the two. But touching does not necessarily imply feeling, or recording, the veracity of what one touches. Instead it registers an encounter as tactile contact, as consummation. In one of the corridors of the Louvre, not far from the *Mona Lisa,* can be found a life-size bronze entitled *Resting Gladiator* by C. Louis Valadier (1780). The patina is dark umber, almost black, but as overwhelming evidence of our human desire to touch, and despite all that protocol demands in the Louvre, the big toe on one foot is shiny, polished, golden bronze. It gets touched—touched, tweaked, tickled—partly because we are not expressly told not to touch it, and partly because its shiny surface acts as a beacon, as an invitation, to carry on a tradition of having a clandestine encounter with a sculpture in the Louvre. This is the Shiny Toe Syndrome: its impetus is desire, not knowledge. To touch Valadier's *Gladiator* is to *steal* the touch, thereby increasing the intensity of our kleptomania to a peak, that is, to steal something that has no value whatsoever. We cannot even brag about our theft; it is, as a pleasure, a perversity that cannot be shared. The Do Not Touch sign that adjoins Serra's sculpture in the Donald Young Gallery represents institutional authority, but our conscience is not troubled by this authority. We are not, that is, worried about what might befall us should we touch the sculpture; we are worried, instead, about what will happen to the sculpture. Will it fall over or not? It is precisely by *not* answering that question, by leaving it open to our ambivalent skepticism, that the piece draws much of its sustenance; and this is one reason *Square Bar Choker* and other prop pieces by Serra are not likely to develop symptoms of the Shiny Toe Syndrome.

Serra's *Square Bar Choker* also provides us with an excellent example of multiple texts, but it is an example more closely related to my previous

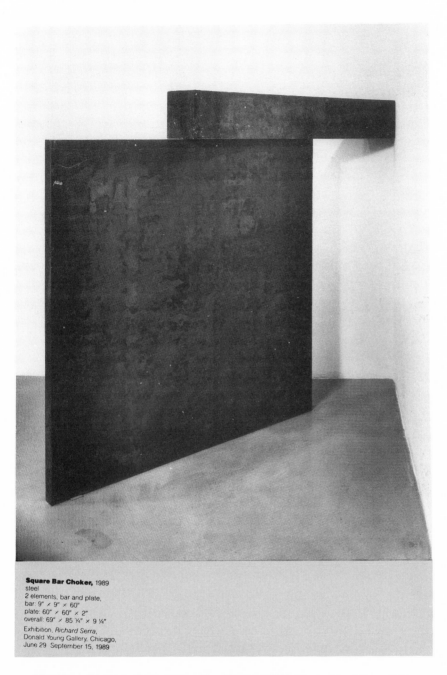

Square Bar Choker, 1989
steel
2 elements, bar and plate,
bar: 9" × 9" × 60"
plate: 60" × 60" × 2"
overall: 69" × 85 ¼" × 9 ¼"

Exhibition, Richard Serra,
Donald Young Gallery, Chicago,
June 29–September 15, 1989

Fig. 12. Richard Serra, *Square Bar Choker,* 1989. Reproduced from *Richard Serra: Sculpture* (New York: Pace Gallery, 1989), p. 47. Photo: Michael Tropea. Photo courtesy of Donald Young Gallery, Seattle.

discussion about *Mona Lisa* than Chardin's *Soap Bubbles*. Where the Donald Young installation of *Square Bar Choker* constitutes one text of the work, the Pace Gallery catalog of Serra's recent sculptures, which includes a photograph of the installation, constitutes a separate text of the same artwork, and both texts can be said to furnish their own distinct (but related) sets of critical possibilities.[49] The Pace Gallery catalog has a single photograph and description of the installation, the photograph being the eye with which we view the sculpture, an eye that for the most part constrains our peripheral vision. We see the sculpture as a fragile balancing act, but we do not see the tape on the floor or the warning on the wall. When I visited the show and asked if the installation was photo-documented, I was assured this was so; but when I asked if the tape and the warning were included in the photographs I was told, "No, those are for people."

This is significant in two ways: one, it was a candid admission (though not from Serra himself) that the tape barrier and wall warning were consciously intended to mediate our relationship with the sculpture—to chaperone our visit, so to speak. Second, there is an implicit admission that the catalog is detached from people while simultaneously remaining accessible to people. The catalog has no need to show the tape or the label because it already *is* a mediator between sculpture and people; that is, the catalog functions as the tape, as the safe distance from which we can view the sculpture. We cannot knock Serra's sculptures over in the catalog, they cannot sever our leg; and the sculptures do not, in the catalog, require an insurance policy for liability. And as the audience we cannot ping them: distanced from the sculptures, we trust the language of the description and the photographic context to assure ourselves of their weight. In the catalog we even notice a shim under the sculpture's lower edge and are invited to read this as a sign of the tolerances that are involved. Yet it remains inarguable that in both texts language establishes itself as the mediator of our experience of the sculpture. More surprising, perhaps, is that the conceptual weight of language varies here. In the catalog we read it as something necessary and inevitable; in the gallery, however, we find it has gained an uncharacteristic control. There seems little doubt that the future will hold for *Square Bar Choker* further textual states—perhaps even a hypothetical text where there is no tape on the floor, no warning on the wall, but merely the weight of our consciousness: to touch or not?

Textual Consciousness

What Serra's work does so convincingly is remind us that the art installation is essentially a bridge between a text and a context, just as a bridge—any bridge—is quite literally a site-specific installation.[50] Serra's installations not only acknowledge their physical context but also take advantage of this context (as the photographs in the catalog do), or force the viewer to acknowledge it (as the tape on the floor does). Critical diction related to contemporary art, particularly terms like "installation" and "site-specific," continually reminds us that most forms of cultural activity are not generic or nominal, but real events occurring at real places in real time. The degree to which this specificity is designated by author, artist, or (in the case of bridges) civil engineer is rarely absolute. In order to realize his work, even Serra must acknowledge the configuring influence of other forces anterior to his inclinations or desires: engineers, materials, spaces, gravity, and so on. Textual critics, in acknowledging how an author relates to editors and printers, occasionally describe this process as a collaboration,[51] but this word implies assent (or consent) that is not always present. The relationship between an artist and the cultural forces by which a word is configured and reconfigured is more properly a relationship characterized by tensions, constriction, and violence. Ultimately, the manifestation of a text is a climax that acknowledges the inevitable *failure* of intentions, a climax that is hardly fit to be called a collaboration since it at once accedes to a creator's desires and defiles them. While textual criticism historically regards these failed intentions as *failures,* my inclination is to instead regard them as a triumph of the resolute conditions under which they were made manifest. There is, I feel, something both humanely and inanely remarkable about how texts are remade in the course of their transmission, something that is at the same time fascinating and ridiculous because it reveals the end-*un*stopped extremes of cultural activity. We who study culture constitute a small segment of this activity, and our vantage point from the academic institution provides a very limited perspective of this activity, much of which comes to us secondhand as discourse about representations of art rather than as art itself. As I said earlier, however, textual criticism does not deal with nominal art: it deals with real texts and real phenomena, and when its methodologies are unable to adapt to new modes of textual dissemination as they arise as a part of cultural activity (dense sign systems, for example), it deals with real shortcomings: its own. This is precisely why textual critics should perhaps

spend more time in museums, in galleries, or even in studios: the physically emphatic aspect of art installations serves as a reminder that literary texts are installations too, and that their status as aesthetic signifiers is one that is similarly caught in a field of cultural forces. Editions, exhibition catalogs, and other means of textual "reproduction" regularly decontextualize these cultural signifiers, but as part of this process they also create new contexts that reflect additional modes of cultural consumption. The sort of stability editorial theory aspires to is thus undercut by its own activities: it seeks to maintain an author-centered status quo, whereas the author-centered moment never existed as a real event, nor can it. But this is by no means a cause for pessimism. By exposing the limits of textual criticism as a *methodology* we are encouraged to conceive it more as an *ideology*. The difference is important. As a methodology textual criticism has proven itself effective, useful, and extremely successful with certain kinds of literature (particularly Renaissance texts), but for other kinds of literature (say, performance texts), its inadequacy is almost embarrassing. Understandably, methodologies tend to fix themselves and avoid situations they are not equipped to handle. But as an ideology that promotes textual consciousness as a concomittant part of critical activity there are more possibilities, for this is just the sort of thing that makes "Hither, hither, love" more than a mere poem, and Chardin's *Soap Bubbles* more than a mere painting. It forces us to explore and acknowledge the vast spaces inhabited by textual appearances. *Context* thus does not define boundaries; it defines an *activity*—looking, feeling, discovering—as Rilke does poking around the Cézannes, working his way among them, and among the people among the Cézannes. This is what textual consciousness is all about: movement, not stasis; transitions, not positions. Texts position themselves, of course, but they are always being repositioned by cultural forces that cannot be predicted by a formal model: they are transformational creations of a transformational human culture.

To close this chapter in a way that brings attention to both a text's space and its nature as an event I would like to make a few remarks about a more unusual textual topic: bootlegged music tapes. Bootlegs are not copies of studio recordings that are sold illegally; rather, they are unauthorized recordings of performance texts: concerts, radio broadcasts, television appearances, and so on. Being unauthorized texts, most recording artists find them detestable, particularly as they preserve the audio context of the performance, a context that includes the normal (read: dynamic, chaotic) things that performances entail: radio static, hollering fans, dropped microphones, and so on. This can sometimes be a problem when making record-

ings of live orchestra performances: at a public forum in the autumn of 1991, New York Philharmonic director Kurt Masur lamented that it cost $100,000 each time the orchestra had to hold a recording session in order to remake sections of a performance that had been "marred" by coughing in the audience.[52] It's an expensive way to correct an auditory proof, particularly as it presupposes the conditions by which the text is "marred." And it also presupposes what we might call the protocol of the genre: people aren't supposed to hear coughing when they're hearing Yo Yo Ma in the middle of a cello solo. But this, for better or worse, happens, and it reflects the conditions under which orchestral performances actually occur. Masur might thus be excused for trying to protect the integrity of the genre and his own intentions as director, but he cannot control these conditions any more than an author or artist can. Bootlegs thus present a conceptual counterpoint. Among some people they are actually gaining favor, perhaps even a privileged reputation, because they contribute to expanding the institutional spaces in which music manifests itself. Not too long ago the *New York Times*'s pop music critic, Jon Pareles, wrote a brief article on bootlegs, and more than any other piece I have read on textual theory does it communicate clearly, effectively, and unpretentiously the idiosyncratic value of textual consciousness in the arts:

> One of my favorite unauthorized recordings is a cassette of a 1988 Keith Richards concert at the Beacon Theater. Taped (I happen to know) on a pocket recorder with a one-point stereo microphone, hidden under a seat, the cassette is sonic sludge, particularly after a few generations of cassette-to-cassette copies. The singing is way out of tune, the bass and drums are muddy and the audience whoops and hollers continually. No recording company would dream of putting it out; most of the songs had just appeared on Mr. Richards's "Talk is Cheap." But it sounds great—wild, sloppy, riotous. It has the secret of a prime bootleg: it sounds like an occasion, not a product.[53]

Chapter Five

Intratextuality

Inter/Intratextuality

Our traditional conception of textual space in art, like our notion of textual space in literature, works primarily around the premise of intertextuality and the ways in which the artwork responds to, or plays off, other artworks. *Il n'y a pas de hors-texte:* Derrida's limitless textual space is a space for an infinite number of comings and goings, entrances and exits, and atemporal conflations. As a bibliographic space, the textual space of a book implies something else: beginnings, endings, and linearity—recto, verso, recto, verso, recto, verso, all without fail. In an important way, the space between books takes us closer to a space that is emphatically, abstractly, *between:* the labyrinth of the library, where books, cover to cover on shelves, actually touch. Here in the stacks, as in the card catalog, there is order and disjunction, the entrances and exits of text vis-à-vis text: a collection. For artworks, the museum is a little like this, perhaps even more self-conscious of its intertextual function than the library. A place consisting largely of pathways and rooms, the museum is, as Philip Fisher observed, a place for juxtapositionings and interaction, a space in which works of art are not merely artworks, but comments on other artworks.[1] In this respect the museum constitutes a mode of critical discourse: using a combination of both the verbal (catalogs, guides, labels) and the nonverbal (artworks, frames, rooms), it does not so much display culture as interpret it so that our arrival involves reading what has already been read for us—what has been, in a sense, "edited" eclectically. The museum is thus a paradox in that it is both distinctly discursive and distinctly hermeneutic, both a site of play (in the Derridean sense) and a site where the playing has been done for us.

The difference between how individual works of art relate to other

individual works of art (what is generally known as intertextuality), and how individual works of art relate to their textual Others and the construction of those Others (what I shall call intratextuality), is important. As artworks are subsumed by various modes of mechanical reproduction (postcards, slides, and monographs), and as these texts are interjected into the sphere of conventional art spaces (studios, galleries, museums), the resulting conflation of authority breaks down the distinctions in the media so that intertextual discourse has the effect of being monotextual: the work is discussed as if it has only one text, and it is discussed in relation to other works—so that, in the end, we realize that the term *intertextuality* is for the most part about the relationship between different works rather than different texts. But as much as there is more than one *Hamlet* there is more than one *Mona Lisa* or one Sistine Chapel. As Jerome McGann recently wrote, "Every text has a variant of itself screaming to get out, or antithetical texts waiting to make themselves known."[2] As a work of art is reproduced by different media and/or reterritorialized in different exhibition sites, the work passes beyond monotextuality. Michelangelo's recently restored Sistine Chapel is not, as we saw, simply Michelangelo's chapel, but a chapel remade (both by cleaning it and by photographing it) so that it is subsequently read as an accretion and imbrication of texts rather than as simply one unique work.[3]

While McGann is correct to note that every text has variants of itself, these texts draw attention to themselves not by screaming at us, but by their insolicitude. This is a warning sign: a passive text can be passive only by hiding that which is not seen and which must be sought out on the part of the reader. This seeking, or reading, involves certain activities that are fundamentally editorial and curatorial in nature: collecting, assembling, sorting, working our way through the variorum of our textual assemblage so as to construct what is ultimately named a *text*. This text is unique in the sense that it is our personal text, for in the process of assembling it (as in our editorial and curatorial operations) we participate in the construction of it. Our participation marks our engagement in textual remaking: how, in a sense, reading is itself an inherently eclectic activity that involves both the selection and rejection of textual traces that can be found in and about the text's ulterior spaces. I use the word "ulterior" ("lying beyond what is immediate or present, coming at a later stage, further, future"—OED) only tentatively at this point to designate the space of a text that is latent, or even supplementary—frames, titles, captions, and so on. This is Gérard

Genette's "paratext" (*para-*: by the side of, alongside, past),[4] as measured, one supposes, from an immeasurable center: something outside the text yet also inside the text. It is also, to an extent, Derrida's *parergon* ("this supplement outside the work," the work being, for Derrida, the thing itself, the art object).[5] For Genette this ulterior space is *alongside;* for Derrida it is *outside;* can it be inside without being outside, inside without actually being present—peri- (round about) textual? Intra- (inside, within) textual? Outside-yet-inside: my preference for intratextuality acknowledges that when supplementary traces are engaged, they no longer lie outside the text, are no longer merely beside it, but have become reprepositionalized, as a title might be above or below or beside a text but when read *enters* the text. Gauguin's titles often do this literally: painted directly onto the canvas, sometimes framed within the framed painting (offset by a *painted* frame and a monochromatic background), that which supposedly merely supplements the painting has become its center: the text inside the text.

This chapter is an attempt to show how this intratextual space is problematic, and my approach involves looking at, around, and behind one work—Jackson Pollock's *Number 1, 1950 (Lavender Mist)*. My inquiry engages questions about the work's title(s), its maker(s), and its media and how this information is represented by the painting, the museum label, and different publications. While there is, ultimately, an emphasis on the relationship between verbal and nonverbal codes (including linguistic and nonlinguistic signatures), the emphasis is not reducible to a matter of discussion about the ligature between words and images. Instead it is about the relationship between one kind of space and another kind, and the ways information is moved between these spaces both by their makers, their institutional remakers (curators, editors), and their readers.

Outside yet Inside: Labels and Media

In the East Wing of the National Gallery of Art in Washington—I. M. Pei's brilliantly open and disjunctive space—one has the freedom not just to move among the rooms and the art with unconstrained latitude, but, because of the way the rooms and doorways intersect (there are no squares in the East Wing—it is a Euclidean composition of triangles, rhomboids, and trapezoids, even in the elevators), one has the oddly engaging opportunity to look at the people looking at the art, and to look at how they are

moving in relation to the art. Perhaps Rilke, positioned between the two rooms of Cézanne's exhibition in the Grand Palais in the autumn of 1907, would have felt spoiled among the perpetual interfaces of art and spectators, spectators and art, in Pei's building.

Our ability to take on the role of voyeur is one way in which we are able to affirm the museum's intertextual approach to its taxonomy of cultural history. In one of the lower exhibition rooms of the East Wing can be found Jackson Pollock's *Number 1, 1950 (Lavender Mist)*. To the left of *Number 1, 1950* is one of de Kooning's *Women;* to the right is a doorway to a cul-de-sac containing Barnett Newman's twelve *Stations of the Cross*. But the space that *Number 1, 1950* inhabits is unconstrained by these presences: they are there, but no one is obligated to read them. That is, we have immense latitude in how we direct our passage through the rooms and pathways of Pei's building. An audio guide takes us in a predetermined path, as does the ramp of Frank Lloyd Wright's Guggenheim Museum, where one has the choice of ascending or descending. A book is like this too: linear. But a museum, despite guides and maps, is a space that is often read discursively. Some people go from de Kooning to Pollock, while others go from Newman to Pollock, yet nobody seems to go from the forehead curls of Leonardo's *Ginevra de' Benci* to Pollock. But that is because Ginevra and her curls (which to me are very predisposed to Pollock) are on the main floor of the West Wing, some 613 paces away via the underground passageway, and even more if one detours at the concourse buffet. Some people walk past the Pollock without even looking. (Is it the Kline next to the de Kooning that pulls them past the Pollock, or is it the Newman they're still trying to get out of their head, or is it the Pollock itself—as the saying goes, see one and you've seen them all?) Some, however, start with the label, while others begin with the painting. And some spend a long time going over the painting, moving from label to painting to label again. It seems to matter too who the viewers are with, if anyone: a friend, a lover, a mother. Groups of critical schoolchildren may have big mouths, but they also have quick eyes: of all the people I have observed observing *Number 1, 1950,* it is they who are quickest to exclaim: "Look! A bug!"

A bug? Well, yes. As if to find it is to crack the code. It's not too hard to find if you look closely enough: three feet from the top, four feet from the right edge, firmly embedded in the pink and black Duco enamel. A big bug really, a good inch and a quarter long. A cicada. Mummified by the paint. Perhaps even more than Pollock's idiosyncratic mode of painting

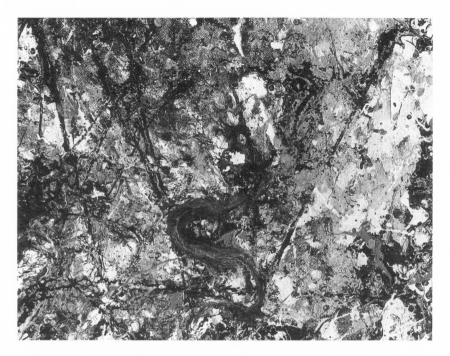

Fig. 13. Jackson Pollock, *Number 1, 1950 (Lavender Mist)*, detail. National Gallery of Art, Washington, D.C.; Alisa Mellon Bruce Fund.

does the bug draw attention to the complexity of authorship. How the bug got in this painting isn't clear. What is clear, however, is that the bug was, at some point, quite alive as it crawled across the wet surface of the painting, dragging its body through the pink topcoat and dredging from beneath it Pollock's trademark black Duco, leaving a pronounced, gray, S-shaped trail through the work.

Foreign matter is typically not foreign in Pollock's paintings. He regularly used as media in his work the detritus of his everyday existence: cigarette butts and ashes, shards of broken glass, nails, screws, and sand. He even used, as Lee Gray pointed out to me during a visit to the Metropolitan Museum of Art, paper muffin cups. At least there is a folded and rippled blob that looks like one in *Autumn Rhythm (Number 30, 1950)*. The inclusion of these materials was, for the most part, conscious, sometimes consciously histrionic, as when performing before Hans Namuth's camera. But the bug? For Pollock to have thrown it into the wet paint, to have watched it drag itself first to the right, then to the left, and then to the

right again—pulling and dragging as the paint stiffened around it—for Pollock to have done this and to have watched this, though not unthinkable for Pollock, would have been a quintessentially sadistic act. It could have been an accident too: a cicada easily could have flown into the painting. Pollock's shed-cum-studio out in the boonies of Long Island wasn't exactly the counterpart of Proust's hermetically sealed room. Pollock, of course, did not admit to accidents in his work: the automatism of his stream-of-consciousness mode of painting meant that accidents theoretically could not exist. This surreal bug could exist consciously only in a painting by René Magritte: *Ceci n'est pas un accident*. But this is not Magritte's painting. It is, with certain qualifications, Pollock's. But that is precisely one of the problems: although Pollock may have been the author of *Number 1, 1950,* he clearly is not the only one who configured its surface.

The label on the wall beside the painting in the National Gallery does not admit this, however. It says that the author of the work is "Jackson Pollock," and Pollock's signature is there in the painting, a tight, slightly sloppy "Jack Pollock 50" inscribed in the lower-left corner. No credit to the bug. Yet the bug's signature is there too: that slow, gray, S-curve through the pink somehow fits the painting, is less conscious of itself, less contrived, and more germane to the work than Pollock's own signature. It has a sense of belonging, whereas Pollock's final conventionalized gesture separates the painting from its act of creation and announces it as a painting. Pollock's signature is an affixation, but the bug's signature, to the contrary, is something else. But what exactly? What does the presence of this bug mean, and how might we understand its relationship to the presence of language in and about the painting—Pollock's signature, the title, the media, and other information cited on the title card—what, in the idiom of curatorial discourse, is called a "label"?

A label: from Old French, a ribbon or fillet—that which is *attached to,* affixed, and hence, supplementary. To label is to designate, as, say, a mailing label functions as a mode of localization by which both name and destination might be recognized. But we know at the same time that a parcel with no label will go nowhere: its contents will be unredeemable. It will, therefore, be co-opted or looted of its contents. As an attachment, the label also protects the document from unauthorized access. A museum label is a little like this too: it regulates certain kinds of access to a work. If artworks could themselves say everything they needed or wanted to say,

labels simply would not exist. But because they do exist, we must recognize that labels perform a significant linguistic function: they *name*. That is, they perform a naming function by categorizing information about a unique, real-world object. The object is thereupon ascribed a place in the network of human history. The ascription is deliberate. As Michael Baxandall has said, the museum label "does not describe the object. It describes the exhibitor's thinking about the object."[6] A label, that is, is a *curatorial* interpretation (of both the object and history) that functions in part to convince us that the institution has vetted the work. Like a birth certificate, the label also authenticates origins: the art object is designated by name, date of birth, and nationality. The purpose of the label is to taxonomize, and thereby metonymize the museum's own larger taxonomic function. But what is being organized, and how might the process of inscribing labels itself be a fiction, if only a selective fiction?[7] Pollock's painting—I will henceforth call it Pollock's as a matter of convenience—has not one, but two titles, both quite different semantically. In the National Gallery, posing on the wall roughly three feet to the right of Pollock's painting, in 24-point black Helvetica roman on clear plexiglass, the label reads:

Jackson Pollock

American, 1912–1956

Number 1, 1950 (Lavender Mist)

Oil, enamel, and aluminum paint on canvas, 1950

Ailsa Mellon Bruce Fund 1976.37.1

What the label does not make clear is an important distinction: *Number 1, 1950* is Pollock's title. *Lavender Mist* is Clement Greenberg's. I will come back to this point later. The brief citation of the painting's media seems selective: the bug, which is an inconspicuous presence in the painting, is here an inconspicuous absence. The title, which seems to say too much, appears awkward against this list of media, which doesn't seem to say enough. It's not always like this for other paintings by Pollock: *Galaxy* (1947) is described in the catalogue raisonné as being of "Oil, aluminum

paint, and small gravel on canvas"; *Full Fathom Five* (1947) is described as "Oil on canvas, with nails, tacks, buttons, keys, combs, cigarettes, matches, etc."[8] One of Pollock's recent biographies has it a little differently: instead of "combs" it has "coins," and instead of "keys" it cites just one.[9] But which one? And that "etc." is ripe with implications. The list of media for *Number 1, 1950* leaves us a little less enthralled: why is the enamel and aluminum paint privileged over the bug? Surely the presence of the bug has its meanings; but what about its absence from language, its displacement from the painting's linguistic locus? Suppose that the label's list of media instead read: "Oil, enamel, aluminum paint, and *Magicicada septendecim* on canvas." How then would we look at, and think about, the painting?

Let's look a little closer at the media of Pollock's work—something that is both present (in the text) and indexical (in the label). Pollock's paintings with cigarette butts or sand we tend to read by using the label as a conceptual connect-the-dots activity. It's perfunctory, a bit monotonous, and in itself unsatisfying as a reading—one invariably wants more out of the experience. But it is hard to expect more out of this experience when we have become inured to getting so little out of it in omnipresent citations like "oil on canvas." This is the sort of naming operation that says everything we do not need, and perhaps do not even care, to know. But the phrase, "Oil, enamel, and aluminum paint on canvas," as the label for *Number 1, 1950* actually says, takes us a little further: this is Pollock's trademark iconography, an iconography that does not point to written texts, but to technological texts: Duco (alkyd) enamel and aluminum paint. But to find a bug where there's supposedly not a bug, or at least not a bug worth mentioning, one is struck by an absence of acknowledgment where we would otherwise expect one to be—why, after all, mention the canvas, when it's so self-evident? But the absence of a linguistic acknowledgment does not mean an absence of signatures: as I mentioned earlier, our cue is the S-shaped indexical trail, which, cutting through the fading pink enamel, leads us to its maker. The double elliptical curve of the S-shape is so much at home in the painting that it is easy to overlook it—a synecdoche almost, the bug's wandering gesture like that of Pollock, whose own double gesture (walking around the canvas and swinging the paint with his own elliptical movements) was always at the perimeter of the painting. There are three handprints along the right margin and at least six more along the left, with Pollock's signature in the lower-left corner.

Pollock's place: the edges, the corners. Only the bug could get where the paint was thickest: in the middle.

Signatures are, in a sense, nothing more than traces, not just of authors, but of appropriators—like initials in sidewalks and on beech trees. A signature says: "I was here," as Van Eyck says in his Arnolfini wedding portrait, "Johannes de eyck fiut hic." Signatures are not always simply names, but are also nonverbal representations, as in self-portraits. These are iconic signatures: they provide presence of a particular kind. At a more complex level, hidden self-portraits are sometimes incorporated into a composition as a reflection on a glass or ceramic surface, as in the work of Pieter Claesz and Clara Peeters.[10] Iconic signatures do not so much say "I was here" as they say "I'm still here." The conventionalized way in which Pollock signed *Number 1, 1950* is worth examining more closely in relation to other traces of his presence, particularly as the signature in the text of the painting is supplanted, upstaged even, by the label, which verifies and authenticates the signature by providing an institutional seal of approval. As a convention the label has conditioned us to presume an artwork is guilty until proven innocent and in possession of this label. Second, the most authentic of signatures is not the name (which can be easily forged), but the fingerprint (which cannot). Thus Pollock's quintessential signature is not to be found in the lower-left corner, but along the right and left margins: the handprints. These are indexical signatures. Most signatures close a painting: they are, in mythological terms, the final stroke of the brush. But Pollock's handprints *inaugurate* this work: they are the under-text of *Number 1, 1950,* covered as they are with dripped paint. This is a crucial moment: the handprints initiate what the signature cannot close. Not with the cicada competing for the final gesture. Not with Clement Greenberg competing for the final word (in the title). The museum label beside the painting tells us that Pollock is the author, but we now realize that this does not quite tell us enough. And it does not tell us enough because questions about making implicitly engage the question of agency. When we say that something is made (whether a painting or a poem or a Ford pickup), we also imply that the process of making is at some point brought to an end—that is, finished. But when is an artwork like *Number 1, 1950* finished? How can we say that a painting or a poem is finished if it is continually reconfigured (by new media) and reterritorialized (by new contexts or spaces), even after its supposed maker is dead? Artworks, it might be said, have endings, but only narrative endings. The work will

continue to change and to experience the peregrinations of cultural remaking—and this, contrary to being a bad thing, is precisely the opposite because the entire process of cultural making *depends* on a work being remade in order to substantiate its existence as art.

To call this process of remaking a "collaboration" is, however, perhaps overstating the nature of the exchange.[11] Yet, something loosely collaborative is a regular part of the production and distribution of art. Work often gets jobbed out, and has been jobbed out for hundreds of years (Warhol's factory was nothing new; before him there was Rodin, and before Rodin there was Rubens); paintings get framed and reframed (Van Gogh liked simple white frames, but when was the last time you saw a Van Gogh in a simple white frame?); works get shown in exhibitions where artists don't want them shown, and bugs get into paintings as easily as they get into computers. Van Gogh complained to Theo that he couldn't paint outside without having to pick the bugs out of the oil. And there's a huge dismembered mosquito-like bug in one of Sigmar Polke's recent resin paintings,[12] but it is not at all like the bug in Pollock's painting. Being dismembered by brushstrokes in the resin—one leg is about fourteen inches from the thorax—Polke's bug is merely a medium; Pollock's is both medium and maker. Instead of interrupting the text, Pollock's bug *is* the text. This, we must remember, is an artwork made by a painter who once told Hans Hoffman, "I am nature." My point here is that most art is, like literature, the product of collaborative forces that are not always the equivalent of mutual consent: the sense of collaboration undercuts itself and becomes a euphemism that occludes the complexity of who is responsible for particular textual states. Since painting is what might be called an art with no isomorphic code (as literature happens to be), it lacks a definable and isolable semiotic unit to which we can ascribe authority. We can make stylistic analogies and point out homologies, but these comparisons will lack formal structure. It's not like we can say Rubens's assistant was responsible for certain brushstrokes the same way we can say an editor of Keats's "Eve of St. Agnes" was responsible for certain words.

It is, therefore, the very nature of labels as interpretations rather than as statements of fact that removes them from the control or intentions of the artist. Traditionally the list of media is an eclectic summary of a painting's most salient materials (at the National Gallery of Art this list is written by the chief curator of the field in which an artwork falls).[13] In Pollock's catalogue raisonné, the compilers observe that "the medium is described as

accurately as can be ascertained without chemical analysis."[14] Being both medium (to the extent that it remains present) and maker (to the extent that the S-shaped trail through the work is not exclusively Pollock's), the cicada could easily be included in the label without contravening extant labeling practices. But who would wish to realign the established and familiar authority of the text? The question is rather like the question I asked in the first chapter about Keats's "Ode to Psyche": who would wish to replace the untroubling phrase "O brightest!" with the far more controversial "O Bloomiest!"—even though we know Keats wrote "Bloomiest," and that he wrote it not once, but twice? The bug itself is not really the problem: one reason it fits so well into the painting is because its presence is not disproportionately aggrandized. But to *say* that the painting is composed of paint and a bug is to introduce a radical transformation in the text we actually see, or read, because the space outside the text will be brought inside the text with a disconcerting emphasis that will eventually lead one to ask: does it matter? Did Pollock know about the cicada? And if he knew about it, did he care? Some artists in fact do use bugs as their media (David Nyzio uses beetles and monarch butterflies—thousands and thousands of them). And some artists occasionally use a medium that intentionally calls attention to itself: Ed Ruscha, for example, who has produced paintings that are cited as being "Pepto-Bismol on paper," "Gunpowder on paper," and "Spinach on paper."[15] But these works do not so much attach themselves to the actual Pepto-Bismol or gunpowder or spinach, as to the *idea* of these materials. It is not the medium as a reality that strikes us; it is the reality of language telling us so. The medium itself might be a supreme fiction, for we cannot judge it by any other way than our belief, and our beliefs, in turn, are guided by what we see and know. In a 1992 exhibition at the Robert Miller Gallery in New York, Ruscha showed a series of "stain" paintings that were produced between 1971 and 1975. The gallery checklist of the work reveals a diverse array of organic media: blueberry juice on moiré, egg yolk and cilantro on canvas, red cabbage on canvas, blood on satin, and blueberry extract on rayon crepe. Fictions? If one looked closely at the works one could see that the red cabbage had faded to orange, and that the blueberry extract had oxidized to umber, but that the egg yolk (a primary component in traditional tempera recipes) remained very yellow. In an important way, the language of the media is here substantiated by empirical observations, although this is possible only by virtue of the presence of the original. In contexts when we deal with representations

of the original, language is more emphatic by bearing the conceptual weight of the work. In such a case it is impossible to tell if Ruscha's Pepto-Bismol pink is really Pepto-Bismol or Winsor & Newton—simply to say "Pepto-Bismol on paper" will do the trick.

Of course, there is nothing to say that a date or a number or even a name is a truth any more than we expect poems to be representations of a truth: Milton's "Lycidas" would not be better or worse as a poem were it an elegy for his drowned guppy rather than his drowned friend. We are often, if not always, at the mercy of art's latent fictions, and as much as labels and captions lead, they also mislead. Watercolor, for example, isn't always *water*color. In his *Diaries,* Paul Klee recounts an incident when, visiting Rome, his friend Haller wanted to paint a scene along the Via Appia but couldn't find any water. No problem: he used his urine instead.[16] There's a related story about a related medium: Andy Warhol and his *Piss Paintings*. When they were exhibited at the Larry Gagosian Gallery in 1986, Andy found himself in a tight spot. As he wrote in, or rather narrated to, his *Diary:*

> My opening was happening at Gagosian's and Stuart sent his car and I locked up and we went over there and ran into Stellan from Sweden who has a girlfriend who works on fashion at *Interview,* Marianne. And Yoko Ono was there. And we saw the show and Stuart was saying, "They're masterpieces," and I don't know if he was just buttering me up or what. These are the Piss Paintings, the Oxidations. And then these nice older women were asking me how I'd done them and I didn't have the heart to tell them what they really were because their noses were right up against them. And it was so crowded.[17]

What language (or an absence of it) does in works like these is put us on an edge and quite simply leave us there. The acknowledged media of *Number 1, 1950* do not put the work on such an excessively narrow interpretative edge as with Warhol's *Piss Paintings,* but Pollock's materials are not insignificant either. As I mentioned earlier, his use of enamel and aluminum paint marked an engagement with technological texts: both the black Duco and aluminum paint were innovations that appeared at the right time, at the transition from easel to mural painting, when the tube of studio oil was abandoned for the gallon of enamel. The aluminum paint was particularly triumphant as technology, for it represented the synthesis

of a new pigment—aluminum—and a new base—alkyd—which, in the 1940s, was probably more advanced (in relation to its time) than today's use of synthetic resins and computer-generated images. No artist today can use aluminum paint without acknowledging a material iconography that points back to Pollock. Artists are always trying to integrate new media and rework old media—Andy Warhol would not be Andy Warhol without the silkscreen, and Richard Serra would not be Richard Serra without the hydraulic iron forge—and this amplifies the importance of materials: art is not merely made of a medium but is conceptually configured by it also, and this in turn reminds us that an artwork's textual representation includes that which lies outside the textual frame.

Outside yet Inside: Labels and Titles

I want to stay outside-the-text for a while longer by discussing the title—or rather titles—of this painting by Pollock. Like the media, the title is located on the label where its position is both obvious and intimidating. It might be even more intimidating if there was no label at all—no title, no artist, no acquisition number even. Like a destabilized text of uncertain or unknown authority, the lack of provenance is unsettling: how do we know this text is not a fake, how do we know we are not being had? Thus, the appeal in a label is not just because it provides certain information, but because it is *there*. Whatever it says, it signifies the assurance that authority is present and at work. The presence of a title takes this sense of assurance a step further: by being of language, titles are presumed to signify in a straightforward way and escort us to, if not through, a work of art. Sometimes they do in fact do this, and sometimes the result is less than genial. The following exchange between Franz Kline and David Sylvester epitomizes the problem:

Sylvester: How do you want your pictures to be read? Are they to be read as referring to something outside themselves? Do you mind whether they are? Do you mind whether they're not?

Kline: No, I don't mind whether they are or whether they're not. No, if someone says, "That looks like a bridge," it doesn't bother me really. A lot of them do.

Sylvester: At what point in doing them are you aware that they might look like a bridge?

Kline: Well, I like bridges.
Sylvester: So you might be aware quite early on?
Kline: Yes, but then I—just because things look like bridges, I
 mean . . . Naturally, if you title them something associated
 with that, then when someone looks at it in the literary
 sense he says, "He's a bridge painter," you know.[18]

What Kline doesn't say here is that he did in fact title several of his abstractions with the names of railway bridges. This doesn't necessarily obligate us to representationalize the paintings, but it does remind us that titles are problematic because they are undeclared speech acts: a caption or a label is what Barthes calls an "anchor"[19] only inasmuch as its function is illocutionary. Since the context of titles is a nonverbal context (in most art anyway), and since they are fragmentary utterances (a subject or an object, but rarely possessing a verb), they tend to be linguistically tentative in their otherwise impassively rhetorical posture. Consider, for example, the titles of Gauguin's Tahitian paintings, which both corner the viewer (because they are painted in the painting) and intimidate the viewer (because they are in Tahitian), and in doing so they remind us that we cannot read a foreign culture without also reading its language. Gauguin's skills with Tahitian are well known to have been bad,[20] but it is partly because his language is a conflation of two cultures (as one could say his paintings are also a conflation of two cultures) that makes his titles so engaging. In 1892, when Gauguin sent his wife Mette a parcel of paintings for an upcoming exhibition, he included a list of translations "for you only so that you may give it to those who ask for it."[21] Here the work's text extends to the letter because it is not so much correct translations that are important, but the translations and mistranslations that Gauguin *himself* provided for the works. When Gauguin's work is reproduced in books and monographs, often the titles are given correct English and French translations, and on one memorable occasion the title *Ia Orana Maria* was cropped off the painting when it was reproduced in the *Larousse Encyclopedia of Modern Art*.[22] Like Pollock's numbered titles (which appear so inconspicuous as to not be there at all), Gauguin's titles have been subject to what might be called underdetermination: they are regarded as supernumerary additions by a man who didn't really know the language, and therefore supposedly do not require curatorial care: they are thereupon ignored, corrected, even eliminated, from their position of being a text within the text. Not all titles by all artists are treated so flippantly, of

course, but one might observe the opposite effect—overdetermination—taking place with respect to Andres Serrano's controversial Cibachrome photograph entitled *Piss Christ*. As an indexical cue, the title *Piss Christ* becomes oppressively overdetermined when information about the photograph's props become known. It becomes, that is, a signifier for the props themselves—the crucifix, the beaker, the urine—more than a signifier for the photograph. Thus in public and critical discourse about *Piss Christ, Piss Christ* is rarely discussed as a photograph, but as a photograph *of* a crucifix immersed in urine. To my knowledge, nobody, not even Jesse Helms, has evinced discomfort with the photograph, but instead with its apparition in the genitive case. In discussing the more general implications of language and art, the critic Ernest Gilman has claimed that "Language may annex but it can never completely subjugate the image,"[23] but it seems to me that *Piss Christ* is precisely what he claims art cannot be: an image completely subjugated by language—language both of its title and the critical discourse it generates.

While titles have received considerable critical attention for the past ten years or so, it is hard to generalize about them because of the various ways in which titles relate to a specific medium (poetry vs. painting) or a specific genre (abstract painting vs. portraits) or even a specific artist (Kline vs. Schnabel). Thus it is easy to find examples that can prove and disprove almost any general hypothesis we might offer about how titles work in the arts. This is also reflected in the varying critical attitudes about the degree to which titles frame a work of art or (to use Barthes's term again) "anchor" it. For John Fisher titles are hermeneutic: "[T]itles," he writes, "are names which function as guides to interpretation."[24] For Johanne Lamoureux the influence of a title (or a caption) must be understood as a legend (as, say, a map legend denotes that which must be read): "[T]he legend no longer prescribes as much as it acts to inflect the sense of the image, at times strategically countering its menacing opacity."[25] For Hazard Adams titles are not semantic indicators (the classical indexical reference), but, like the rest of the artwork, an uninterpreted code, so that text and title comprise a composite text.[26] There is little middle ground: a title can easily anchor a work as much as it can unanchor a work, and as a consequence there is always a danger of putting too much faith in a title. Consider, as an example, David Salle's painting *Tennyson* (1983): a very large (78″ × 117″) oil and acrylic work of a reclining nude with "TENNYSON" inscribed across her body. This is the sort of title that tempts us with an iconographic reading, but one would search in vain to get anything concrete from this.

In a videotaped interview that accompanied a traveling exhibition of his paintings between 1986 and 1987, Salle remarked that he had no specific reason for inscribing the painting in this way and for using *Tennyson* as a title; he had, he said, read some of Tennyson's poetry and kind of liked the name. But it didn't really have anything to do with the painting.[27] It is a disarming remark—one senses that he is intentionally trying to elude his viewer—and seems to epitomize Lessing's belief that "The less [a title] betrays of the contents, the better it is."[28] But Salle's *Tennyson* is no empty signifier: on the one hand is is a classical deconstructive maneuver, a self-effacing dodge that is characteristic of postmodernism in the early 1980s. On the other hand we can see here Salle's predilection for decontextualized appropriation, which may be understood as a desire to undermine logical coherence. The title is read *in relation to* the painting; the painting is read *in relation to* the title—and in the end the relationship is of no relation. *Tennyson* may have been an arbitrarily chosen title, but it is by no means a meaningless title.

The possibility that there is such a thing as a meaningless title is powerfully engaging, for its very premise is to say something that represents nothing: the mythical, elusive, empty signifier. One might argue that the most characteristic evidence of this desire is to title a work *Untitled,* as if one could simultaneously use language to escape from language. To leave a work untitled or to call it *Untitled* does not, however, dedesignate the work, for it designates what is absent, and this, in turn, will affect how we approach it. A work that is entitled *Untitled* is merely a work that states an unwillingness to proclaim itself: a deliberate act of not naming, or refusing to name. There is a hint of defiance here, although this defiance might very well be supplanted by convention. To call a work *Untitled* is today a common maneuver, but sometimes almost hypocritical in its self-mocking irony. In the autumn of 1991 Haim Steinbach exhibited at Jay Gorney Modern Art in New York five sculptures; two of the sculptures had the following captions, which are here reprinted from the gallery's handout:

Untitled (rustic wall with music box and candle snuffer), 1991
Hog pen siding with iron hinges and objects.
11 × 57 1/2 feet.

Untitled (barn wall with pail of milk), 1991
Enamel painted pine siding with hardware and object.
10 1/2 × 21 feet

Steinbach isn't alone; Robert Rauschenberg and Dan Flavin, among others, have done this too. *Untitled* is a conventional title that has today evolved to a point that it cannot keep its mouth shut—it whispers through parentheses. It is very different than saying nothing—simply having no title, no label, no inscription whatsoever. The contrast is more acute in the case of works whose titles are, for various reasons, unknown. To entitle such works *Untitled* is to unfairly pigeonhole them. The opposite problem is introduced by the presence of multiple titles, which develops a text's space without cornering it. I am thinking here of the Italian artist Enzo Cucchi, who once remarked: "I give a painting five or six titles, and they become a little story around it."[29]

Whether or not Cucchi really does give his paintings five or six titles is hard to tell: none of his exhibited works that I have seen has multiple titles, and none of the paintings reproduced in major catalogs (including a Guggenheim retrospective catalog in 1986) document this fact. But this does not mean Cucchi's titles remain stable; it may merely mean we are unaware of their transience. Titles, like poems and novels, implicitly have textual histories: they are changed and altered by authors as much as texts themselves are (one thinks here of Keats's *Hyperion,* Shelley's *Laon and Cythna,* and Lawrence's *Chatterley*), and these changes—usually, but not always, intentional—are not unimportant. But whatever importance they have, it is not acknowledged in most curatorial files or in the standard catalogue raisonné, where curators and editors seem to have little regard for either diplomatic transcriptions or related forms of bibliographical documentation. This may initially seem an unjust complaint, but inasmuch as textual transience is about change, its usefulness in critical discourse depends on being able to document transient states, whether those states were intended by the author-artist or not. Through most of this essay I have been referring to *Number 1, 1950* as the title of a particular painting by Pollock, as it in fact is. This is Pollock's title: a numbered and dated title, like so many other numbered and dated titles among his works. There is also, as I mentioned earlier, a second title: Greenberg's parenthetical addition. The official title of the work—which is to say, the institutional interpretation of the title of the work—is *Number 1, 1950 (Lavender Mist)*. But here there are complications. The publication release provided by the National Gallery of Art explicitly states that "information within parentheses is not part of the *required* caption and credit" (italics in original). *"Lavender Mist"* is within parentheses, but it is not clear if *(Lavender Mist)* is really meant to be disposable, because also within parentheses can be found the date the

painting was made (a redundancy, given Pollock's title), the media, the dimensions, and the museum's acquisition number. The paralinguistic function of the parentheses is like Genette's paratextual function of the title, but twice removed: Greenberg's title supplements Pollock's title, which supplements Pollock's painting. But now the National Gallery is asserting that I have the right to *select* (within a certain limit) the supplements that I must cite: to create my own composite version of the text. My minimum citation according to the press release must include Pollock's title (*"Number 1, 1950"*), the gallery name ("National Gallery of Art, Washington") and the source of the money that paid for the acquisition ("Ailsa Mellon Bruce Fund"), all of which may be combined with the other elements at will—Greenberg's title, the acquisition number, the media, the date, and the size of the painting. This option makes for a number of interesting possibilities, particularly if I should exceed the limit of the rights allowed by this institutional construction permit.

Suppose, for example, I were to do something very horrible and disfigure Pollock's painting with a knife. We can be pretty sure that the National Gallery would not be too happy with my gesture. But suppose, instead, I disfigured the *title* of the painting . . . ? It has been done before. In their Pulitzer Prize–winning biography of Pollock, Steven Naifeh and Gregory White Smith turn the title inside out, putting *Number 1, 1950* in the parentheses: *Lavender Mist (Number 1, 1950).*[30] There is something unmistakably disconcerting here, as if we are witnessing the usurpation of identity, the tension between Pollock's cigarette-in-the-jaw toughness and the Cecil Beatonish softness of *Vogue,* where, in 1951, *Number 1, 1950* appeared in a fashion spread entitled "The New Soft Look." It's like the Cedar Tavern being up against the Russian Tea Room. Or something like that. Pollock's catalogue raisonné doesn't even bother with the parentheses; instead, it uses a colon: *Lavender Mist: Number 1, 1950.*[31] But at least the catalogue raisonné says what others do not say: "The title 'Lavender Mist' was given to this work by Clement Greenberg during Pollock's lifetime and was accepted by the artist after he gave it a numbered title."[32] The phrase "accepted by" is intriguing. Does it mean Pollock merely acquiesced to Greenberg's title? Or merely ignored it? Or did he use it himself? There is no evidence that Greenberg's title appeared on the gallery label when the painting was first exhibited at the Betty Parsons Gallery in the winter of 1950. Or when it was exhibited again a year later in Chicago. In 1993, when the National Gallery removed at my request the backing pads protecting the verso of

the painting, I discovered a small typewritten label pasted onto the stretcher that is not cited in either the catalogue raisonné or in the museum's two conservation reports on the painting.[33] It read:

33. No. 1—1950 Box no. [torn]
Lent by Betty Parsons Gallery

The mystery is this: between October 2 and October 27, 1951—almost a full year after Pollock first exhibited *Number 1, 1950* at Parsons's gallery—he participated in a three-person exhibition (with de Kooning and Ben Shahn) at the Arts Club of Chicago. *Number 1, 1950* was given catalog number 33. The painting, that is, was still titled *Number 1, 1950* at this time—it had not yet been supplemented by Greenberg's reputed addition.

Eventually, however, Greenberg's title would supplant Pollock's in critical and curatorial discourse: the curatorial file in the National Gallery is labeled *Lavender Mist*, the official black-and-white photograph in the file is labeled *Lavender Mist*, and throughout their biography of Pollock, Naifeh and Smith refer to *Lavender Mist*. No more parentheses even. For better or worse, what this does is provide concrete evidence of the way titles are intentionally and unintentionally changed. This does not, however, mean authority is an altogether useless concept. To the contrary, it emphasizes the importance of knowing who is responsible for a particular textual state and how those textual differences need to be understood in relation to their sources—not simply ignored or forgotten. Otherwise we would be unmaking cultural history, or at the very least occluding it.[34]

So what, exactly, is the authority upon which Greenberg's *Lavender Mist* is based? Lee Krasner recalled Greenberg, a neighbor named Ralph Manheim, and others going out to Pollock's studio and suggesting titles for paintings, some of which stuck and some of which didn't.[35] This is not unusual: Frank Stella had the sculptor Carl Andre and the filmmaker Hollis Frampton contribute titles for a series of black paintings that he made in the late 1950s.[36] But there is a difference: the titles Andre and Frampton made up for Stella's paintings fit within the overall conceptual scheme of Stella's titles; *Lavender Mist* doesn't. The parentheses that surround it in the compound title almost acknowledge the embarrassment of its presence. And *Lavender Mist* doesn't make its first appearance as a title until the painting had been exhibited at least twice. Yet the oddest thing is this: if Greenberg is indeed the author of this title, then it is almost a paradox that the critic who pushed hardest for the cause of purely optical

art should have representationalized one of Pollock's paintings by titling it as if it were a perfume.

As if, lacking any sense of intertextual history, that's about as far as we can go. "Lavender Mist" is, of course, also the title of a popular Duke Ellington piece from 1947,[37] but there is nothing to suggest Greenberg was trying to be coy in making any reference to it. It would seem to me that subsequent public attachment to the title *Lavender Mist* (no parentheses now) over the past forty years tells us about how, over time, a text of the avant-garde can be modulated by its audience into a text of genteel propriety. Numbered titles may have given Pollock a way of resisting specific interpretations, but this resistance was only temporary. It is by surrendering his title to Greenberg that Pollock initiated his surrender to quaintness. The man who once took a piss in Peggy Guggenheim's fireplace had thus irrevocably begun the process of social rehabilitation. Ultimately this must happen to every avant-garde movement and every avant-garde artist. Duchamp's antiaesthetic, for example, has undergone transformation into kitsch by contemporary artists who, in search of a new antiaesthetic, have resorted to turning against the turn by appropriating mass-cultural kitsch, as in the work of Jeff Koons and Daniel Oates. Pollock could not resist the impetus of this transformation any more than Duchamp could. Greenberg's title *Lavender Mist* had the additional effect of speeding up the process and making it easy.

But easy or not, it is important to know if Pollock's (or anyone's) titles are the product of multiple authority. Art historians cannot continue to speak about an artist's intentions until they acknowledge the importance of documenting, and documenting with care, the traces of agency and authorship. Even more than this, art historians must somehow come to terms with what exactly *constitutes* authorship and how, in relation to the work, its title, and its exhibition sites, intentions are inevitably shared and contested, just as they are with any work of literature. The parenthetical subtitle for *Number 1, 1950 (Lavender Mist)* does not adequately demarcate its disparate authority, and not being aware of this conflation can get one in a fine mess. This is Robert Hughes on Pollock:

> Many of the passages in his "heroic" paintings of 1947–51 remind one of Monet, or even of Whistler. Fog, vagueness, translucency, the scrutiny of tiny incidents pullulating in a large field—the title Pollock gave to his most ravishingly atmospheric painting, *Lavender Mist*, 1950, about sums it up.[38]

One of the favorite pastimes enjoyed by textual critics was to point out to various New Critics (as Fredson Bowers often did) or various deconstructionists (as G. Thomas Tanselle often did) that they had based their interpretations upon something their author had in fact *not* written, but what was instead an editorial accretion. Precisely because Pollock didn't entitle *Number 1, 1950* as *Lavender Mist* more or less puts Hughes in the same position of trying to make so much out of something his author-artist didn't say. Either we can describe this as typically Hughes (a writer who will twist a hard fact in order to spring a memorable phrase), or as typically textual (an imbroglio of undemarcated authority: nobody knows who wrote what, and nobody, it seems, really cares). The "fog" that Hughes sees in Pollock's painting is a trace, not of titles, but of a distinctly intertextual kind: Monet's, Whistler's, the Accabonic Bay near Pollock's studio, and Pollock's own irridescent mind. What this amounts to is a form of representationalizing: a way of giving some concrete tag to an abstract form. An abstract painting is thus said to "look like" X because to say it "is" Y doesn't satisfy our linguistic desire for something to hold onto. And Pollock is vulnerable. Various early critics described his paintings as being *like* vomit, *like* baked macaroni, and *like* a bombed-out Hiroshima by moonlight. The paradox is that this amounts to hammering representational pitons into a cliff Pollock did not, apparently, want us to hold onto. In the famous *Life* magazine spread on Pollock that appeared in August 1949, a photograph of *Number 17* is captioned: "He numbers his paintings instead of naming them, so his public will not have any preconceived notion of what they are."[39] The intention was a good one, but it could not withstand what seems to be a pervasive human desire to representationalize experience by categorizing it in terms of the quotidian. The net result—and there is no record of Pollock actively protesting—is that Pollock's paintings ultimately got named like a litter of nameless kittens: *Number 9* (photographed in *Life*) became *Summertime*; *Number 30, 1950* became *Autumn Rhythm*; *Number 11, 1952* became *Blue Poles*. Compound titles like these cannot be unmade. Nor should we even want to unmake them: it is instead the people who make them and the reasons they are made that are so telling, for they reflect how Pollock's cultural texts were being read and remade by their readers. The crucial realization is that the autonomous abstract painting that Pollock sought to make ultimately could not be made: language would make it more than just a painting.

A contemporary example might help us understand the dilemma and

how important it can be. In the spring of 1991 the Tony Shafrazi Gallery in New York exhibited a painting by Jean-Michel Basquiat, *Price of Gasoline in the Third World* (1982). The painting consists of two hinged panels of paper mounted on canvas, and when I saw it, it was directly on the floor, opened slightly so that the bisecting edges provided necessary support. This allowed an unusual opportunity to examine the back of the painting. Attached to the stretcher was a gallery label from the Larry Gagosian Gallery that had the same title as the label on the Shafrazi Gallery wall, and both were identical to the inscription painted on the back of the canvas: "Price of Gasoline in the Third World J M Basquiat 1982." But on the verso there was also another title that had been painted over, yet remained clearly legible. It read: "Wasted a lot of Money on that Girl Part Two J M Basquiat 1982." The transition between these two titles, like the transition between *Number 1, 1950* and *Lavender Mist,* is abrupt and does not declare itself as conceptually resolved. There's a lot of interpretive space between Basquiat the bourgeois spendthrift and Basquiat the radical socialist. And Basquiat never had what one might call a linear mind: Warhol's diaries reveal him to have been extraordinarily detached and unpredictable, full of unresolved dualities. To make matters more difficult, most of Basquiat's work has received little serious critical treatment, although the recent Whitney Museum retrospective in the autumn of 1992 has been of some help. It's hard enough to get past the front of Basquiat's paintings without having to worry about what is on the back of them.

But perhaps we should. Not outside the text, but behind the text: this is the location where a work's textual history is most marked by language— signatures, titles, directions for hanging, gallery labels, exhibition records. The protocols relating to the exhibition of artworks usually stop us from from going beyond polite perusal. It's not like one can walk into MOMA and take a peek behind a Pollock or a Kline. The manner in which art is exhibited has become so conventionalized that it contributes to effacing, rather than making visible, the work's textual space. Convention thus predetermines the range of possible approaches to a work. Few curators (and I say this based on experience) will disrupt normal exhibition activities for a critic to look at the painting from a presumably perverse angle— that is, to look at what is hidden: the "private parts" of a painting. The verso of a painting is, in this sense, a protected space, one which, when exposed, exposes a painting's vulnerability. The canvas here is "bare." The superstructure of the painting—stretcher or strainer, mountings, tacks, and occasionally the frame itself—is equally vulnerable from this position.

It is almost ironic that the public side of the painting should ultimately find such a stark contrast in its private side; it is not as if we presume artworks have some privileged secret to withhold from us.

Yet we cannot know what secrets are there unless we look for them and find them, as we find in the important label from Pollock's show at the Arts Club of Chicago. The verso of a painting, I would like to suggest, is a symbolic form of still life without being self-conscious of its niche within the genre. And the verso is a still life because this is the location where the transience of the artwork is documented, where traces are accumulated of its passage through particular places at particular times. The still life, as Norman Bryson tells us, is most characteristic in its representation of the quotidian: "Still life takes on an exploration of what 'importance' tramples underfoot. It attends to the world ignored."[40] It is the verso of the painting that captures the ordinariness that the recto ignores and discards. The verso, in this sense, is the recto's wastebasket: this is the site of accumulations of textual trash, and, like the waste of history, it is a waste that says everything but admits nothing. These accumulations are also marked by erasures: labels get removed and scratched off, and reinscriptions (as in Basquiat's case) occur. It is, in some ways, fortuitous that a painting should have such a large expanse of space to accumulate traces of its history. Yet, while museological conservation has largely been directed at material transience as the result of natural factors (light, humidity, temperature) and human factors (shipping, vandalism, and earlier restorations), little equivalent attention has been provided for linguistic transience applicable to the same works: the verso is very rarely documented as the recto and subsurface pentimenti are. Only when the verso actually becomes the recto (as in Cornelius Norbetus Gijsbrechts's *The Back of a Picture* and Roy Lichtenstein's variations on the same theme), or when the verso is mistaken for the recto (as happened to one of Lucio Fontana's paintings when it was auctioned in London in 1994),[41] does the sense of reversal reverse itself.

Conclusion: Outside Yet . . .

When carpenters construct a house, they engage the word *framing* as a verb; that is, to frame a house they construct its infrastructure. When a painting is mounted, it is framed (from the outside), as a sculpture is similarly framed when it is mounted (on a pedestal) or situated within a site or a room. When we engage in what is loosely called a context in our reading of a text (whether that text is of literature, art, or human action),

we again frame the text—move what is outside to the inside. In all of these activities the frame is not a thing, an object, but an act of construction: it involves agency. This is Derrida on the subject at one of his more stoical moments:

> It is the analytic which *determines* the frame as *parergon,* which both constitutes it and ruins it [*l'abîme*], makes it both hold (as that which causes to hold together, that which constitutes, mounts, inlays, sets, borders, gathers, trims—so many operations gathered together by the *Einfassung*) and collapse. A frame is essentially constructed and therefore fragile: such would be the essence or truth of the frame. If it had any truth. But this "truth" can no longer be a "truth," it no more defines the transcendentality than it does the accidentality of the frame, merely its *parergonality.*
> Philosophy wants to arraign it and can't manage.[42]

It is this last phrase, acknowledging the fragility of human constructions, that admits to the paradoxical organization of the text and the relationship between text and title, label and painting, media and maker. Like philosophy, perhaps even *as* philosophy, posteditorial textual criticism wants to put its finger on the peritextual text, and while it does, as a discipline and ideology, make us aware of textual movement, and while it does make it possible for us to trace traces of this movement, it does not, even in its own domestic domain of literary texts, permit us the possibility of arraigning or arranging this movement—call it up, order it, pose it like a group of people before a photographer. "Hold still!" But texts don't. Movement leads to movement. Outside finds its way inside. The frame will not save us—will not decide *for* us—what is inside or outside. Perhaps then it is the label for Pollock's painting that deserves the frame: a glassed-in frame, not to protect the label, but to remind us that we are on the other side of this window, and that it is the painting, spread against the wall, that is unframed despite its polished aluminum frame. Another movement here: Pollock painted on the floor. The work is now on the wall. Perhaps if it were to return to the floor again and be cut free from its conventionalized frame, we could observe it from the perspective of Pollock's perspective— to walk around the painting, to frame it with our own movement: no top, no bottom, no side. The point is not so much to *regain* Pollock's perspective as to unmake our own and that of institutional history, thereby freeing us from the frame of being framed.

It is clear then—or at least I hope it is clear by now—that a label is not supplementary to an artwork any more than a bibliographical feature is supplementary to a literary work. The relevance of verbal information to art, and nonverbal information to literature, is a relationship between *available* information and our use of that information: on the edge of the text, neither inside nor outside, yet both inside and outside, what matters is *what ends up inside,* the inside that is always realigning itself and being realigned. This inside, this intratext, is, I would prefer to say, a process of accretion: painting on painting, text on text, fiction on fiction. The historian is by definition an interlocutor engaged in an act of discourse, but this discourse is essentially monologic. The artwork does not speak; it is spoken *for.* But it is spoken for in different ways by different people and by different institutions, and this is what constitutes remaking and making over. Like textual criticism, art history participates in the act of accretion by sequencing certain events and objects, at times eliminating what is considered nonessential to the sequence. As we curate, catalog, attribute, and reattribute artworks, we prove that the previous sequence was, *in fact,* a fiction; fact effacing fact, each new discovery functions to verify its own ultimate lack of veracity. New titles, new exhibition sites, and new reconfigurations—cleanings, restorations, and so on—all contribute to reminding us that a work of art can only exist in the plural: it cannot be singular. That is why there is an almost perverse sort of critical pleasure to be found in the aporias of cultural change: controversial restorations, relocated site-specific sculptures, colorized films, condensed books, and even censored exhibitions. These are the extremes by which an artwork bears the traces of its movement. And it is in these extremes that we find what is for me something fundamental about art: how it is immutable only in its continuous mutability. Culture, in other words, *depends* on remaking texts in order to exist. If this is disconcerting, it is so because the sense of dislocation and movement is contrary to the very idea of a history of art or a history of texts: we know that each work of art and each literary text will inevitably outgrow the history we construct of it and for it. But that is the point: textual transformation must be understood *qua* textual transformation if it is to be useful in our understanding of human culture. These transformations are increasingly and unavoidably significant to those who think and write about art in an age of mechanical and electronic reproduction. In the same way that the museum functions to juxtapose artwork against artwork, these textual Others, which comprise everything from postcards to virtual reality, generate new juxtapositionings, artwork against artwork, artwork against ideology,

artwork against its multitextual selves. Such texts are not to be despised but respected: they exert an enormous influence on our cultural consciousness, and the only way we can understand this influence is to explore the conditions by which different textual states exist in the synchronic and diachronic manifestation of artworks. It is almost beside the point to worry about the plausibility of multiple meanings, for the work is unstable even before we begin to read it. We are at a stage where deconstruction cannot save the text, for the text cannot declare itself among the presence of other texts. Philosophy wants to arraign it and can't manage. If philosophy can't arraign it, what can? Textual criticism wants to arraign it and can't manage. If textual criticism can't arraign it, what is textual criticism *for*? The answer, as we can now surmise, is paradoxical and contradictory. Textual criticism (or its application as panoptical textual consciousness) functions in cultural studies by using microhistories to deny the possibility of a master history. That is, textual criticism reveals the complexities of cultural history by exposing the myths of reification and reproduction as ideologically vested enterprises rather than as disinterested formalisms. There can be no such thing as a disinterested text or a disinterested history. Textual criticism thus forces us to rethink *how* we think about the history of cultural objects, and about how this history is not linear but discursive. To adapt a phrase of Keith Moxey's, it is about using history to be more theoretical and it is about using theory to be more historical.[43] What is ironic here is that the greatest implication for this position is perhaps not for art history, but for textual criticism itself. In becoming an ideology (as textual theory) rather than a set of practices (as textual criticism), textual studies must also realign itself vis-à-vis its own history as a discipline. It must, that is, acknowledge the implications of its own theories and how they are fundamentally about the processes by which meaning is produced rather than about meaning per se. Like deconstruction. That this is surprising—it really shouldn't be—is because we easily forget that deconstruction and textual criticism play with opposite ends of the sign. Yet what they both do, and do well, is show that there is no natural end to their respective end. The ultimate effect is that textualterity both frees us from the constraints of art's objecthood and binds us with the burden of endless temporal locations and dislocations through which objects move and are moved. Art subsumes not just order, but our *desire* to order and taxonomize what is inherently disordered. In its disciplinary desire to arraign and arrange what it cannot in the end arraign and arrange, textual criticism becomes a victim of its own success, defining in its own premises why it must fail to be everything it wants to be. But

then—to complete the circle—this failure becomes another success, revealing to us the process by which the history of culture is made, taking us closer to the experience of disorder and showing us what to look for: transformations, displacements, drift, and rupture. But then what? Order or the illusion of order? Inside or outside? The text or the reader, or the peregrinations of forever moving in the space between?

Notes

Introduction

1. Michel Foucault, *The Archaeology of Knowledge*, trans. A. M. Sheridan Smith (New York: Pantheon, 1972), 172.

2. *Read to Succeed: A Parent's Guide to the Reader's Digest Best Loved Books for Young Readers* (New York: Choice Publishing, 1989), 2.

3. Mohsen Mostafavi and David Leatherbarrow, *On Weathering: The Life of Buildings in Time* (Cambridge, Mass.: MIT Press, 1993), 64, 69.

4. Keith Moxey, *The Practice of Theory: Poststructuralism, Cultural Politics, and Art History* (Ithaca: Cornell University Press, 1994), 18.

5. Norman Bryson, "Art in Context," in *Studies in Historical Change*, ed. Ralph Cohen (Charlottesville: University Press of Virginia, 1992), 18–42.

6. Moxey, *The Practice of Theory*, 5.

7. On the notion that framing is "something we *do*" (my emphasis), see Jonathan Culler's *Framing the Sign: Criticism and Its Institutions* (Norman: University of Oklahoma Press, 1988), xiv ff., and Mieke Bal and Norman Bryson, "Semiotics and Art History," *Art Bulletin* 73, no. 2 (June 1991): 174–208.

8. Walter Benjamin, "The Work of Art in the Age of Mechanical Reproduction," in *Illuminations*, ed. Hannah Arendt, trans. Harry Zohn (New York: Schocken Books, 1969), 221.

9. Donald Preziosi, *Rethinking Art History: Meditations on a Coy Science* (New Haven: Yale University Press, 1989), 72. For a recent study on the significance of photographic representations of artworks, see Mary Bergstein, "Lonely Aphrodites: On the Documentary Photography of Sculpture," *Art Bulletin* 74, no. 3 (September 1992): 475–98.

10. *Tilted Arc* and the Sistine Chapel are both discussed in chapter 2.

11. Recent studies that might be described as New Textual criticism began with the publication of Jerome McGann's *A Critique of Modern Textual Criticism* (Chicago: University of Chicago Press, 1983). McGann's later work, including *The Beauty of Inflections* (Oxford: Clarendon Press, 1985) and *The Textual Condition* (Princeton: Princeton University Press, 1991), has continued to be influential in its exploration of textual difference qua difference. Current issues in textual scholarship are regularly treated in *Text: Transactions of the Society for Textual Scholarship*,

ed. D. C. Greetham and W. Speed Hill (New York: AMS, 1984–93; Ann Arbor: University of Michigan Press, 1994–). For an extensive bibliography of studies in textual criticism and allied fields, see David Greetham's *Textual Scholarship: An Introduction* (New York: Garland, 1992).

12. David Greetham, "The Manifestation and Accommodation of Theory in Textual Editing," in *Devils and Angels: Textual Editing and Literary Theory*, ed. Philip Cohen (Charlottesville: University Press of Virginia, 1991), 78–102.

13. Donald McKenzie, *Bibliography and the Sociology of Texts* (London: British Library, 1986), 31.

Chapter One

1. Leonard Darwin, *The Need for Eugenic Reform* (London: John Murray, 1926), 10.

2. Francis Galton, *Inquiries into Human Faculty* (London: Macmillan, 1883), 25n.

3. For recent discussion of rDNA experiments and their social and scientific implications, see *The Code of Codes: Scientific and Social Issues in the Human Genome Project*, ed. Daniel Kevles and Leroy Hood (Cambridge, Mass.: Harvard University Press, 1992).

4. For a more advanced state of inquiry whereby eugenics was seen as a "practical" question rather than a theoretical (even utopian) idea, see Galton's *Essays in Eugenics* (London: Eugenics Education Society, 1909).

5. Darwin, *The Need for Eugenic Reform*, 186.

6. Paul Popenoe and Roswell Hill Johnson, *Applied Eugenics*, rev. ed. (New York: Macmillan, 1933), 357.

7. In America, the most influential of these texts was probably Charles Davenport's *Heredity in Relation to Eugenics* (New York: Henry Holt and Company, 1911).

8. Leonard Darwin's distinction is as follows: "The aim of eugenists is to alter human surroundings in such a way as to increase the chance of 'survival' of those types which are held to be most desirable; and consequently in eugenic discussions the 'fittest' is a term used to indicate those who *ought* to 'survive' in the evolutionary sense—that is to help to people the earth—rather than those who actually do survive. *Natural* selection seems to take no thought as to what is 'good,' whilst in eugenic problems the moral qualities of man should be the primary consideration" (*The Need for Eugenic Reform*, 114–15).

9. Darwin, *The Need for Eugenic Reform*, endpaper advertisement.

10. See Charles Darwin, *The Origin of Species: A Variorum Text*, ed. Morse Peckham (Philadelphia: University of Pennsylvania Press, 1959).

11. Darwin, *The Origin of Species,* 20.

12. *The Poetical Works of Coleridge, Shelley, and Keats* (Paris: A and W Galignani, 1829), n.p.

13. For two recent overviews of the genome project controversies, see John Horgan, "Eugenics Revisited," *Scientific American* 268, no. 6 (June 1993): 122–31, and Kevles and Hood, *The Code of Codes*.

14. Leonard Darwin, "Presidential Address," in *Problems in Eugenics: Papers Communicated to the First International Eugenics Congress* (London: Eugenics Education Society, 1912), 6.

15. W. W. Greg, "What Is Bibliography?" *Transactions of the Bibliographical Society* 12 (1911–13): 39–53.

16. James Thorpe, *Principles of Textual Criticism* (San Marino, Calif.: Huntington Library, 1972), 57. For another view on the problem of describing bibliography and textual criticism as science, see G. Thomas Tanselle, "Textual Study and Literary Judgment," *Papers of the Bibliographical Society of America* 65 (1971): 109–22, reprinted in Tanselle's *Textual Criticism and Scholarly Editing* (Charlottesville: University Press of Virginia, 1990), 325–37.

17. For a discussion on Thorpe's influence on conceptions of authorial collaboration, see Jack Stillinger's *Multiple Authorship and the Myth of Solitary Genius* (New York: Oxford University Press, 1991), 198–200.

18. "A text is incurable, or curable only with the aid of a lucky coincidence (methodically speaking this comes more or less to the same thing), not only where a reading that is not abnormal has suffered deep corruption, but often when a deliberate anomaly or something unusual or unlikely has suffered only small damage." Paul Maas, *Textual Criticism*, trans. Barbara Flower (Oxford: Clarendon, 1958), 12.

19. This is one reason recent emphasis on a text's "bibliographical code" (paper, typeface, layout, binding, and so on) is difficult to represent using traditional editorial formats, even when using hypertext: the bibliographical code is a dense sign system that is in fact *not* a code in the sense language is a code possessing what linguists would describe as isomorphism, duality of patterning, and iterability.

20. W. W. Greg, *The Calculus of Variants* (Oxford: Clarendon, 1927), 2.

21. Galton, *Essays in Eugenics*, 42.

22. G. Thomas Tanselle, "Textual Criticism and Literary Sociology," *Studies in Bibliography* 44 (1991): 83–143.

23. Thorpe, *Principles of Textual Criticism*, 55.

24. Fredson Bowers, *Textual and Literary Criticism* (Cambridge: Cambridge University Press, 1966), 8.

25. Bowers, *Textual and Literary Criticism*, 7–12.

26. Fredson Bowers, "Textual Criticism," in *The Aims and Methods of Scholarship in Modern Languages and Literature*, ed. James Thorpe (New York: Modern Language Association, 1963), 23–42.

27. K. K. Ruthven, "Textuality and Textual Editing," *Meridian: The La Trobe University English Review* 41, no. 1 (May 1985): 85–87. I am grateful to Paul Eggert for bringing this essay to my attention.

28. Daniel J. Kevles, *In the Name of Eugenics: Genetics and the Uses of Human Heredity* (Berkeley and Los Angeles: University of California Press, 1985), 113–18.

29. *Mein Kampf,* trans. Helmut Ripperger et al. (New York: Reynell & Hitchcock, 1939), 608.

30. See Andrew Kimbrell, *The Human Body Shop: The Engineering and Marketing of Life* (San Francisco: HarperSanFrancisco, 1994), and John Rennie, "Grading

the Gene Tests," *Scientific American* 270, no. 6 (June 1994): 88–97. For brief but compelling remarks from within the field of genetic research, see Louis A. Peña, "It's Our Own Genes We Should Worry About," *New York Times*, July 27, 1993, A12, and Richard Horton, "New Genetics Offers Agonizing Choices," *New York Times*, November 19, 1993, A16.

31. For a genial biocritical discussion on Bowers's life and influence, see G. Thomas Tanselle's "The Life and Work of Fredson Bowers," *Studies in Bibliography* 46 (1993): 1–154.

32. Louis Hay, "Genetic Editing, Past and Future: A Few Reflections by a User," *Text 3* (New York: AMS, 1987), 117.

33. *Life,* January 15, 1951, 64. In the same issue PM De Luxe Whiskey was advertised as having "clear clean taste": "Taste is funny! If we used half the words in Webster's Dictionary trying to explain PM's 'clear, clean taste' we just couldn't do it!" On the opposite page, Richardson's After Dinner Mints were advertised as "Clean–Cool–Refreshing" (100–101).

34. See McGann's *The Textual Condition*, McKenzie's *Bibliography*, and two recent collections of essays, *Palimpsest: Editorial Theory in the Humanities*, ed. George Bornstein and Ralph G. Williams (Ann Arbor: University of Michigan Press, 1993) and Cohen, *Devils and Angels*.

35. Thorpe, *Principles of Textual Criticism*, 50–51.

36. G. Thomas Tanselle, *A Rationale of Textual Criticism* (Philadelphia: University of Pennsylvania Press, 1989), 65.

37. Thorpe, *Principles of Textual Criticism*, 112.

38. Georges Canguilhem, *The Normal and the Pathological*, trans. Carolyn R. Fawcett (New York: Zone Books, 1989), 239.

39. Stillinger, *Multiple Authorship*, 199.

40. See Gary Taylor's essay "The Renaissance and the End of Editing" in Bornstein and Williams, *Palimpsest*, 121–49.

41. *Mr. Johnson's Preface to His Edition of Shakespear's Plays* (1765; fac. rpt. Menston: Scolar Press, 1969), lxviii.

42. See *The Destruction of "Tilted Arc": Documents*, ed. Clara Weyergraf-Serra and Martha Buskirk (Cambridge, Mass.: MIT Press, 1991), as well as my discussion of *Tilted Arc* in chapter 2.

43. *The Letters of Sarah Hutchinson from 1800 to 1835*, ed. Kathleen Coburn (London: Routledge and Kegan Paul, 1954), 132.

44. Thomas De Quincey, "Notes on Gilfillian's 'Gallery of Literary Portraits': John Keats," *Tait's Edinburgh Magazine*, April 1846, 249–54.

45. For a brief account of Milnes's handling of Keats from the perspective of early-twentieth-century Keatsian scholarship, see Robert Lynd's introduction to *The Life and Letters of John Keats,* by Lord Houghton (London: J. M. Dent, ?1927), vii–xv.

46. Miriam Allott, ed., *The Poems of John Keats* (London: Longman, 1970), 101.

47. Francis Jeffrey, review of *Endymion*, *Edinburgh Review* 34 (August 1820): 203–13.

48. Keats probably could have returned the gesture by accusing Byron of having hemorrhoids in *his* imagination: years after Keats died, Byron, scratching his dis-

satisfaction, asked Leigh Hunt what Keats, in his "Ode to a Nightingale," meant by "a beaker full of the warm south." As Hunt described the situation, Byron not only asked the question, but had the unembarrassable willingness to ask it while "living in Italy, drinking its wine, and basking in its sunshine." See Hunt's *Lord Byron and Some of His Contemporaries,* 2d ed., (London: Henry Colburn, 1828), 1:438.

49. Robert Gittings, *The Odes of John Keats and Their Earliest Known Manuscripts* (Kent, Ohio: Kent State University Press, 1970), 72.

50. *The Letters of John Keats,* ed. Hyder E. Rollins (Cambridge, Mass.: Harvard University Press, 1958), 2:105.

51. The manuscript of this famous journal-letter (February 14–May 3, 1819) is at Harvard's Houghton Library.

52. For a photograph of the advertisement, with an annotation by Keats described below, see Amy Lowell, *John Keats* (Boston: Houghton Mifflin, 1925), vol. 2, between 424 and 425.

53. Lowell, *John Keats*, vol. 2, between 424 and 425.

54. *Letters of John Keats,* 2:294.

55. Jack Stillinger, ed., *The Poems of John Keats* (Cambridge, Mass.: Belknap Press, Harvard University Press, 1978), 666.

56. John Bayley, *The Uses of Division: Unity and Disharmony in Literature* (New York: Viking, 1976), 115–30.

57. *Mr. Johnson's Preface,* xlvi.

58. *New York Times Book Review,* April 25, 1993, 10.

59. *Read to Succeed,* 2.

60. *The Adventures of Tom Sawyer: A Condensation of the Book by Mark Twain* (New York: Choice Publishing, 1989).

61. *Adventures of Tom Sawyer: A Condensation,* 92.

62. *The Adventures of Tom Sawyer* (New York: New American Library, 1980), 173.

63. To my knowledge the first to tell the story to an audience of textual critics was James Thorpe in *Principles of Textual Criticism,* 147.

64. *Read to Succeed,* 2.

65. *Read to Succeed,* 4.

66. *The Adventures of Tom Sawyer,* illus. Troy Howell and True W. Williams (New York: Children's Classics and dilithium [*sic*] Press, 1989), iv.

67. McGann, *The Textual Condition,* 67.

68. Terry Eagleton, *Literary Theory* (Oxford: Basil Blackwell, 1983), 214–15. The last sentence of Eagleton's quotation is lifted, nearly verbatim, from Benjamin's essay "Theses on the Philosophy of History" in *Illuminations,* 256.

69. See, particularly, Jerome McGann, "The Monks and the Giants: Textual and Bibliographical Studies and the Interpretation of Literary Works," in *The Beauty of Inflections,* 69–89.

70. For a brief but compelling discussion about errors and their ontological slippage, see Greetham's essay "Manifestation and Accommodation." See also Sebastian Timpanaro, *The Freudian Slip: Psychoanalysis and Textual Criticism,* trans. Kate Soper (London: Verso, 1976).

71. The comments about Devon's urinary weather can be found in separate

letters to Benjamin Robert Haydon and James Rice in *Letters of John Keats*, 1:249, 255; "purplue" can be found in a letter to his sister Fanny, 2:262. For the creeping wam slumpers, see Stillinger's *Poems of John Keats*, 477.

72. Jaime Sabartés, *Picasso: An Intimate Portrait*, trans. Angel Flores (London: W. H. Allen, 1949), 119.

73. John Velz, "What Variorum Editors Know About the Mural," paper presented at the Convention of the Society for Textual Scholarship, New York, April 1993. For a study on how Shakespeare was edited, reedited, and revised by eighteenth-century editors, see Colin Franklin's *Shakespeare Domesticated: The Eighteenth-Century Editor* (Aldershot: Scolar Press, 1991).

74. See Almuth Grésillon, *Éléments de Critique Génétique* (Paris: Presses Universitaires de France, 1994). See also Louis Hay, "Genetic Editing, Past and Future: A Few Reflections by a User," *Text 3*, 117–33, and, as an example, Hans Walter Gabler's edition of *Ulysses* (New York: Garland, 1984).

75. Ralph Williams, "I Shall Be Spoken: Textual Boundaries, Authors, and Intent," in Bornstein and Williams, *Palimpsest*, 45–66.

Chapter 2

1. In *Professing Literature: An Institutional History* (Chicago: University of Chicago Press, 1987), Gerald Graff patiently explores the history of the institutional study of literature in America and its roots in humantistic study. Graff's book is, in this sense, a history of the institutional incorporation of the critical practice of "reading" and does not investigate the role that early textual critics and bibliographers—even people as different as Samuel Johnson and Karl Lachmann—played in editing and preparing texts so that "reading" could take place. American classical scholarship and philology depended almost entirely on a history of continental editing; and it was not until Fredson Bowers (among others) initiated large-scale editing projects of American authors in the 1950s and 1960s that an American school of textual criticism evolved. For a comprehensive history of continental and American textual criticism and bibliography, see Greetham's *Textual Scholarship*.

2. Vinton Dearing, *Manual of Textual Analysis* (Berkeley and Los Angeles: University of California Press, 1959), vii.

3. Thorpe, *Principles of Textual Criticism*, 14.

4. For a discussion on the importance of bibliographical codes, see McGann's *The Textual Condition*, 67. For an example of recent work engaging these codes, see George Bornstein's "What Is the Text of a Poem by Yeats?" in Bornstein and Williams, *Palimpsest*, 167–93.

5. These topics, among others of similar interest, were recently discussed at the 1993 and 1995 conferences of the Society for Textual Scholarship and in Bornstein and Williams, *Palimpsest*. For related discussions on restoration and conservation, see *Shared Responsibility: Proceedings of a Seminar for Curators and Conservators*, ed. Barbara A. Ramsay-Jolicoeur and Ian N. M. Wainwright (Ottawa: National Gallery of Canada, 1990).

6. For recent discussions on this subject see Martha Buskirk's "Commodification as Censor: Copyrights and Fair Use," *October* 60 (1992): 82–109, and her

"Moral Rights: First Step or False Start?" *Art in America,* July 1991, 37–45. See also Weyergraf-Serra and Buskirk, *Destruction of "Tilted Arc."* Canada's Bill C-60 (which is part of the amended Copyright Act of 1988) provides for "Exhibition Rights," whereby artists have the right to permit or prohibit the public display of their work, regardless of the owner of the particular work(s) in question. Exhibition organizers have the responsibility of both securing permission to exhibit the work and to pay an exhibition fee to the artist. What this also means is that artists will now have a greater voice in the way their work is presented, thereby directly affecting the work's textual space. The bill applies only to art made after 1988. For more on this subject, see Diana Nemiroff, "Copyright: A Museum Curator's Point of View," in *Shared Responsibility,* 145–48.

7. Weyergraf-Serra and Buskirk, *Destruction of "Tilted Arc,"* 171.

8. Richard Serra, letter to Don Thalacker, January 1, 1985, in *Richard Serra's "Tilted Arc,"* ed. Clara Weyergraf-Serra and Martha Buskirk (Eindhoven: Van Abbemuseum, 1988), 40. See also Richard Serra, *"Tilted Arc* Destroyed," *Art in America,* May 1989, 34–47.

9. Weyergraf-Serra and Buskirk, *Destruction of "Tilted Arc,"* 171.

10. Serra, *"Tilted Arc* Destroyed," 35.

11. See Michael Kimmelman, "Restoration of a Painting Worries Dutch Art Experts," *New York Times,* December 17, 1991, C15, 19. A double irony here: the painting was first said to be "destroyed" by the slasher, and then the conservator, Daniel Goldreyer, was charged by critics with botching the restoration by overpainting the entire work, thereby destroying the destruction. The question that arises from this sequence of events is the question of conceptualizing transience and how this transience might be expressed in more precise terms than those offered by the (now) meaningless rubric of "destruction." As the title *The Destruction of "Tilted Arc"* reminds us, the appeal in the use of variants of *destruction* is an appeal to our psychological sense of guilt in order to extract from us our sympathy—what is, in effect, an emotional text.

12. *Destruction of "Tilted Arc,"* 187.

13. *Andrei Rublëv,* dir. Andrei Tarkovsky (Kino International, 1966). See also the *kino-roman,* or screen novel of the film, *Andrei Rublëv,* trans. Kitty Hunter Blair (London: Faber and Faber, 1991).

14. *The Family Shakspeare,* ed. Thomas Bowdler (London: Longman, Hurst, Rees, Orme, and Brown, 1818), 1:vii–viii.

15. Weyergraf-Serra and Buskirk, *Destruction of "Tilted Arc,"* 168.

16. Tanselle, *A Rationale of Textual Criticism,* 27–28.

17. For a discussion about how semiotic distinctions are undermined by the act of reading, see my essay "The Implosion of Iconicity" in *Word and Image Interactions: A Selection of Papers Given at the Second International Conference on Word and Image,* ed. Martin Heusser (Basel: Wiese Verlag, 1993), 243–50.

18. Weyergraf-Serra and Buskirk, *Destruction of "Tilted Arc,"* 253.

19. Penny Smith, "The 'Cave of the man-eating Mothers': Its Location in *A Glastonbury Romance,"* *Powys Review* 3, no. 1 (1981–82): 10–17; Margaret Moran, "The Vision and Revision of John Cowper Powys' *Weymouth Sands,"* *Powys Review* 3, no. 3 (1982–83): 18–31.

20. John Cowper Powys, letter to Lulu Powys, February 28, 1911, in *Letters of John Cowper Powys to His Brother Llewelyn*, ed. Malcolm Elwin (London: Village Press, 1975), 90.

21. John Cowper Powys, *Autobiography* (New York: Simon and Schuster, 1934), 336.

22. Ian Hughes, "A Poor Ragged Maiden: The Textual History of *Maiden Castle*," *Powys Review* 3, no. 4 (1983): 17–25; Wilbur T. Albrecht, "Editing *Porius*," *Powys Notes* 7, no. 2 (1992): 4–10.

23. Walter Friedlander, *Caravaggio Studies* (Princeton: Princeton University Press, 1974), 178.

24. For an excellent discussion on how dispersed references to Leonardo's *Battle of Anghiari* can be read as a study in Leonardo's working methods, see Claire Farago's essay, "Leonardo's *Battle of Anghiari*: A Study in the Exchange between Theory and Practice," *Art Bulletin* 76, no. 2 (June 1994): 301–30.

25. The incident is described in Malcolm Yorke's *Eric Gill: Man of Flesh and Spirit* (1981; rpt. New York: Universe, 1982), 102–4.

26. *Letters of Eric Gill*, ed. Walter Shewring (New York: Devin-Adair, 1948), 369.

27. See Gianliugi Colalucci, "Michelangelo's Colours Rediscovered," in *The Sistine Chapel: The Art, the History, and the Restoration*, ed. Giancarlo Pietrangeli et al. (New York: Harmony Books, 1986), 260–65.

28. John Tagliabue, "Cleaned *Last Judgment* Unveiled," *New York Times*, April 9, 1994, 13.

29. Paul Eggert, "Editing Paintings/Conserving Literature: The Nature of the 'Work,'" *Studies in Bibliography* 47 (1994): 65–78.

30. For X rays of *The Concert*, see the unattributed exhibition catalog, *The Age of Caravaggio* (New York: Metropolitan Museum of Art, 1985), 231. While it is generally acknowledged among art historians that Caravaggio did not draw, his practice of using the back of his brush or a stylus to incise lines into the canvas's ground is a more controversial consideration. See Keith Christiansen, "Caravaggio and 'L'esempio davanti del naturale,'" *Art Bulletin* 68, no. 3 (September 1986): 421–45.

31. Foucault, *The Archaeology of Knowledge*, 169–75.

32. Philip Fisher, *Making and Effacing Art: Modern American Art in a Culture of Museums* (New York: Oxford University Press, 1991), 102; George Kubler, *The Shape of Time: Remarks on the History of Things* (New Haven: Yale University Press, 1962), 60–61, 75.

33. Kubler, *The Shape of Time*, 60–61. Kubler's model for linguistic change seems to have been provided not just by Dell Hymes (whom he cites), but also by Edward Sapir, whose chapter on "Drift" in his widely influential book, *Language* (1921) has been a foundation for historical linguistics.

34. Ken Lieberman, Ken Lieberman Laboratories Services Brochure, New York, May 1992, n.p.

35. For recent photographs of the sculpture, see Frank Hine, "Desert Song," *Artforum*, February 1990, 119–22.

36. For photographs of the reemergence of *Spiral Jetty* in 1993–94, see Jean-Pierre Criqui, "Rising Sign," *Artforum*, Summer 1994, 80–81.

37. For an overview of the *Last Supper* project, see David Alan Brown, *Leonardo's "Last Supper": The Restoration* (Washington, D.C.: National Gallery of Art, 1983).

38. For a historical taxonomy of various agents of change, see Ian S. Hodkinson, "Man's Effect on Paintings," in Ramsay-Jolicoeur and Wainwright, *Shared Responsibility*, 54–68. Hodkinson's essay is extremely important in that it documents changing curatorial attitudes toward transience in the discourse of art conservation. The term "damage" (in 1956) was used to describe a transient state; by 1971 the chosen term was "deterioration." By 1989 the nonjudgmental word "change" was considered most appropriate. Hodkinson remarks: "It should be noted that whilst most types of change from original state in historic and artistic works can be regarded as 'damage' or 'deterioration,' there are some changes which may be seen as contributing to the 'aesthetic merit,' or the 'historical or sociological significance' of the object. All changes or additions to an object should be carefully examined from this point of view before a decision is made to reverse or remove them. Changes can be brought about by Physical, Chemical, or Biological agents, and complex interactions of all three" (58).

39. *The Diaries of Paul Klee, 1898–1918*, ed. Felix Klee, trans. Pierre Schneider et al. (Berkeley and Los Angeles: University of California Press, 1964), 108–9.

40. *Diaries of Paul Klee*, 66.

41. For an excellent overview of this important matter, see G. Thomas Tanselle's "Reproduction and Scholarship," *Studies in Bibliography* 42 (1989): 25–54.

42. Peter Shillingsburg, "Text as Matter, Concept, and Action," *Studies in Bibliography* 44 (1991): 31–82.

43. *The Writings of Robert Smithson*, ed. Nancy Holt (New York: New York University Press, 1979), 183.

44. Foucault, *The Archaeology of Knowledge*, 169.

45. Alan Cowell, "Over Masterpieces, Protection Vies with Access," *New York Times*, November 19, 1991, A4.

46. Cowell, "Over Masterpieces." For a discussion on vandalism against artworks (or what is generally known as "iconoclasm"), see David Freedberg's "Iconoclasts and Their Motives," *Public* 8 (1993): 8–47.

47. *Francis Bacon: In Conversation with Michel Archimbaud* (London: Phaidon Press, 1993), 166.

48. Philip Ward, *The Nature of Conservation: A Race against Time* (Marina del Rey, Calif.: Getty Conservation Institute, 1986), 20.

49. *The Diary of Benjamin Robert Haydon*, ed. Willard B. Pope (Cambridge, Mass.: Harvard University Press, 1963), 3:452; *The Autobiography and Journals of Benjamin Robert Haydon*, ed. Malcolm Elwin (London: Macdonald, 1950), 242.

50. Helen Borsick, "Gloom Cast on Museum by Bombing of *Thinker*," *Cleveland Plain Dealer*, March 25, 1970, 1, 5. I am grateful to Tom Hinson of the Cleveland Museum of Art for providing a copy of this text and related curatorial information about the sculpture.

51. "Damaged *Thinker* to Stand as Symbol of Destruction," *Cleveland Press*, March 28, 1970, n.p.

52. In helping to document the installation history of Hammons's *How Ya Like Me Now?* I am indebted to the assistance of Janine Cirincione (Jack Tilton Gallery, New York), Leslie King-Hammond (Maryland Institute, College of Art), Sharon Patton (University of Michigan), and Grant Samuelsen (Washington Project for the Arts).

53. Elizabeth Kastor, "Artist Expected Portrait to Draw Angry Reaction," *Washington Post*, December 1, 1989, B1, 4.

54. Alan Cowell, "Italians Try to Place Blame for Bomb Damage at Uffizi," *New York Times*, May 29, 1993, 4.

55. My information about this story as described in this paragraph comes largely from Michael Winerip's article, "Porch War: Is 19th Century Better than 18th Century?" *New York Times*, July 20, 1990, A16.

56. Winerip, "Porch War."

57. Rosenberg's remark is quoted in Ginger Danto's "Taking *Mona Lisa*'s Temperature," *Artnews*, September 1991, 98–101.

58. See David Robertson, *Sir Charles Eastlake and the Victorian World* (Princeton: Princeton University Press, 1978), 95–99.

59. *The Journal of Eugène Delacroix*, ed. Hubert Wellington, trans. Lucy Norton (Oxford: Phaidon, 1980), 38.

60. James Beck and Michael Daley, *Art Restoration: The Culture, the Business, and the Scandal* (New York: Norton, 1993), 39–40 (on *secco* techniques), 65, 96–102.

61. Beck and Daley, *Art Restoration*, 116.

62. Kathleen Weil-Garris Brandt, "The Grime of the Centuries Is a Pigment of the Imagination: Michelangelo's Sistine Ceiling," in Bornstein and Williams, *Palimpsest*, 257–84.

63. Mostafavi and Leatherbarrow, *On Weathering*, 16.

64. Brandt, "Grime of the Centuries."

65. For a compelling discussion on the relativity of intentions with respect to conservation, see Gerry Hedley, "Long Lost Relations and New Found Relativities: Issues in the Cleaning of Paintings," in *Shared Responsibility*, 159–69.

Chapter Three

1. In contrast to the textual-critical tradition, the deconstructionist use of the term *text*, rather than closing itself on a material state of language, opens itself up to the intertextual, even metatextual, loci of language. Cf. Roland Barthes: "[T]he text is not a line of words releasing a single 'theological' meaning (the 'message' of an Author-God), but a multi-dimensional space in which a variety of writings, none of them original, blend and clash." *Image-Music-Text*, trans. Stephen Heath (New York: Hill & Wang, 1977), 9.

2. Jerome McGann, "*Ulysses* as a Postmodern Text: The Gabler Edition," *Criticism* 27 (1985): 283–306.

3. Peter Shillingsburg, *Scholarly Editing in the Computer Age: Theory and Practice* (Athens: University of Georgia Press, 1986), 49–50. For Shillingsburg a text is

more particularly an immaterial representation of words and punctuation inasmuch as that order has some kind of physical representation. For his more recent exegesis on the distinctions between conceptions of the work, a version, and a text, see his "Text as Matter."

4. William Proctor Williams and Craig S. Abbott, *An Introduction to Bibliographical and Textual Studies*, 2d ed. (New York: Modern Language Association, 1989), 3.

5. Jerome Rothenberg, *Pre-Faces and Other Writings* (New York: New Directions, 1981), 10–11, 36.

6. McGann, *The Beauty of Inflections*, 343.

7. Jacques Derrida, "Signature Event Context," in *Margins of Philosophy*, trans. Alan Bass (Chicago: University of Chicago Press, 1982), 307–30.

8. Derrida, *Margins of Philosophy*, 315.

9. Robert Scholes, "Deconstruction and Communication," *Critical Inquiry* 14 (1988): 278–95.

10. Derrida, *Margins of Philosophy*, 317.

11. Shillingsburg discusses four different conceptions, or "orientations," of completion: the historical ("the work of art is finished when it becomes a material artifact"); the sociological (a work is finished when it is ready to be distributed); the aesthetic (a work of art is never really complete); and the authorial (a work is finished when the author says so) (*Scholarly Editing*, 75–78). Although there are some problems with these orientations (particularly where they overlap), Shillingsburg's distinctions are very useful outlines.

12. Nelson Goodman, *Languages of Art*, 2d ed. (Indianapolis: Hackett, 1976), 114.

13. *New York Times*, November 12, 1991, D26.

14. Benjamin, *Illuminations*, 220.

15. Goodman, *Languages of Art,* 113.

16. Goodman, *Languages of Art*, 121, 207–11. See also Goodman's *Of Mind and Other Matters* (Cambridge, Mass.: Harvard University Press, 1984), 139.

17. Goodman, *Languages of Art*, 115–16.

18. For an illuminating reply to Goodman on this topic, see Barbara Herrnstein Smith's *On the Margins of Discourse* (Chicago: University of Chicago Press, 1978), 3–13.

19. McGann, *Critique*, 52.

20. A similar, but more finely honed, point of view is shared by Shillingsburg in *Scholarly Editing*, 46–47.

21. The editions and prices I have cited derive from an advertising supplement on the endpapers to Peterson's "Cheap Edition for the Million" edition of Scott's *Ivanhoe* (Philadelphia: T. B. Peterson and Brothers, n.d.).

22. I leave aside for now the theoretical implications of sound poetry, as well as some *Zaum'* and L=A=N=G=U=A=G=E poetry (which for the most part is intranscribable, but recordable), and some concrete poems (which are not speakable, or in some cases transcribable, but are reproducible by other means). As an oral language, the implications offered by sign language poetry would fall under the rubric posited for sound poetry, that is, intranscribable, but recordable.

23. Goodman, *Languages of Art*, 113.

24. Jorgé Luis Borges, "Pierre Menard, Author of the *Quixote*," trans. James E. Erby, in *Labyrinths*, ed. Donald A. Yates and James E. Erby (New York: New Directions, 1964), 39.

25. Borges, *Labyrinths*, 43.

26. Goodman, *Of Mind and Other Matters*, 140–41.

27. Arthur Danto, *Transfiguration of the Commonplace* (Cambridge, Mass.: Harvard University Press, 1981), 35–36.

28. Mikhail M. Bakhtin, *Speech Genres and Other Late Essays*, trans. Vern W. McGee, ed. Caryl Emerson and Michael Holquist (Austin: University of Texas Press, 1986), 105.

29. Bakhtin, *Speech Genres,* 108–9.

30. Bakhtin, *Speech Genres*, 147.

31. Jacques Derrida, "Form and Meaning: A Note on the Phenomenology of Language," in *Margins of Philosophy*, 160–61; see also *Positions*, trans. Alan Bass (Chicago: University of Chicago Press, 1981), 26–27.

32. Foucault, *The Archaeology of Knowledge*, 23.

33. Bakhtin, *Speech Genres*, 120.

34. John Sutherland, "Publishing History: A Hole at the Centre of Literary Sociology," *Critical Inquiry* 14 (1988): 574–89.

35. Cited in Jo Ann Lewis's review of *Stieglitz in the Darkroom*, *Washington Post*, October 3, 1992, D1.

36. Alfred Stieglitz, letter to Herbert Seligman, 14 October 1921, Beinecke Library, Yale University. Quoted in Sarah Greenough, *Stieglitz in the Darkroom* (Washington, D.C.: National Gallery of Art, 1992), 9.

37. Greenough, *Stieglitz in the Darkroom*, 9.

38. Hollis Frampton, "Eadweard Muybridge: Fragments of a Tesseract," *Artforum*, March 1973, 43–52.

39. See McGann's *Black Riders: The Visible Language of Modernism* (Princeton: Princeton University Press, 1993), 23–41, and Bornstein's "What Is the Text?"

40. Danto, *Transfiguration of the Commonplace*, 18.

41. Ian Frazier, "A Reporter at Large: Great Plains III," *New Yorker*, March 6, 1989, 41–68.

42. *Collected Papers of Charles Sanders Peirce*, ed. Charles Hartshorne and Paul Weiss (1931; rpt. Cambridge, Mass.: Belknap Press, Harvard University Press, 1960), 2:135.

43. Jan Mukařovský, "Art as a Semiotic Fact," in *Semiotics of Art: Prague School Contributions*, ed. Ladislav Matejka and Irwin R. Titunik (Cambridge, Mass.: MIT Press, 1976), 3–9.

44. *Poetry in Motion*, dir. Ron Mann (Sphinx Productions, 1981).

45. Williams and Abbott, *Introduction*, 3.

46. This has not, however, stopped Finley from publishing texts of her performance monologues. Several monologues (including her "Black Sheep") were published in *Shock Treatment* (San Francisco: City Lights, 1990), while a different text of "Black Sheep" appeared in Maria Nadotti's essay "Karen Finley's Poisoned Meatloaf," *Artforum*, March 1989, 113–16.

47. For an excellent discussion on the influence of performance on contemporary artists, particularly Calle, see Peggy Phelan's *Unmarked: The Politics of Performance* (New York: Routledge, 1993), 146–66.

48. Paul Ricoeur, "The Model of the Text: Meaningful Action Considered as Text," *New Literary History* 6 (1974): 95–110.

49. Bakhtin, *Speech Genres*, 134.

50. Stephen Mailloux, *Interpretative Conventions* (Ithaca: Cornell University Press, 1982), 20.

51. Stanley Fish, *Is There a Text in This Class?* (Cambridge, Mass.: Harvard University Press, 1980), 3.

52. George Lakoff, *Women, Fire, and Dangerous Things: What Categories Reveal About the Mind* (Chicago: University of Chicago Press, 1987), 542.

53. Phelan, *Unmarked*, 146.

54. Barthes, *Image-Music-Text*, 77.

55. McGann, *The Beauty of Inflections*, 96.

Chapter Four

1. Rainer Maria Rilke, *Letters on Cézanne,* ed. Clara Rilke, trans. Joel Agee (New York: Fromm, 1985), 50.

2. Rilke, *Letters on Cézanne*, 28.

3. Three recent and particularly compelling studies of these problems include Gilles Fauconnier's *Mental Spaces: Aspects of Meaning Construction in Natural Language* (Cambridge, Mass.: MIT Press, 1985); Lakoff's *Women, Fire, and Dangerous Things*; and a volume of essays edited by Umberto Eco, Marco Santambrogio, and Patrizia Violi, *Meaning and Mental Representations* (Bloomington: Indiana University Press, 1988).

4. G. Thomas Tanselle, "Textual Criticism and Deconstruction," *Studies in Bibliography* 43 (1990): 1–33.

5. For a recent survey on emerging problems related to curatorial conventions and museological practices, see *Exhibiting Cultures: The Poetics and Politics of Museum Display*, ed. Ivan Karp and Steven D. Lavine (Washington, D.C.: Smithsonian Institution Press, 1991).

6. Arnold Newman, photographs accompanying "Jackson Pollock: Is He the Greatest Living Painter in the United States?" *Life*, August 8, 1949, 42–45; Cecil Beaton, photographs accompanying "The New Soft Look," *Vogue*, March 1951, 156–59.

7. For a discussion on these dialectical images, see W. J. T. Mitchell, *Picture Theory* (Chicago: University of Chicago Press, 1994), 45–57.

8. James Meyer, "The Condition of Bohemia," catalog accompanying Christian Philipp Müller's exhibition at American Fine Arts, New York, March 1994.

9. Rilke, *Letters on Cézanne*, 89. The German words in brackets are from the edition prepared by the Rilke-Archiv, *Rainer Maria Rilke: Briefe* (Wiesbaden: Insel Verlag, 1950).

10. Helen Vendler, *The Odes of John Keats* (Cambridge, Mass.: Belknap Press, Harvard University Press, 1983), 306n.

11. Vendler, *Odes of John Keats*, 77; McGann, *The Beauty of Inflections*, 43–44.

12. Haydon, *Autobiography*, 292–95. In the one surviving letter by Keats to Elmes, Keats apologizes for the delay in sending him a copy of the "Nightingale" ode, explaining that "I have but just received the Book [i.e. transcript-book] which contains the only copy of the verses in question. I have asked for it repeatedly ever since I promised Mr Haydon and could not help the delay; which I regret" (*Letters of John Keats*, 2:118). That he had "promised" the poem to Haydon strongly suggests that he was acquiescing to Haydon's request to publish the poem in the *Annals*.

13. The appearance of "Hither, hither, love" in *Ladies' Companion* is probably a lot less controversial in the context of the journal's full title: *The Ladies' Companion, a monthly magazine, embracing Literature and the arts, embellished with engravings, and music arranged for the piano forte, guitar, &c.* (New York: W. W. Snowden, vol. 7, August 1837). *The Ladies Pocket Magazine* (London: J. Robins and Co., part 1, 1838), however, comes across as an early hybrid of *Cosmopolitan*, *Elle*, and *Family Circle*: articles from the 1838 publication (which includes "Hither, hither, love") discuss "Traits of Female Character," "The Science of Gloveology," and "Carefree Marriages." A lengthy section is devoted to current fashions: essentially an up-to-date guide to what's in and what's out in London, Paris, and (this was the summertime) Brighton Pier. Since "Hither, hither, love" was (like most of Keats's carpe diem poems) given to a male friend, its appearance in these magazines is something of an anomaly: it deviates from the audience one assumes Keats intended it to reach and thus reveals how the vicissitudes of textual transmission affect our encounters with the poem. A textual stemma would reveal Keats's brother George showing his MS to John Howard Payne, Payne publishing it in *Ladies' Companion*, and—a year later—subsequent republication of the *Ladies' Companion* text in *The Ladies Pocket Magazine,* where it sat (bypassed by Keats's biographers Forman, Colvin, and others) until the unabashed and unembarrassable Amy Lowell resurrected it as an instance of Keats's "bad poetry" (*John Keats*, 2:113–14). Few of Keats's poems have such a rich and revealing textual history.

14. *Kunkel's Musical Review,* December 1892, 80.

15. McGann, *The Beauty of Inflections*, 85.

16. Shillingsburg, "Text as Matter."

17. Bakhtin, *Speech Genres*, 112.

18. Barthes, *Image-Music-Text*, 9.

19. Bakhtin, *Speech Genres*, 114.

20. Bakhtin, *Speech Genres*, 114.

21. Bakhtin, *Speech Genres,* 120.

22. Gerald Mast, "On Framing," *Critical Inquiry* 11 (1984): 82–109.

23. Witold Rybczynski, *The Most Beautiful House in the World* (New York: Viking, 1989), 48.

24. Francesco Clemente, interview with Giancarlo Politi [and Helena Kontova], in *Art Talk: The Early 80s*, ed. Jeanne Siegel (New York: Da Capo, 1988), 120–38.

25. See, for example, Norman Bryson's erudite exegesis of still-life painting in *Looking at the Overlooked: Four Essays on Still Life Painting* (Cambridge, Mass.: Harvard University Press, 1990), esp. 60–95.

26. Marcia Kupfer, *"Soap Bubbles" of Jean-Siméon Chardin* (Washington, D.C.: National Gallery of Art, 1991), n.p.

27. A rather good example of this can be found in B. R. Haydon's journal entry for March 7, 1844: "Nearly finished the Duke and Copenhagen. I have painted nineteen Napoleons. Thirteen musings at St. Helena, and six other musings, and three Dukes and Copenhagens. By heavens! how many more?" (*Autobiography*, 621). Answer: plenty. On December 30, he wrote: "Began and finished a Napoleon in two hours and a half; the quickest I ever did, and the twenty-fifth" (*Autobiography*, 627).

28. Most of these efforts depend on finding transaesthetic denominators, such as the relationship between color and music that is explored in A. Wallace Rimington's *Colour-Music: The Art of Mobile Colour* (London: Hutchinson and Co., 1912). For a fairly recent discussion of related efforts see Wendy Steiner's *The Colors of Rhetoric: Problems in the Relation between Modern Literature and Painting* (Chicago: University of Chicago Press, 1982), 51–54. For a linguistic argument on why these efforts all fail, see Diane Brentari's essay "Phonological Constituents of Sign Languages," in Heusser, *Word and Image Interactions*, 237–42.

29. McGann, *The Textual Condition*, 15–16.

30. Tanselle, *Rationale of Textual Criticism*, 27.

31. Michelangelo originally intended *David* to be situated in the Palazzo Vecchio in Florence, where it stood until 1873, when it was removed and subsequently installed in the Accademia delle Belle Arti (Charles Seymour, Jr., *Michelangelo's "David": A Search for Identity* [New York: Norton, 1967], 3). A double of the sculpture was placed in the Palazzo in 1882, and this "fake" text is, I would venture to say, only partly a fake; at least it is situated in the location that Michelangelo specified. The "original" David is perhaps now a fake too because it is installed in a context that is contrived—that is, indoors. Of course, no one would think that Michelangelo's *David* is a fake in a sense that the double is a fake, but this potential aporia seems to me a good reason to examine the criteria by which forgery is presupposed.

32. Shillingsburg, "Text as Matter." The question was first posed, in a slightly different form, by F. W. Bateson in an essay entitled "The Philistinism of 'Research,'" and was later taken up by James McLaverty in "The Mode of Existence of Literary Works of Art: The Case of the *Dunciad Variorum*," *Studies in Bibliography* 37 (1986): 82–105.

33. For an insightful analysis of how textual forgery can be read in political terms, see Neil Fraistat's "Illegitimate Shelley: Radical Piracy and the Textual Edition as Cultural Performance," *PMLA* 109, no. 3 (May 1994): 409–23.

34. I could actually take this consideration one step further and write about different representations of the same image on different postcards. While I presently lack necessary textual documents to do this with *Mona Lisa,* I do, however, have in my possession two different postcards of Jackson Pollock's *Number 1, 1950 (Lavender Mist),* both of which were purchased at the bookstore of the National Gallery of Art, where the painting is exhibited. The first, obtained in 1985, is a full-frame image with white borders; the second, obtained in 1992, is radically cropped and has no borders: Pollock's signature has been effaced from this text, his

handprints (which border the left, top, and right edges of the painting) are similarly effaced, and a splotch of raw sienna on the far right margin—the only incongruous color in the painting—is absent from the 1992 text. The color separations of the two postcards are also quite different. As Jerome McGann remarks in *The Textual Condition,* "Variation, in other words, is the invariant rule of the textual condition" (185).

35. Susan Hapgood's essay entitled "Remaking Art History" in *Art in America,* July 1990, 114–23, 181, serves as an excellent introduction to both the terminology and the problems inherent in art from this period.

36. Again Rothko would play an important role here: when he accepted the Seagram Project (the building was designed by Philip Johnson and the paintings were to fill one room of the Four Seasons Restaurant), Rothko, with his distaste for swank, told a friend that he did so "as a challenge, with strictly malicious intentions. I hope to paint something that will ruin the appetite of every son of a bitch who ever eats in that room" (John Fischer, "Portrait of the Artist as a Young Man," *Harper's Magazine,* July 1970, 16–23). Later Rothko used the excuse that he did not know his paintings would be installed in the restaurant and withdrew entirely from the project. See Michael Compton's essay in *Mark Rothko: The Seagram Mural Project* (Liverpool: Tate Gallery, 1988), 8–17.

37. Donald Judd, "Artist Disowns 'Copied' Sculpture," *Art in America,* April 1990, 33.

38. *Artforum,* March 1990, 80.

39. Quoted by Patricia Failing in "Judd and Panza Square Off," *Artnews,* November 1990, 146–51. See also Hapgood, "Remaking Art History," 181 n. 12.

40. The work of Joseph Beuys has presented incessant trouble, as Beuys frequently created art by subtly transforming extant objects and adding his signature. In a recent full-page advertisement, Lucrezia DeDomizio Durini warned readers that the only multiples Beuys produced are published in the catalog *Joseph Beuys Multiples,* and she offered the following caveat: "In addition, I wish to inform the public that the sailboat with outboard motor PC0164D, named 'Irma,' which belonged to Baron Giuseppe Durini until June 1989, was never signed by Joseph Beuys and is not a work by the artist." (I have been unable to document the origin of my xerox of the advertisement, and my task is made more difficult by the fact that indices [such as *Art Index*] do not list advertisements, even when, like Judd's ad in *Artforum,* such advertisements have important textual and historical authority.)

41. *New York Times,* September 14, 1988, A32.

42. "[J]e déclare que le travail exposé sous mon nom à *Bilderstreit,* est un Faux aussi longtemps qu'il ne sera pas ôté de cette exposition," *Galleries* 31 (June–July 1989): 94.

43. For a recent discussion on these issues, see Martha Buskirk's "Commodification as Censor."

44. Richard Serra, *Richard Serra: Sculpture* (New York: Pace Gallery, 1989), n.p.

45. Richard Serra, interview with Robert Morgan, *Flash Art News,* January–February 1989, n.p.

46 All art installations involve unexpected risks. Christo's seemingly benign

Umbrellas killed two people in 1992; one when an umbrella broke loose from its moorings and struck a spectator, and another when a crane operator was electrocuted during deinstallation when his crane came into contact with an electrical transmission line.

47. *Art in America,* October 1989, inside cover.

48. The Lawrence Oliver sculpture (*Keystone Prop*) had a small (approximately one-foot) strip of red tape on the floor in front of it; the Hirshhorn piece (*2–2–1: To Dickie & Tina*) is separated from the audience by a plexiglass wall approximately eighteen inches high; and the Pace Gallery installation (*LA Cross*) was boxed into a corner by white tape on the floor and a small "Do Not Touch" sign on the adjoining wall.

49. It is worth noting that the *MLA Handbook* (3d ed., 1988) implicitly acknowledges this distinction in describing the procedures for citing a work of art. If the "original" work is being used, the institution in which it is housed or installed should be cited; if a reproduction (slide or photograph) is being used, both the institution the work is in *and* the publication in which the image appears should be cited (149, sec. 4.8.9). This seems to me an excellent paradigm; but how many critics will admit to not having seen the "originals" of the works they are writing about?

50. While every bridge is essentially site-specific, the complexities of the integration of disparate factors relating to the site, the materials, and the design are exemplified in a compelling way in Robert Maillart's Schwandbach Bridge (1933) near Hinterfultigen, Switzerland. Faced with an irregularly curved ellipsis at both ends of the approach, Maillart combined a horizontally curved deck with a vertically curved arch using primarily straight members. The result is brilliantly ironic. See David Billington, *Robert Maillart's Bridges: The Art of Engineering* (Princeton: Princeton University Press, 1979), 94–98. On the problem of making historical inferences in which the problem of a bridge's "context" is addressed in a detailed way, see Michael Baxandall, *Patterns of Intention: On the Historical Explanation of Pictures* (New Haven: Yale University Press, 1985), 12–40.

51. The term "collaboration" has been favored by Jack Stillinger for a number of years. More recently, in *Multiple Authorship*, he has used the phrase "collaborative authorship" to describe incidents of active collaboration between the author, transcriber, editor, and so on, even though, in the case of Keats, his friend Richard Woodhouse, and his publisher John Taylor, Stillinger acknowledges that "the extent of Keats's approval of their contributions is not always clear" (45–46). Whether we call this collaboration (or as T. H. Howard Hill suggests, "conjunctive") is merely semantic: Stillinger has latched onto an important and very complicated issue. Considering the fact that a great amount of art is produced by delegating authority (particularly in the case of sculpture), and further considering the fact that few people are actually aware of the extent to which this occurs (Rodin signed his name to works entirely made by others, and a number of active painters have exhibited works painted, for the most part, by assistants), it would seem that this kind of collaboration is worth looking at more closely.

52. Allan Kozinn, "Masur, as Just Plain Kurt, Gives His Audience Some Answers," *New York Times,* November 21, 1991, C15, 21.

53. Jon Pareles, "Bootlegs: Industry's Bane, Fans' Bonanza," *New York Times,* July 21, 1991, H24, 25.

Chapter Five

1. Fisher, *Making and Effacing Art*, 6–7. See also Donal Preziosi, "Modernity Again: The Museum as Trompe l'oeil," in *Deconstruction and the Visual Arts*, ed. Peter Brunette and David Wills (Cambridge: Cambridge University Press, 1994), 143.

2. McGann, *The Textual Condition*, 10.

3. For discussions on the work's transience, see Pietrangeli et al., *The Sistine Chapel*, and *The Sistine Chapel: A Glorious Restoration*, ed. Pierluigi de Vecchi (New York: Abrams, 1994); for a discussion on how the work has been read through photographs, see Leo Steinberg's "Who's Who in Michelangelo's *Creation of Adam*: A Chronology of the Picture's Reluctant Self-Revelation," *Art Bulletin* 123, no. 4 (December 1992): 552–66.

4. Gérard Genette, "Introduction to the Paratext," *New Literary History* 22, no. 2 (1991): 261–72, and "Structure and Functions of the Title in Literature," *Critical Inquiry* 14 (1988): 692–720.

5. Jacques Derrida, *The Truth in Painting*, trans. Geoff Bennington and Ian McLeod (Chicago: University of Chicago Press, 1987), 55.

6. Michael Baxandall, "Exhibiting Intention: Some Preconditions of the Visual Display of Culturally Purposeful Objects," in Karp and Lavine, *Exhibiting Cultures*, 33–41.

7. Sometimes labels are simply inaccurate. Once, at Chicago's Museum of Contemporary Art, a sculpture by Jeff Koons had the following label attached to the wall: "*Hoover Celebrity III*, 1979. Two New Hoover Celebrity III Vacuum Cleaners, Plexiglass, and Fluorescent Lights. Collection of the Lannan Foundation, Los Angeles." When I pointed out to a curator that the sculpture had only one vacuum cleaner instead of two, he responded: "Oh, that's a mistake."

8. *Jackson Pollock: A Catalogue Raisonné of Paintings, Drawings, and Other Works*, ed. Francis V. O'Connor and Eugene V. Thaw (New Haven: Yale University Press, 1978), 1:166, 178.

9. Steven Naifeh and Gregory White Smith, *Jackson Pollock: An American Saga* (New York: HarperPerennial, 1991), f3v between 504 and 505.

10. For a study on these hidden self-portraits, see Celeste Brusati, "Stilled Lives: Self-Portraiture and Self-Reflection in Seventeenth-Century Netherlandish Still-Life Painting," *Simiolus Netherlands Quarterly for the History of Art* 20, nos. 2–3 (1990–91): 168–82.

11. For an account explaining the degree to which "collaborative authorship" is a general condition of literary works, see Jack Stillinger's *Multiple Authorship*.

12. *The Spirits That Lend Strength Are Invisible (Salt of Silver)*, 1988.

13. While curators are indeed the authors of these texts, they also work with a fairly specific set of conventions that are constantly subject to revision. For a recent discussion on the inconsistencies of labeling practices, see David C. Devenish, "Labelling in Museum Display," *Museum Management and Curatorship* 9, no. 1 (March 1990): 63–72.

14. O'Connor and Thaw, *Jackson Pollock*, 2:x.

15. See Ed Ruscha, *Guacamole Airlines and Other Drawings* (New York: Abrams, 1980).

16. *Diaries of Paul Klee*, 68.

17. *The Andy Warhol Diaries*, ed. Pat Hackett (New York: Warner, 1989), 771.

18. Franz Kline, "An Interview with David Sylvester," *Living Arts* 1 (1963): 2–13.

19. Roland Barthes, "The Rhetoric of the Image," in *Image-Music-Text*, 32–51.

20. See Bengt Danielsson, "Gauguin's Tahitian Titles," *Burlington Magazine* 59 (March 1967): 228–33.

21. *Paul Gauguin: Letters to His Wife and Friends*, ed. Maurice Malingue, trans. Henry Stenning (London: Saturn Press, n.d.), 177.

22. *Larousse Encyclopedia of Modern Art: From 1800 to the Present Day*, ed. René Huyghe (New York: Prometheus Press, 1965), 192.

23. Ernest Gilman, "Interart Studies and the 'Imperialism' of Language," *Poetics Today* 10, no. 1 (spring 1989): 5–30.

24. Lawrence Kramer, "Representation in Music," paper presented at the annual convention of the Modern Language Association, New York, 1988; John Fisher, "Entitling," *Critical Inquiry* 11 (1984): 286–98.

25. Johanne Lamoureux, "Underlining the Legend of the Gallery Space," *October* 65 (1993): 21–28.

26. Hazard Adams, "Titles, Titling, and Entitlement To," *Journal of Aesthetics and Art Criticism* 46, no. 1 (1987): 7–21.

27. A reproduction of the painting can be found in the exhibition catalog by Janet Kardon, *David Salle* (Philadelphia: Institute for Contemporary Art, 1986), 57.

28. Gotthold Lessing, *Hamburg Dramaturgy*, ed. Victor Lange, trans. Helen Zimmern (New York: Dover, 1962), 53.

29. Enzo Cucchi, interview with Giancarlo Politi and Helena Kontova, in *Art Talk*, 142.

30. Naifeh and Smith, *Jackson Pollock*, f4r between 504 and 505.

31. O'Connor and Thaw, *Jackson Pollock*, 2:86. The colon is not without purpose, but the purpose is inconsistent. In their prefatory notes O'Connor and Thaw explain:

> Titles which have become standard through usage and publication but which are not Pollock's are enclosed in parentheses. . . . Numbered titles which also have verbal titles are subject to the same treatment as purely verbal titles. When both titles are Pollock's they are separated by a colon; otherwise they are separated by a slash. (2:x)

O'Connor and Thaw title the painting *Lavender Mist: Number 1, 1950*, thereby suggesting both titles are Pollock's (2:86). In a note, however, they remark that *Lavender Mist* is Greenberg's contribution (2:86), which (if we follow their editorial premises) would call for a slash between the two titles. But even a slash won't tell us who wrote what. I would like to suggest that this kind of confusion illustrates the need for a textual apparatus for documenting titles of artworks.

32. O'Connor and Thaw, *Jackson Pollock*, 2:86.

33. The first report, made when the museum acquired the painting, is dated July 1976; the second, made when the painting was recently examined and cleaned, is dated 1990.

34. Thus, it is important to know the authority responsible for certain kinds of art transformations—say, the dismantling and "storage" of Richard Serra's *Tilted Arc,* the colorization of Capra's *It's a Wonderful Life,* or the stripping of paint from David Smith's sculptures by his estate in order to make the work more salable. The relationship between transformations like these and textual editing, is, I think, something that needs to be looked at more closely in connection with moral-rights legislation in the arts.

35. For Greenberg, see Naifeh and Smith, *Jackson Pollock*, 553. For Manheim, see Ellen Landau, *Jackson Pollock* (New York: Abrams, 1989), 169 and 261 n. 20.

36. Brenda Richardson, *Frank Stella: The Black Paintings* (Baltimore: Baltimore Museum of Art, 1976), 4.

37. Charles F. Stuckey, "Bill de Kooning and Joe Christmas," *Art in America,* March 1980, 67–79.

38. Robert Hughes, *Nothing If Not Critical* (New York: Knopf, 1990), 219.

39. "Jackson Pollock: Is He the Greatest Living Painter in the United States?"

40. Bryson, *Looking at the Overlooked*, 61.

41. The *Times*'s account is as follows: "On Thursday, as Lucio Fontana's 'Spacial Concept Waiting,' a 1965 all-green canvas, came on the block, a Christie's clerk began to display the painting on its wrong side, revealing only the bare backside of the canvas adorned with strips of black masking tape, then he realized his mistake and, blushing, whirled it around. When the work failed to sell (there was not a single bid) someone in the audience suggested loudly, 'Why not try selling the other side?'" *New York Times*, July 2, 1994, A9, 15.

42. Derrida, *The Truth in Painting,* 73. In his translation of the "Parergon" chapter in *October* 9 (1979): 3–40, Craig Owens translates this last sentence as "Philosophy wants to examine this 'truth,' but never succeeds." Derrida's original text reads: "La philosophie veut l'arraisonner et elle n'y parvient pas." *La vérité en peinture* (Paris: Flammarion, 1978), 85.

43. Moxey, *The Practice of Theory*, 2.

Index

Abridgments. *See* Condensed books
Adams, Hazard, 169
Advertising, 14–18, 26–27, 40, 43–44, 49, 96
Agency and authority, 10, 60–69, 74–75, 83–84, 93, 111–12, 162–64, 165. *See also* Authorship
Alexandria, library of, 22–23, 30, 51
Andrei Rublëv (Tarkovsky), 61
Annals of the Fine Arts, 127–28
Aporia, 9, 10, 54, 95, 130
Apparatus, 40, 108–9
Archetype, 21–22
Architecture, 2–3, 80–88
Art history, 3–4, 8–10, 66–67, 174–75, 179–81. *See also* Textual criticism; Art history
Art magazines, 57, 142. *See also* Virtual galleries
Authorship, 142–44, 174–75; as collaboration, 33, 151, 159–62, 164–65, 171–74, 199n

Bacon, Francis, 75–76
Bakhtin, Mikhail, 104–5, 113–14, 117, 131–33
Barthes, Roland, 61, 168
Basquiat, Jean-Michel, 176–77
Baxandall, Michael, 161
Bayley, John, 37–38
Beaumont, Sir George, 85
Beck, James, 85–86
Beetles and bugs: as authors, 72, 158–59, 162–63, 165; as media 158–59, 162, 164, 165
Bellori, Pietro, 66
Benjamin, Walter, 4–6
Berne Convention Treaty, 55, 144
Beuys, Joseph, 198n
Bibliographical codes, 44, 53–54, 80, 185n
Body criticism, 21–22. *See also* Eugenics
Bootlegged music tapes, 152–53
Borges, Jorge Luis, 102–4
Bostrychidae and *Lyctidae* (powder-post beetles), 72
Bowdler, Thomas, 31, 61–64, 69–70, 74
Bowers, Fredson, 20, 23, 26–27, 175
Breuer, Marcel, 82
Bridges, as installations, 151
Bryson, Norman, 3, 177
Buren, Daniel, 143–44
Byron, George Gordon, Lord, 34–35

Cage, John, 112
Calculus of Variants (Greg), 19, 21–22, 52
Canguilhem, Georges, 29–30
Canons and canonization, 11, 31–32, 38, 46, 54–55, 91, 122
Capra, Frank, 55
Caravaggio, 66, 69
Center for the Editing of American Authors (CEAA), 21

"Certificate of Appropriateness," 82–83

Cervantes, Miguel de, 102–3

Cézanne, Paul, 121–22, 125–27

Chardin, Jean Siméon, 136–37

Mr. Clean, 26–27

Clemente, Francesco, 135

Cliff's Notes, 46

Clorox bleach, 26–27

Collaboration. *See* Authorship

Colour of Pomegranates, The (Paradjanov), 73

Condensed books, 2, 39–44

Context: as an activity, 124, 152, 179–81; etymology of, 4; installations as, 123–25; as opposed to framing, 132–35. *See also* Framing; Texts, boundaries of

Contradiction, as a necessary element of cultural theory, 9

Copies. *See* Reproduction

Critique genetique, 47

Critique of Modern Textual Criticism, A (McGann), xi, 51, 99

Cucchi, Enzo, 171

Cultural change, 1–3, 6–7, 8–9, 30–46; as fundamental phenomena, 2–3, 32–33, 45–46, 128–30, 179–81; in relation to architecture, 73, 74, 80, 82–84; in relation to Thomas Bowdler's *Family Shakspeare,* 61–64; in relation to Eric Gill's *Prospero and Ariel;* in relation to Richard Serra's *Tilted Arc,* 56–65; in relation to titles, 172–75

Danto, Arthur, 103–4, 110

Darwin, Charles, 14, 16–18

Darwin, Leonard, 12–19, 184n

Dearing, Vinton, 52

Deconstruction, 4, 105, 108, 117, 138, 155, 175, 180–81, 192n

Defamiliarization, 73, 80–87

Delacroix, Eugène, 85

Dense sign systems, 136–37

De Quincey, Thomas, 34

Derrida, Jacques, 93–94, 96, 105, 155, 157, 178

Deterioration, textual, 27–28; entropy and weathering, 86–87

Difference, 18–19, 28–30, 45–46, 47–49, 118–19. *See also* Textualterity

Di Suvero, Mark, 58

Dr. T. Felix Gouraud's Oriental Creme or Magical Beautifier, 128–29

Don Quixote (Cervantes), 102–3

Double Negative (Heizer), 71

Duchamp, Marcel, 60, 111

Dysgenics, 13, 16, 18, 20–21, 28, 48

Eagleton, Terry, 45

Eastlake, Sir Charles, 84

Eclectic editing, 20–23, 155. *See also* Eugenics

Eggert, Paul, 4, 69

Elgin, Lord, 2, 76

Ellington, Duke, 174

Erased de Kooning (Rauschenberg), 61

Eugenics, 11, 12–19, 22, 24–27, 49–50, 184n

Eugenics Education Society, 14–15, 26

Events, 113–16; exhibitions and installations as, 125–26; forgeries as, 143–44

Family Shakspeare, The (Bowdler), 61–64

Finley, Karen, 194n

First Amendment, 55, 61

Fish's lemma, 114

Fisher, John, 169

Fisher, Philip, 70, 155

Foucault, Michel, 70, 74, 105

Foxon, David, xi

Framing, 113, 132–35, 177–81

Frampton, Hollis, 107

Gabler, Hans Walter, 46, 87

Galignani, *Poetical Works of Coleridge, Shelley, and Keats,* 18, 31, 32

Galton, Francis, 12–13, 22
Gauguin, Paul, 157, 168
General Services Administration, 56, 64–65
Genette, Gérard, 156–57
Gill, Eric, 67–70
Gilman, Ernest, 169
Gittings, Robert, 35
Goodman, Nelson, 95, 98–106
Graff, Gerald, 188
Grammatology, 117
Graves, Michael, 82
Greenberg, Clement, 171–74
Greetham, David, 8
Greg, Sir Walter, 19–20, 21–22, 52
Grocery stores, as bookstores, 40, 44

Hammons, David, 77–80
Hay, Louis, 26
Haydon, Benjamin Robert, 76
Heizer, Michael, 71
Helms, Jesse, 75
Hitler, Adolph, 24, 26–27
Holzer, Jenny, 113
How Ya Like Me Now? (Hammons), 77–80
Hughes, Robert, 174
Hutchinson, Sarah, 34

Iconoclasm and violence, 75–81
Ink, Dwight, 56, 58, 62
Inscription, 94–95
Installations, 113, 123–24, 144–52, 197n, 199n
Intentional fallacy, 88
Intentions, 6–7, 28–29, 32–33, 59, 99–110, 127–28; failure of, 1–2, 59, 111–12, 151–52, 164; multiple, in architectural restoration, 83–88
Intertextuality, 155–56
Intratextuality, 155–56
Introduction to Bibliographical and Textual Studies (Williams and Abbott), 90–91, 112
Isomorphism, 136–37, 164

Iterability, 93–111
It's a Wonderful Life (Capra), 55

Jeffrey, Francis, 37
Johnson, Samuel, 20, 30, 39
Judd, Donald, 142–43

Keats, John, 32, 33–39, 46; "To Autumn," 35, 38; 'bad' Keats, 34–35, 37–38, 165; *Endymion,* 34; "Ode to Psyche," 35–38; as a phrasemaker, 39
Kitsch, 60, 174
Klee, Paul, 72–73, 166
Kline, Franz, 167–68
Koons, Jeff, 60
Kubler, George, 70, 73–74
Kunkel's Musical Review, 128

Labels, 160–77, 179, 200n
Lachmann, Karl, 21–22
Lakoff, George, 114–15
Lamb, Charles, 42
Lamoureux, Johanne, 169
Language, 70, 73–74, 93–94, 117; and language-like codes, 122, 136–37
Languages of Art (Goodman), 95, 98–106
Lear House (East Hampton, New York), 82–84
Lee, Sherman, 77
Leonardo da Vinci: *Ginevra de' Benci,* 158; *Last Supper,* 55, 59, 72; *Mona Lisa,* 84–85, 139–40
Lessing, Gotthold Ephraim, 62, 170
Life, Letters, and Literary Remains of John Keats, The (Milnes), 32, 33–34

Maas, Paul, 21
Magicicada septendicim, 162
Mailloux, Stephen, 114
Manual of Textual Analysis (Dearing), 52
Manzoni, Piero, 60
Mapplethorpe, Robert, 32, 75

Marquez, Gabriel García, 95
Mast, Gerald, 134
Masur, Kurt, 152
McGann, Jerome, 44, 45, 91–92, 95, 106, 117, 127–28, 130, 138, 156
McKenzie, Donald, 9
McLaverty, James, 139
Mein Kampf (Hitler), 24, 26
Mental Deficiency Act of 1913, 13
Meyer, James, 125
Michelangelo: *David,* 75, 197; *Sistine Chapel,* 67, 68–69, 85–87
Milnes, Richard Monckton, 11, 32, 33–34, 39
Monospondence, 125
Mostafavi, Mohsen, and Leatherbarrow, David, 2, 87
Moxey, Keith, 3, 180
Mukařovský, Jan, 112
Murray, John, 14, 15–18
Museums and galleries, 121–27, 195n; American Fine Arts, 124–5; Barnes Foundation Collection, 32; Cleveland Museum of Art, 76–78; Guggenheim Museum, 80–82; National Gallery, Washington, 155–58; Uffizi Gallery, 76, 80, 82
Music, 52–53, 136. *See also* bootlegged music tapes

Naming, 160–61
National Socialism, 24, 26
Nature's Secrets Revealed, 24–25
Need for Eugenic Reform, The (L. Darwin), 12–19
New historical criticism, 3, 47–50
Newman, Barnett, 59
Newman, Jon O., 65
Normal and the Pathological, The (Canguilhem), 29–30

Oral literature, 91
Oral texts, 115
Origin of Species, The (Darwin), 14, 16–18
Outcomes, 116

Paintings: and language, 133–34, 164–67, 172–75, 176; versos of, 176–77, 202n
Paradjanov, Sergei, 73
Paratext, 156–57
Pareles, Jon, 153
Parergon, 157, 177
Parsons, Laurie, 124
Parthenon, 2, 76, 84. *See also* Elgin, Lord
Pathology, 21–22
Peirce, Charles Sanders, 112
Pepto-Bismol, 165–66
Performance art, 113–16, 194n
Phelan, Peggy, 115–16
Photography, 5–6, 64, 106–8, 123, 137, 150–51, 183n
Picasso, Pablo, 46
Piss Christ (Serrano), 169
Piss Paintings (Warhol), 166
Polke, Sigmar, 164
Pollock, Jackson, 123, 178, 157–67, 197–98n
Postcards, 139–40, 197n
Powys, John Cowper, 65–66
Practice of Theory, The (Moxey), 3
Preziosi, Donald, 5
Prince, Richard, 60

Quantum textuality, 4–6, 57, 66–67, 94, 98–101, 107, 114–16

Rassenhygiene, 24–26
Rauschenberg, Robert, 61
Reader's Digest Condensed Books, 39–44, 96
Reading, 45–46, 47–48, 52, 122–23, 135, 138, 177–81
Readywrits, 110–11
Reconfigurations, 1–3, 31–32, 39–44, 64, 70–88, 151–53, 156–57, 172–75, 179, 200n
Reproduction, 4–6, 97–101; of artworks, 138–44; autograph replicas, 136–7; facsimiles, 97, 109, 197n; forgeries, 45, 101–2, 143–44; illu-

sion of, 5, 97, 106, 108–110, 139;
originals, 140–41; reprints and reis-
sues, 93, 99–101. *See also* Textual
criticism; Eugenics
Restoration, 76, 84–87, 189n
Reterritorialization, 5–6, 40, 53,
102–4, 108, 130, 152, 156–57,
179–80
Rice, James, 34
Rilke, Rainer Maria, 121–22, 125–27
Rodin, Auguste, 77–78
Rosenberg, Pierre, 84–86
Rothko, Mark, 141–42, 198n
Rupture. *See* Transience
Ruthven, K. K., 23–24
Rybczynski, Witold, 134–35

Saint Matthew (Caravaggio), 66
Salle, David, 169–70
Schnabel, Julian, 71, 115
Sculpture: *David* (Michélangelo), 75,
197n; *Prospero and Ariel* (Gill), 67–
70; *Resting Gladiator* (Valadier),
147–48; *Spiral Jetty* (Smithson),
71–72; *Square Bar Choker* (Serra),
144–50; *Thinker* (Rodin), 77–78;
Tilted Arc (Serra), 56–65, 72
Semiotics, 9, 54, 64, 112–13
Serra, Richard, 56, 57–67, 72, 144–
51
Serrano, Andres, 75, 169
Shakespeare, William, 20, 30, 39, 42,
44, 60, 86. *See also* Bowdler, Thomas
Shape of Time, The (Kubler), 70, 73–
74
Shillingsburg, Peter, 73, 90, 130, 139
Shiny Toe Syndrome, 148
Signatures, 162–63
Sign language, 91, 113
Smithson, Robert, 59, 71–72, 74
Soap Bubbles (Chardin), 136–37
Society for Textual Scholarship, 51
Speech acts, 113–116
Steinbach, Haim, 170–71
Stella, Frank, 173
Stieglitz, Alfred, 106–8

Stillinger, Jack, 30, 39, 48, 49
Still life, 177
Stonehenge, 84
Sutherland, John, 106

Tanselle, G. Thomas, 22–23, 28, 64,
122, 138–39, 175
Tarkovsky, Andrei, 61
Taylor, John, 35, 37–38
Tennyson (Salle), 169–70
Texts: boundaries of, 53–55, 105–6,
113–14, 126–27, 130–35, 156–57,
166–67, 176–77, 177–81; and de-
construction, 192n; defined, 89–93;
as events, 152–53; as objects, 90–
91; as poses, 27, 123–24. *See also*
Works of art and literature
Textual criticism, xi, 8–10, 11, 47–48,
51–52, 89–93, 111–12, 127–28,
188n; and art history, xi–xii, 51–56,
151–52; and eugenics, 19–30, 49–
50, 185n; and idealism, 22–23, 27–
30, 32; as ideology, 26–30, 47–50,
52–53, 55, 117–19, 151–52, 177–
81; as methodology, 7, 8, 22–23,
108–9
Textualterity, 1, 11, 28–30, 39–40,
46, 48–50, 53–56, 96–97, 117–19,
141–43, 177–81
Thorpe, James, 20, 27–28, 52
Tintern Abbey, 73, 85
Titles, 167–77, 201n
Tom Sawyer (*Reader's Digest* condensed
text), 2, 11, 31, 40–44
Tom Sawyer (Signet text), 41
Transience, 1–3, 6–7, 58–59, 70–87.
See also Cultural change
Trauma, 71, 74–75
Trump, Donald, 143
Turner, Ted, 55
Twain, Mark, 42

Valadier, C. Louis, 148
Velz, John, 46
Vendler, Helen, 127–28
Virtual galleries, 57, 150

Virtual texts, 97
Vitrines, 75–76, 140

Ward, Philip, 76
Warhol, Andy, 60, 166
Washington Project for the Arts, 78
Weathering, 86
Weathering, On (Mostafavi and
 Leatherbarrow), 2, 86

*Who's Afraid of Red, Yellow, and Blue
 III* (Newman), 59
Williams, Ralph, 49
Woodhouse, Richard, 37–38
"Work of Art in the Age of Mechanical
 Reproduction, The" (Benjamin), 4–6
Works of art and literature: distin-
 guished from texts, 98–101, 136–
 37, 193n; as signifiers, 112